SWITZERLAND

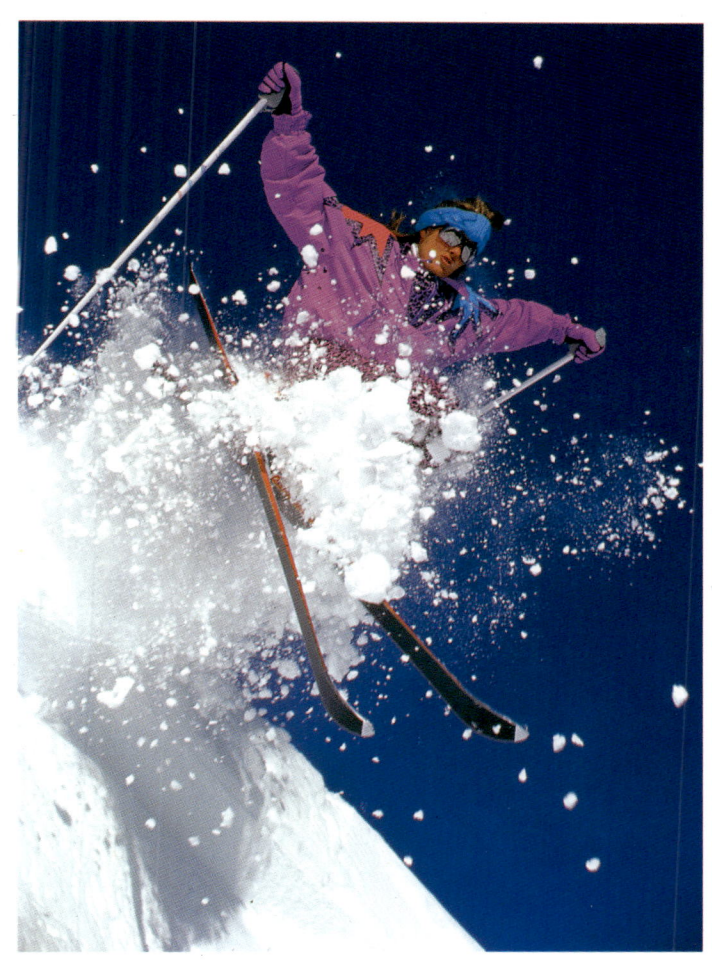

WHITE STAR
PUBLISHERS

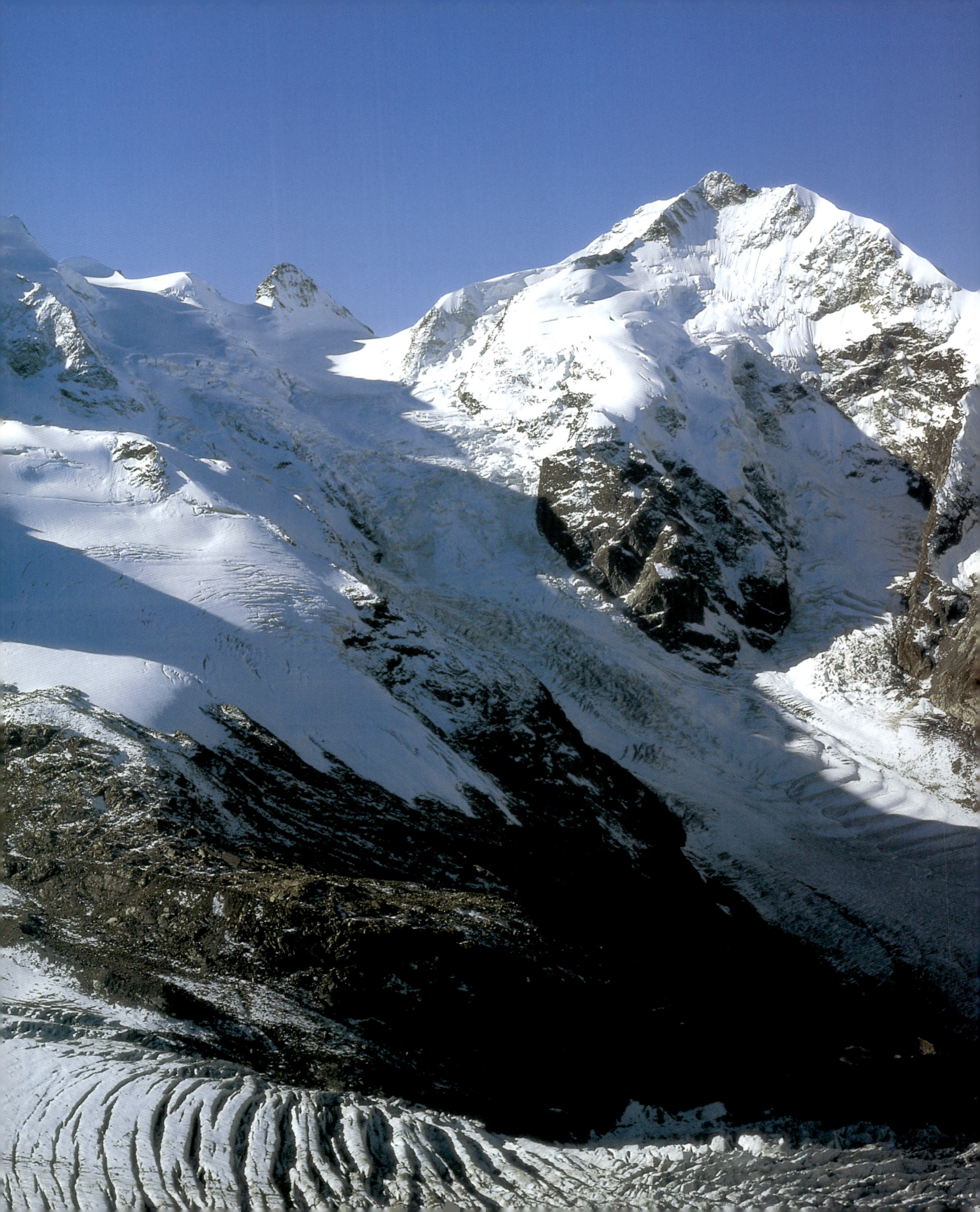

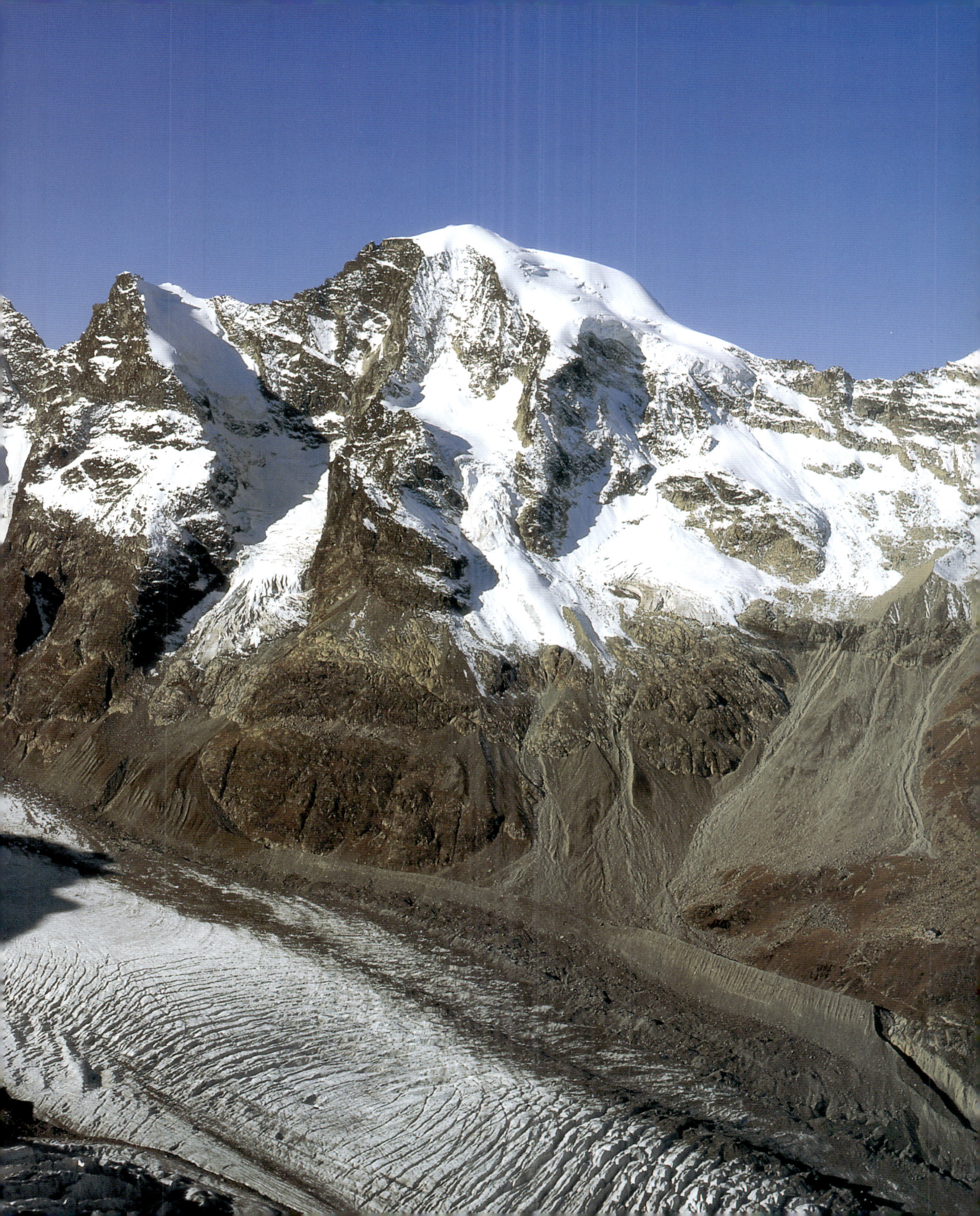

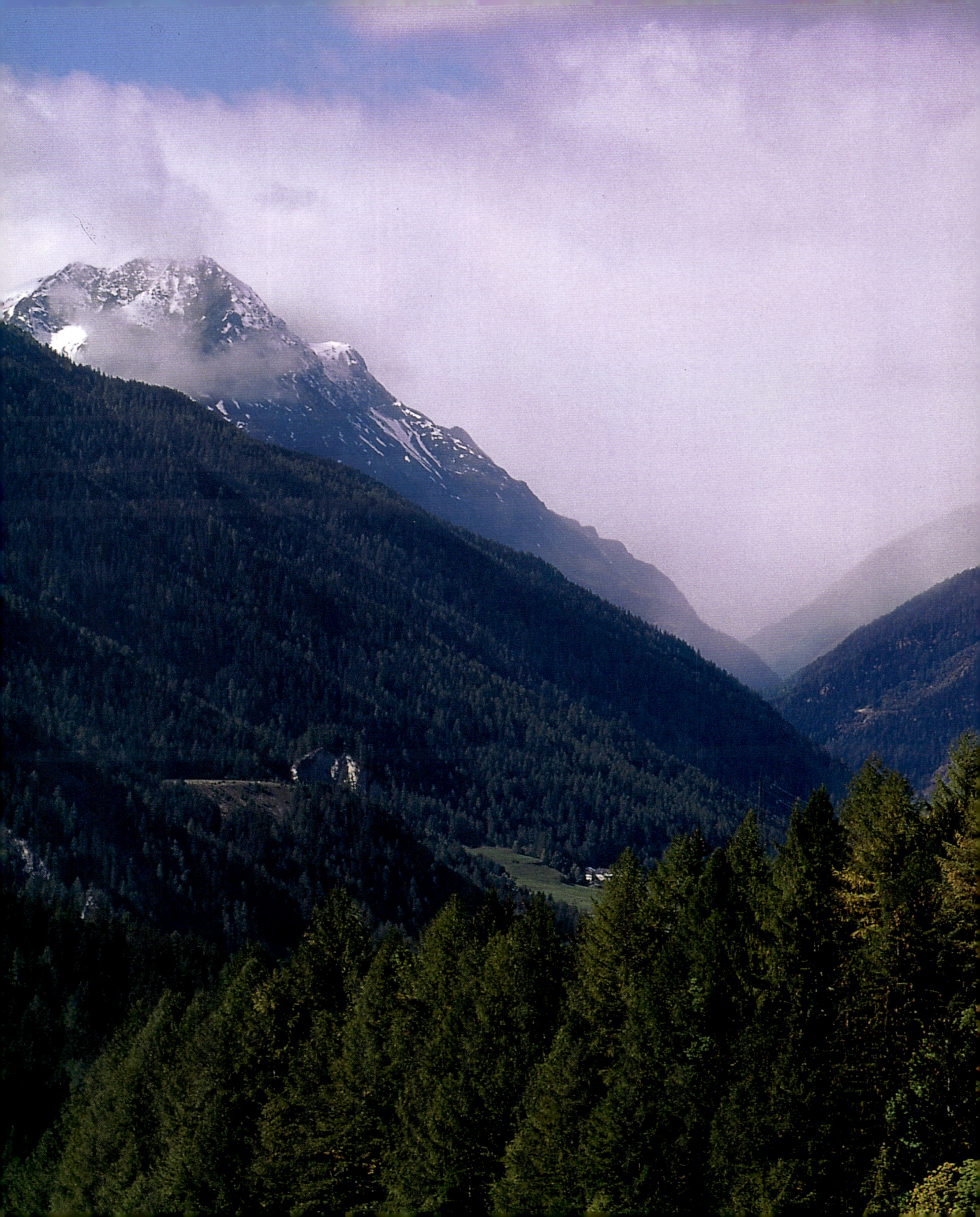

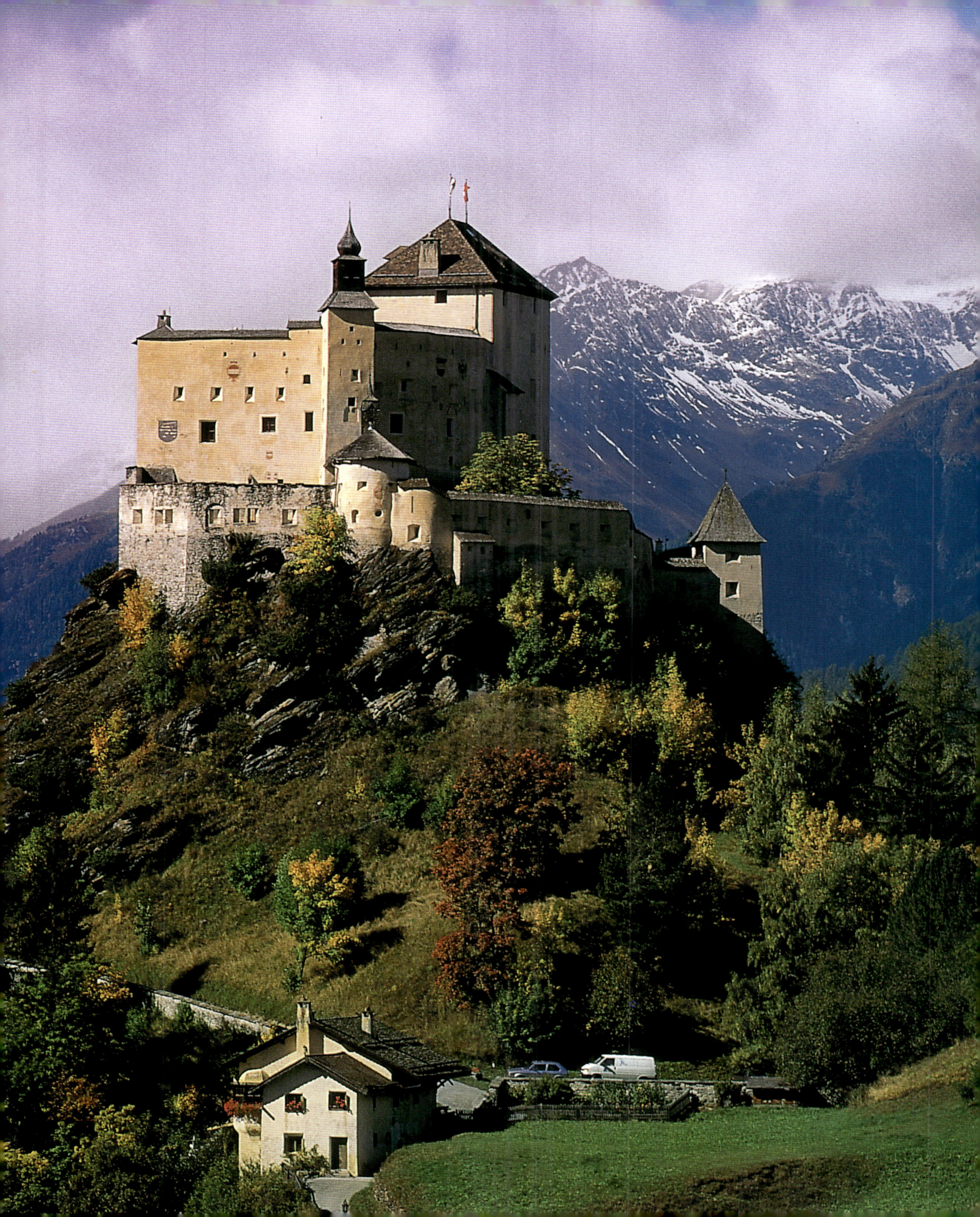

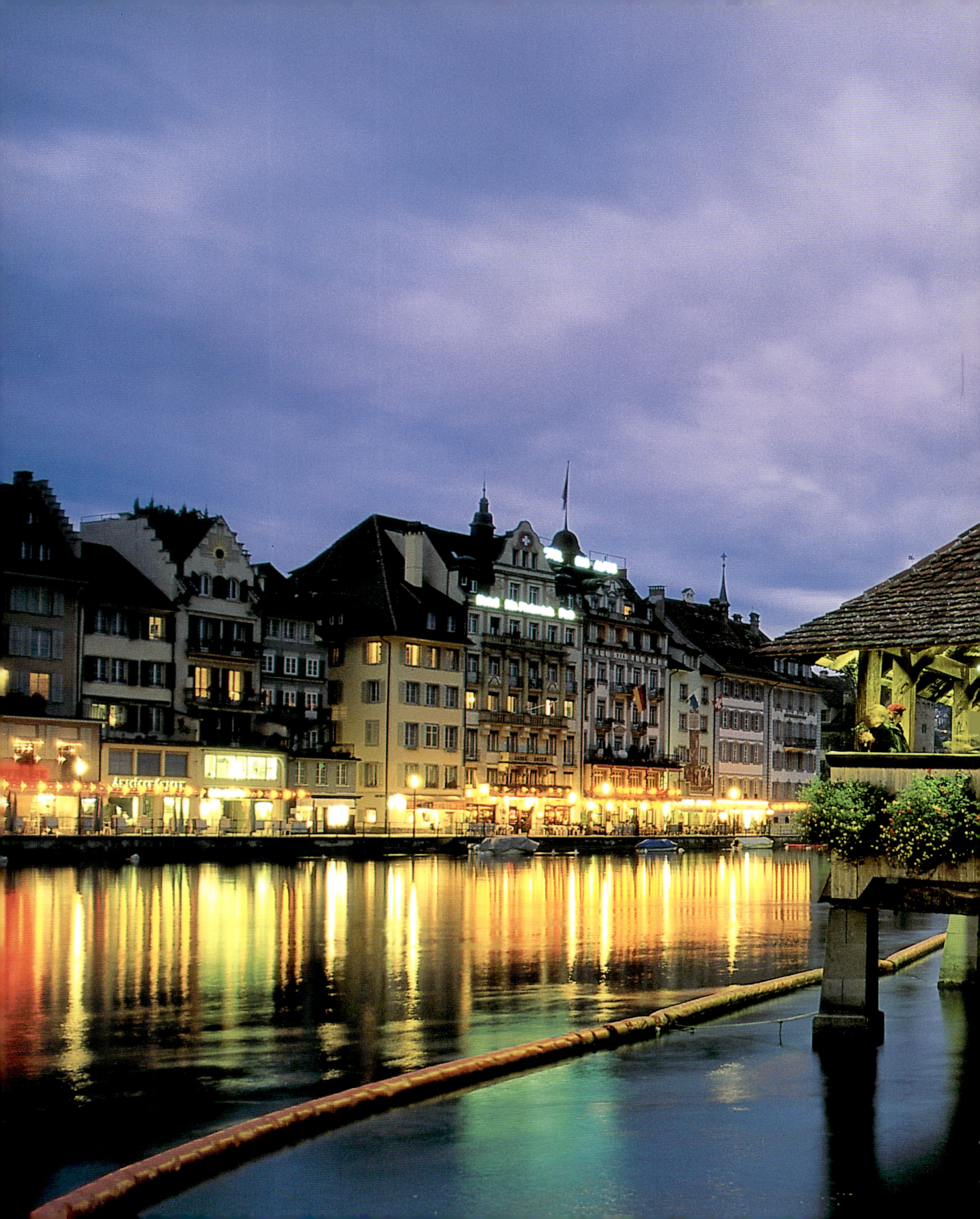

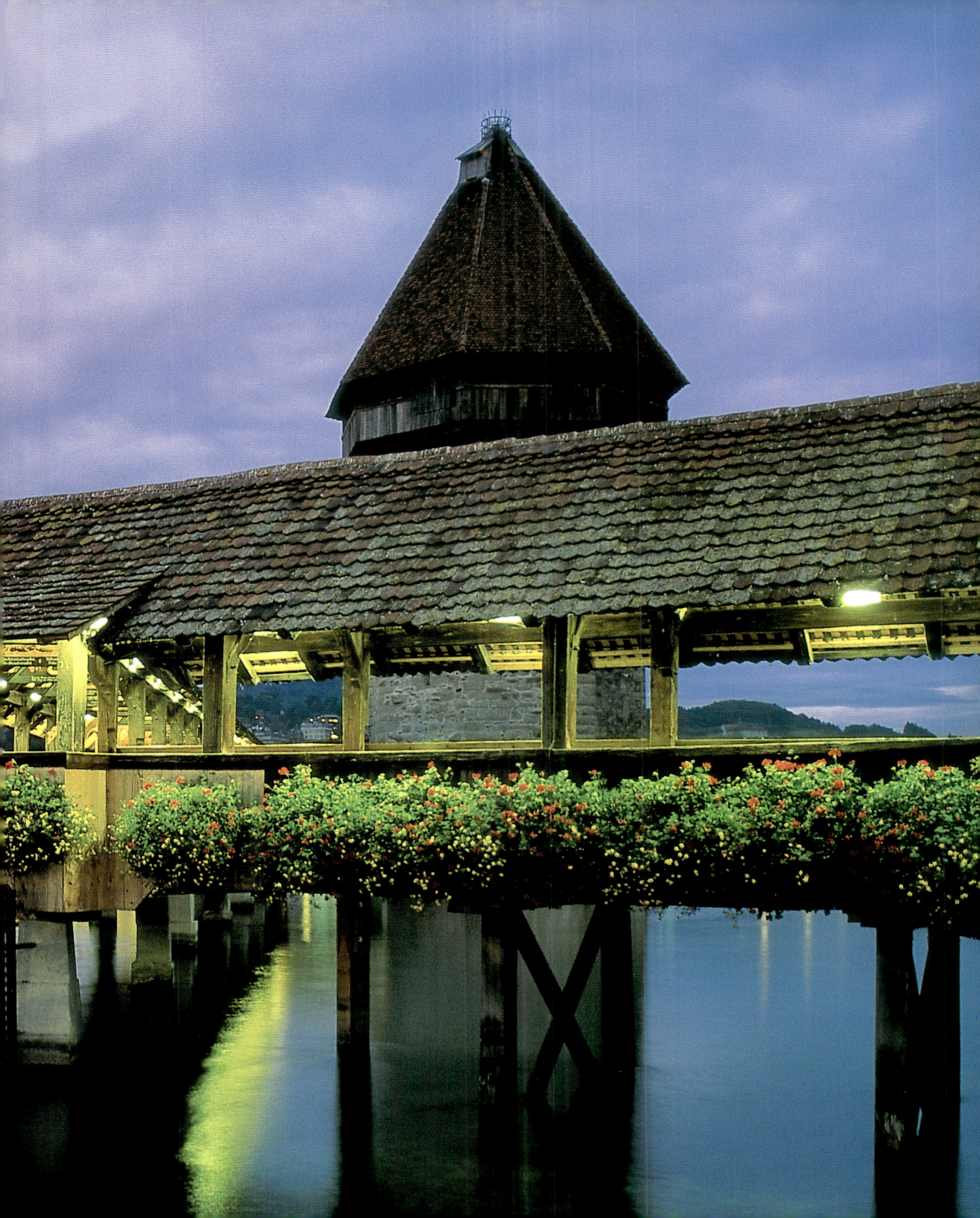

Texts
Secondo Carpanetto

Graphic design
Anna Galliani

Map
Giancarlo Gellona

Translation
Ann Hylands Ghiringhelli

Contents

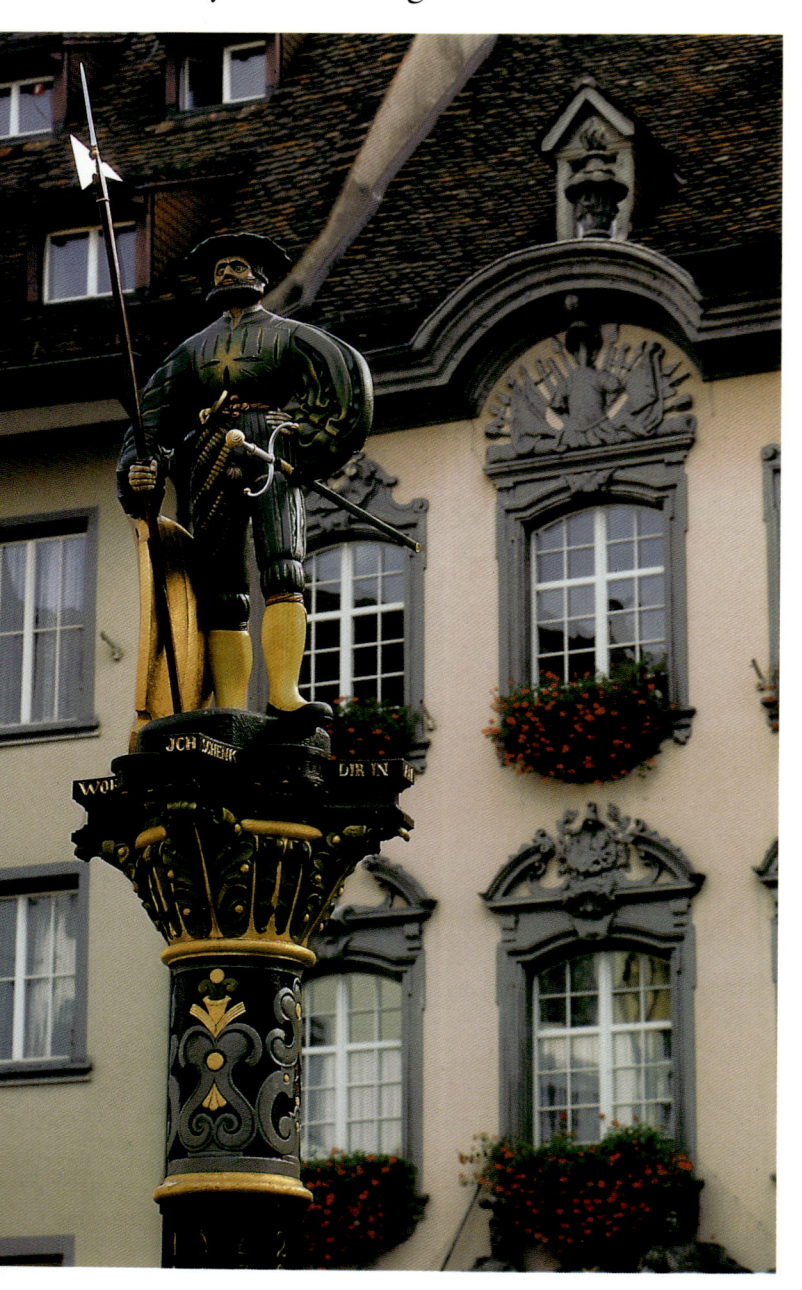

1 *An acrobatic dive onto freshly fallen snow, fun and thrills amid scenic splendours: with 3,107 miles of downhill pistes, as many of cross-country trails, 2,000 ski lifts and 200 ski schools, Switzerland is a paradise for winter sports enthusiasts.*

2-3 *Pictured in this view are the snow-covered slopes of the Bernina mountains, seen from the Diavolezza cable car station. In the foreground are the rugged peaks of Palù (12812 feet) and Bernina (13284 feet), favourite haunts of climbers; long tongues of ice can be seen descending towards the valley, forcing their way between these "giants" of the Alps.*

4-5 *Overlooking the woods and mountains of Lower Engadine are the pale, bare walls of Tarasp castle, a sombre-looking medieval fortress in the Graubunden canton. Built by the Tarasp family in the 11th century, its ownership was long disputed by the bishops of Chur and the counts of Tyrol. Owned by the Austrians until 1815, it now belongs to the dukes of Hesse.*

6-7 *The Kapellbrucke - Lucerne's oldest bridge and symbol of the city - is covered by a wooden structure, of the kind used for bridges in mountainous regions, as protection against the elements. It crosses the Reuss River diagonally and is flanked by the 13th-century Wasserturm (Water Tower), an old, fortified building used through the centuries as a*

prison and treasury. The beams of the bridge are decorated with a cycle of 17th-century paintings depicting the history of Switzerland and the lives of Saints Leodegar and Maurice, patron saints of the city.

8 *Schaffhausen, on the right bank of the Rhine, close to the border with Germany, still looks like a typical medieval town, in spite of its importance as an industrial centre. The city has the river to thank for its fame and fortune, having always monopolized trade in the Upper Rhine region. The statue in this photo is of a lansquenet standing guard over the Fronwagplatz, the old market square, still the vibrant hub of Schaffhausen today.*

9 *With the two arms projecting from its round central tower, Munot Fort seems to be welcoming visitors to Schaffhausen. As well as the deep caverns and high lookout posts along its massive walls, the castle has many features typical of a 16th-century fortress, including covered trenches, battlement towers and lunettes.*

12-13 *In less mountainous parts of Switzerland, close to lakes and on the hills around Geneva, the milder climate is ideal for growing grapes and excellent white wines are produced in these regions. The castle depicted here - its architecture reminiscent of the castles of northern France - overlooks a long south-facing vineyard, probably once part of the immense estate owned by the noble family that lived here.*

© 2002 White Star S.r.l.
Via C. Sassone, 22/24
13100 Vercelli, Italy
www.whitestar.it

ISBN 88-544-0028-9

Reprints:
3 4 5 6 08 07 06 05 04

Printed in Singapore
Color separation by Graphic Service, Milano, Italy

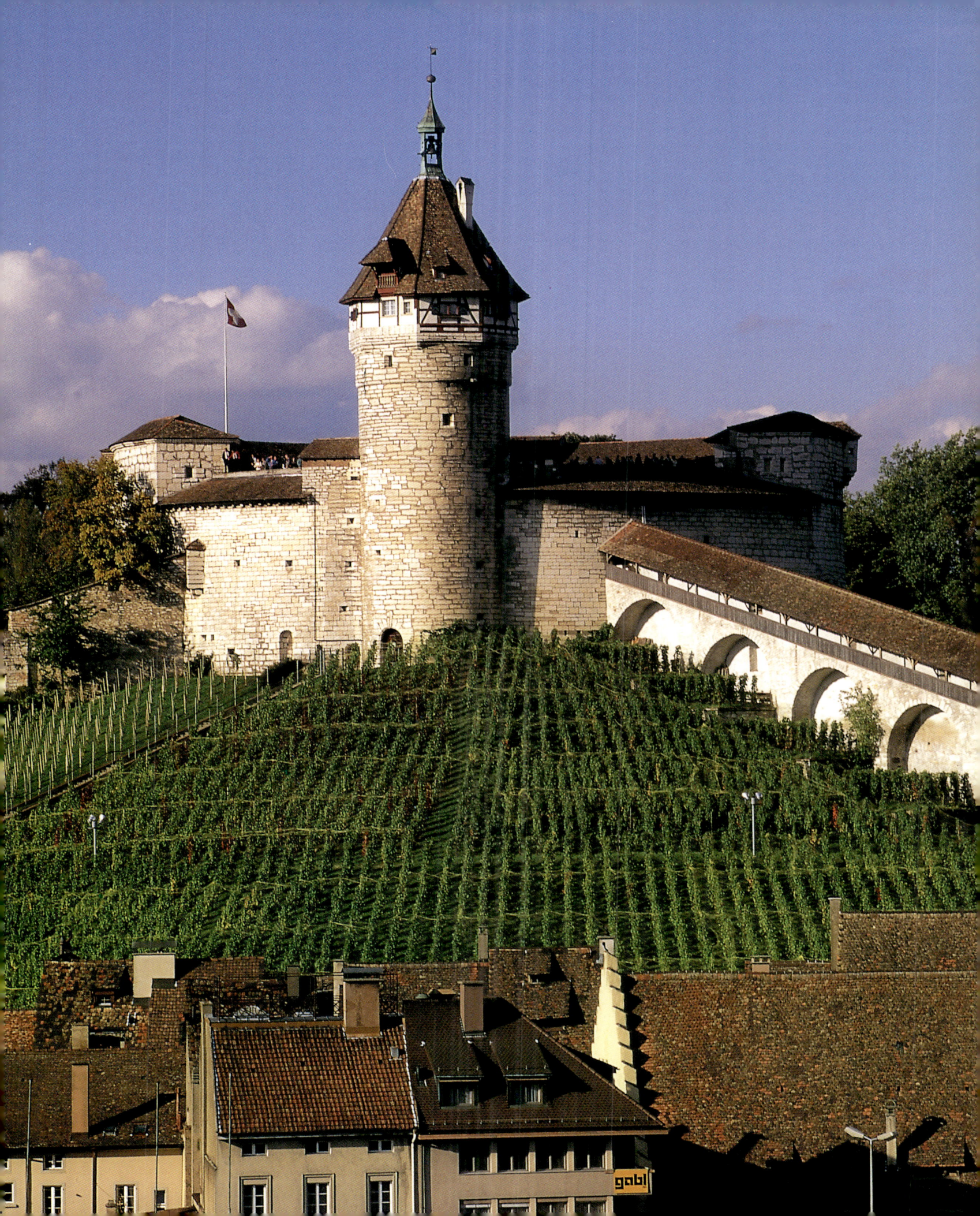

GERMANY

BASEL

AARAU

FRANCE

Aare

LA CHAUX DE FONDS

BIEL

NEUCHÂTEL

BERN

Lac de Neuchâtel

FRIBOURG

THUN

Brienzer See

Thunersee

GRINDELWALD

WENGEN

Eiger

Monchsgrat

V A U D

S w i s s J u r a M o u n t a i n

LAUSANNE

ADELBODEN

Jungfrau

Aletschhorn

Lake Geneva

Rhone

B e r n e s e A l p s

CRANS

Fletschhorn

SION

GENEVA

V A L A I S

Weisshorn

Weissmies

Dent Blanche

Rimpfischhorn

ZERMATT

Matterhorn

Grand Combin

I T A L Y

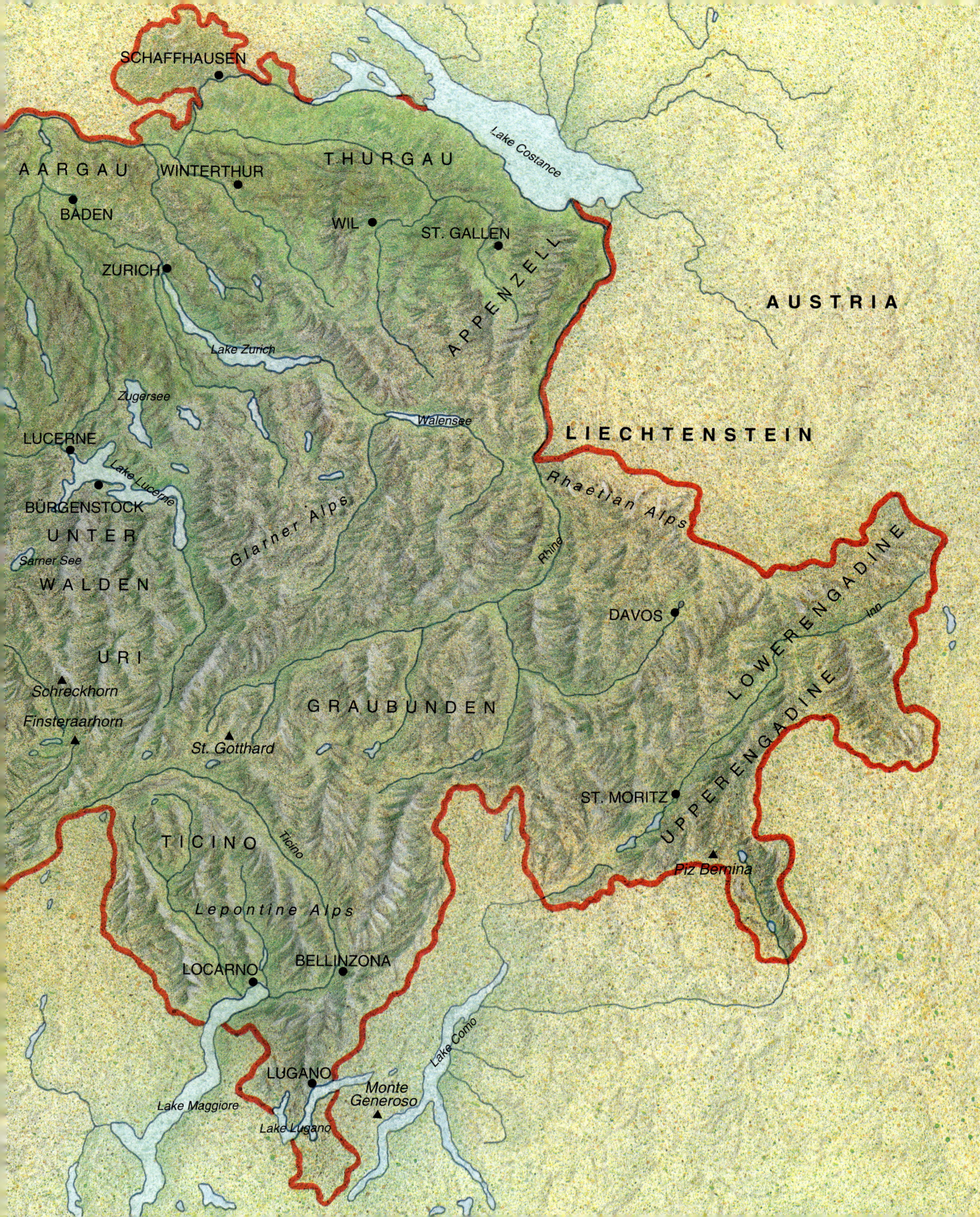

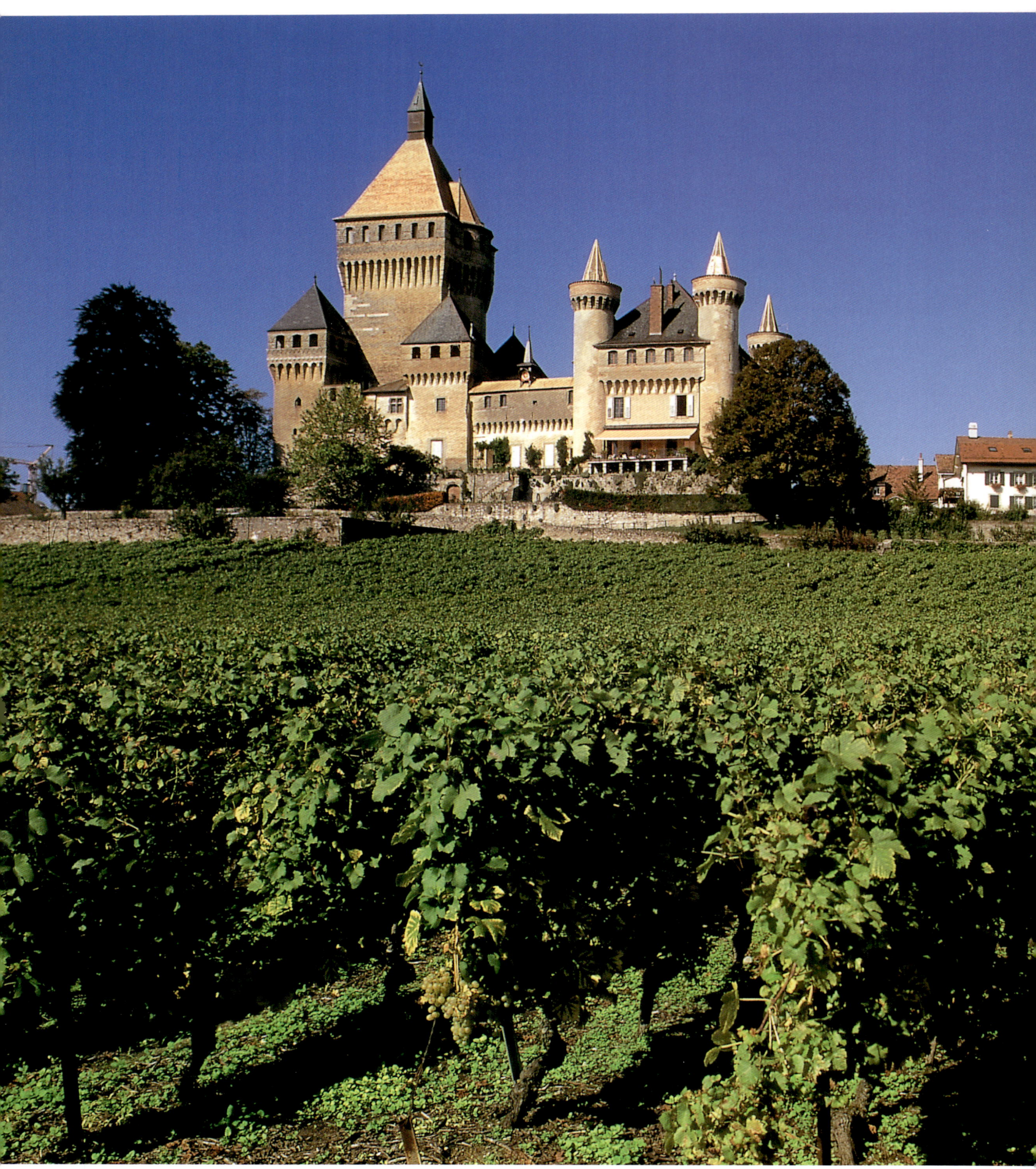

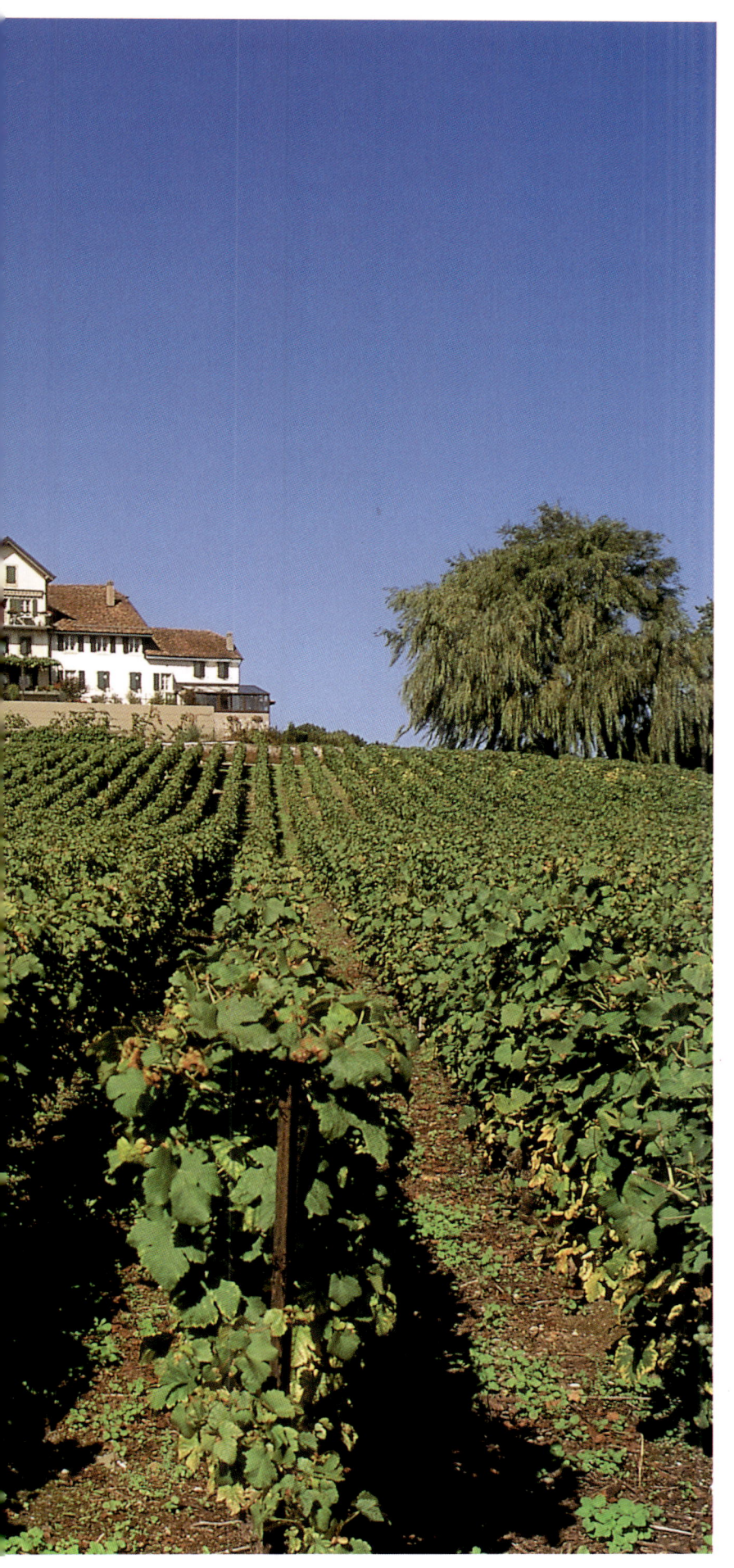

Introduction

Switzerland as we know it today is the product of a unique geomorphological setting crossed with the vicissitudes and achievements of its variegated population. It is formed of three distinct regions - the Alps, the Jura and the Central Plateau or Mittelland. Since the late 18th century, when the first people to explore the country as "tourists" were captivated by its picturesque beauty, their descriptions left no doubt as to the romantic impact of Switzerland and its landscapes. The stereotyped image put about by travellers of those days - whose Swiss experience hinged on unhurried, roundabout journeys in horse-drawn carriages and leisurely mountain walks - portrayed a land populated by "soaring peaks covered by eternal snows", "towers of granite and castles of ice", "flower-decked meadows" and "wild lakes, black forests, rocks, sheer cliffs and abysses".

In distinct contrast was the perception shared by pioneers of the alpine regions, men whose "re-invented" mountains had little in common with the remote, inaccessible places that were the stuff of fanciful conjecture and fairy tales. In their view, mountains were an open-air laboratory in which to study the workings of nature, and a breathtaking spectacle to feast on, body and soul. Few peoples have been as successful as the Swiss in anticipating and intelligently benefiting from the thirst for knowledge and hunger for

emotions that, already in the 1700s, led the first naturalists to venture into these regions (not unlike the missionaries who, having set out to conquer a foreign culture, returned converted to the beliefs of a totally different world). It was their research and their tales that opened the gates of Switzerland to tourism. An 18th-century geologist and native of Geneva, Horace Bénédict de Saussure played a precursory role in this process. Acknowledged founder of scientific alpinism, Saussure travelled alpine valleys, ascended mountains, classified flowers and plants and studied the customs of people who had been "imprisoned" for centuries in remote villages. His travel notes formed the corpus of a great work - "Voyages dans les Alpes" - published volume by volume between 1779 and 1796 as his explorations provided him with new material.

But it took more than this to attract the first batch of tourists to Switzerland. Inspired by the myth of the noble savage and offering stirring descriptions of pristine natural beauty, the mysterious and romantic overtones of early 19th-century travel writings had more persuasive effects. The writer of a German guide book published in 1801 painted an awe-inspiring picture of Engadine: "At the place where the Rhine bursts its way through the impervious mountains of Graubunden, a terrifying, dark, subterranean chasm gapes wide. Beyond this abyss, a narrow path leads to a realm of fear and horror; close by there reportedly dwell people who contend their nighttime abode beneath trees and in caves with bears and aurochs: primitive people of giant stature, whose like has been seen only in the huge forests of America. So far few men have dared venture into this nightmarish place, and hardly a single one of them has returned." No better ingredients could have been found to tempt visitors, especially eccentric, well-to-do members of the English aristocracy, with a strong sense of adventure. And sure enough, the British market provided Switzerland's burgeoning tourist industry with its first

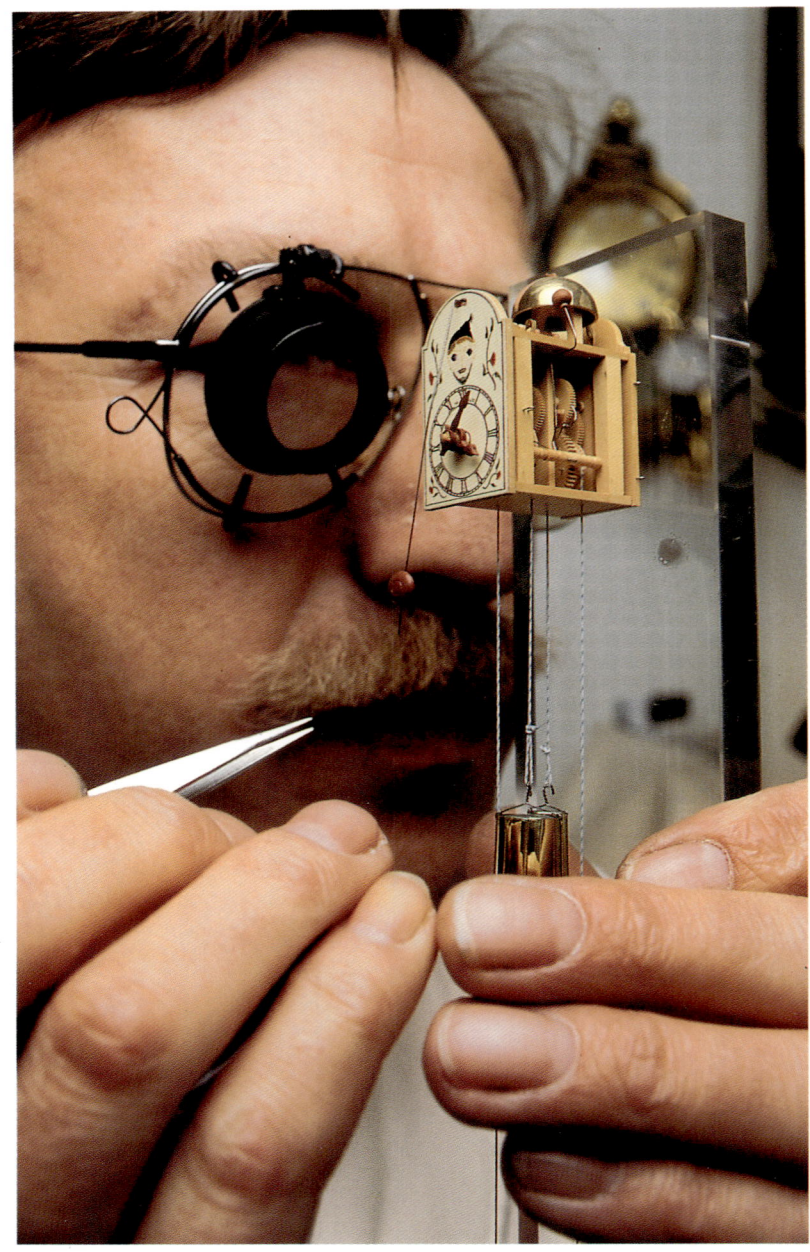

14 *Clocks and watches can be beautiful objects as well as precision instruments and in Switzerland time-honoured craft skills are now combined with state-of-the-art technology. The Swiss clock and watch manufacturing industry is concentrated in the Jura and Mittelland regions, with both small workshops and big companies whose most upmarket brand names - Audermas Piguet, Blancpoin, Jaeger-Le-Coultre - are synonymous with the very finest quality products. Visitors to the clocks museum at Le Sentier can see precious and highly original examples of sophisticated Swiss workmanship.*

15 *This picture was taken during a national gathering of alphorn enthusiasts. This instrument has long been part of Swiss life, sounded during everyday work and in time of war, as well as on festive occasions. Its notes echoed from valley to valley when herdsmen were gathering their cattle together, at the end of the day. During wars it was used to communicate over long distances: certain sounds were traditionally used to call to arms all men who were fit to fight, as soon as any threat of invasion was reported from the borders; other notes served to gather together mercenary soldiers to be sent to battlefields far from Switzerland.*

16-17 *Steim-am-Rhein is situated on the right bank of the Rhine, at the point where the river leaves Lake Constance; with its well-preserved frescoed buildings, balconies enclosed by windows and fountains, the main square of this delightful little town still has a medieval aura and reflects a typically German approach to urban ornamentation.*

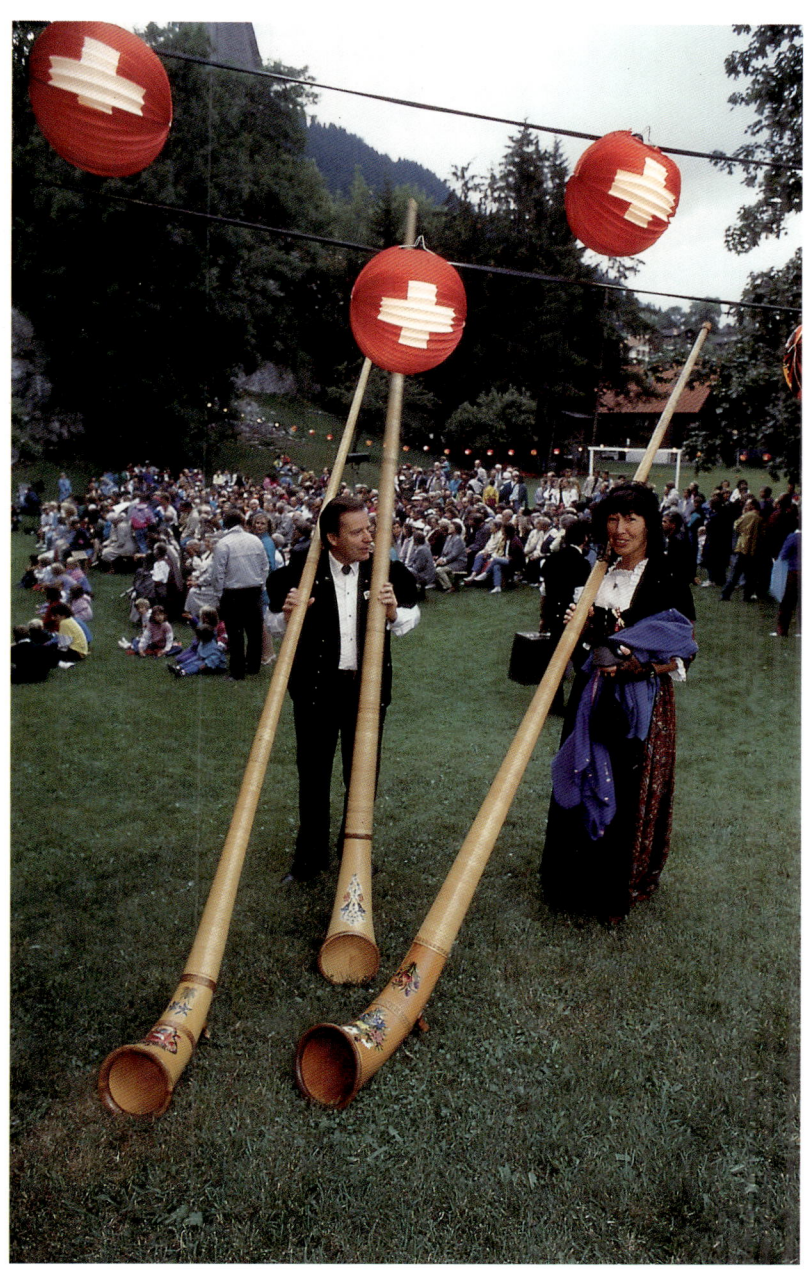

clients. A sojourn in the Swiss mountains soon became de rigueur for the wealthy, upper-class travellers who, until the end of the 1800s, alone indulged in the excitement of European tourism. The first itineraries mapped out during those years and the infrastructure for panoramic Alpine tours then created still serve the foreign visitors who now flock to Switzerland en masse (tourism is the second-most-important item in the country's balance of payments).

Much of the credit for today's flourishing tourist trade goes to 19th-century hoteliers who were quick to realize the money-making potential of the snow-capped peaks of the Bernese Oberland, Engadine, Valais, Graubunden and Ticino, popular summer destinations of royalty and nouveau riche alike. Grand hotels - called Ritz or Victoria perhaps - and family-run guest-houses dotted the valleys, bringing fame and fortune to places like St.Moritz, Zermatt, Grindelwald, Wengen, Adelboden, Burgenstock, Davos, and Crans. With the advent of narrow-gauge railways, the thrill of walking across a glacier was offered even to mountain enthusiasts whose mountaineering experience was nil.

Many other traces of by-gone days of tourism - besides old hotels and railway tracks - add a touch of romanticism to tourism today. As well as admiring mountains and valleys, visitors can make a journey back in time as they pass through numerous towns and villages that display their medieval origins.The "high spots" of traditional itineraries still hold a unique charm. Bear with the crowds waving Japanese camcorders rather than miss the trip up to the Jungfrau range, taking the train that climbs, from Interlaken Ost station, up along the river and through the woods to Kleine Scheidegg. From this point a cogwheel railway - Europe's highest and an outstanding feat of engineering - ascends through Alpine scenery of stunning beauty, dominated by three giants: the Jungfrau, the Monch and the Eiger. A tunnel takes the train into the very bowels of the

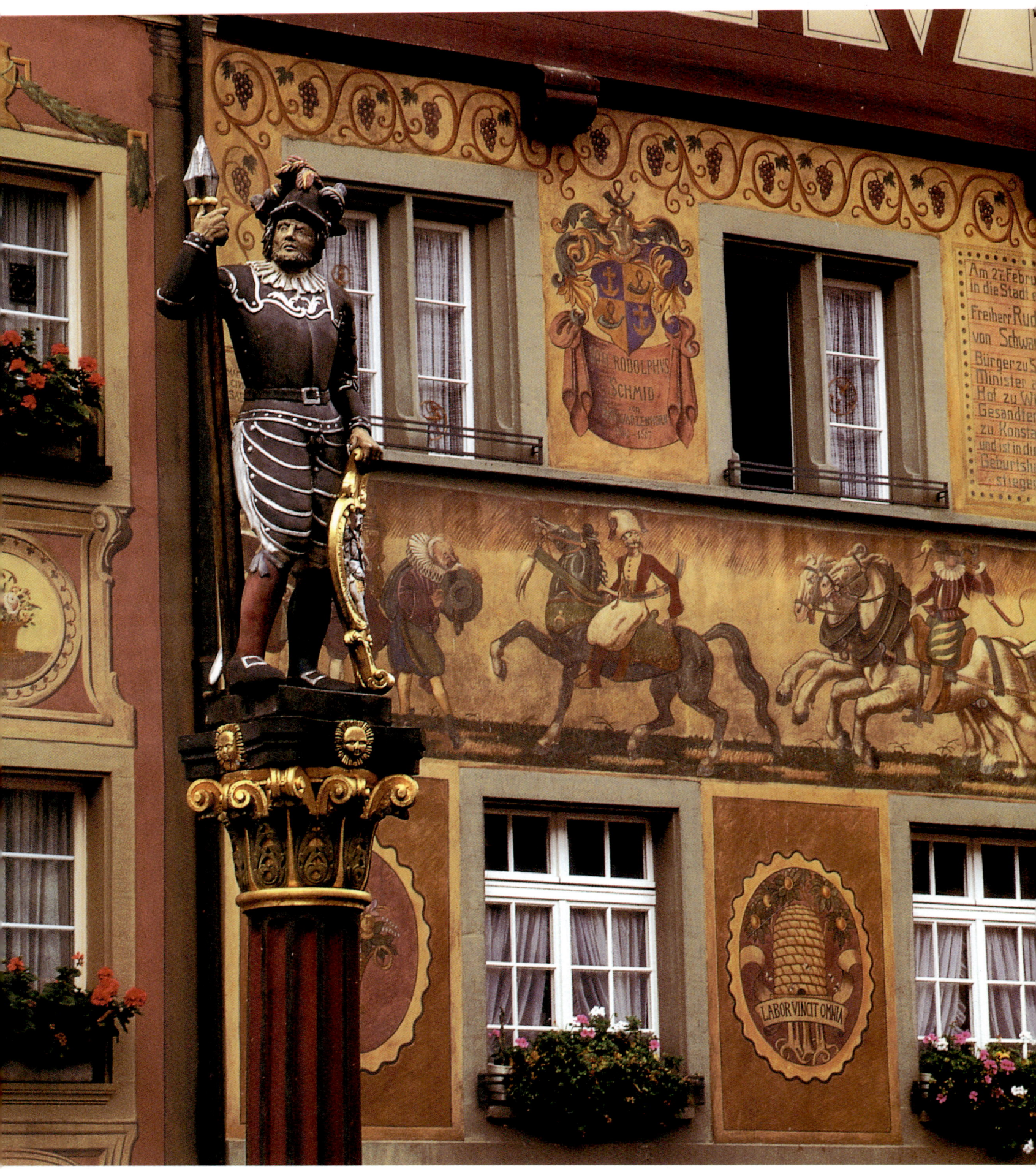

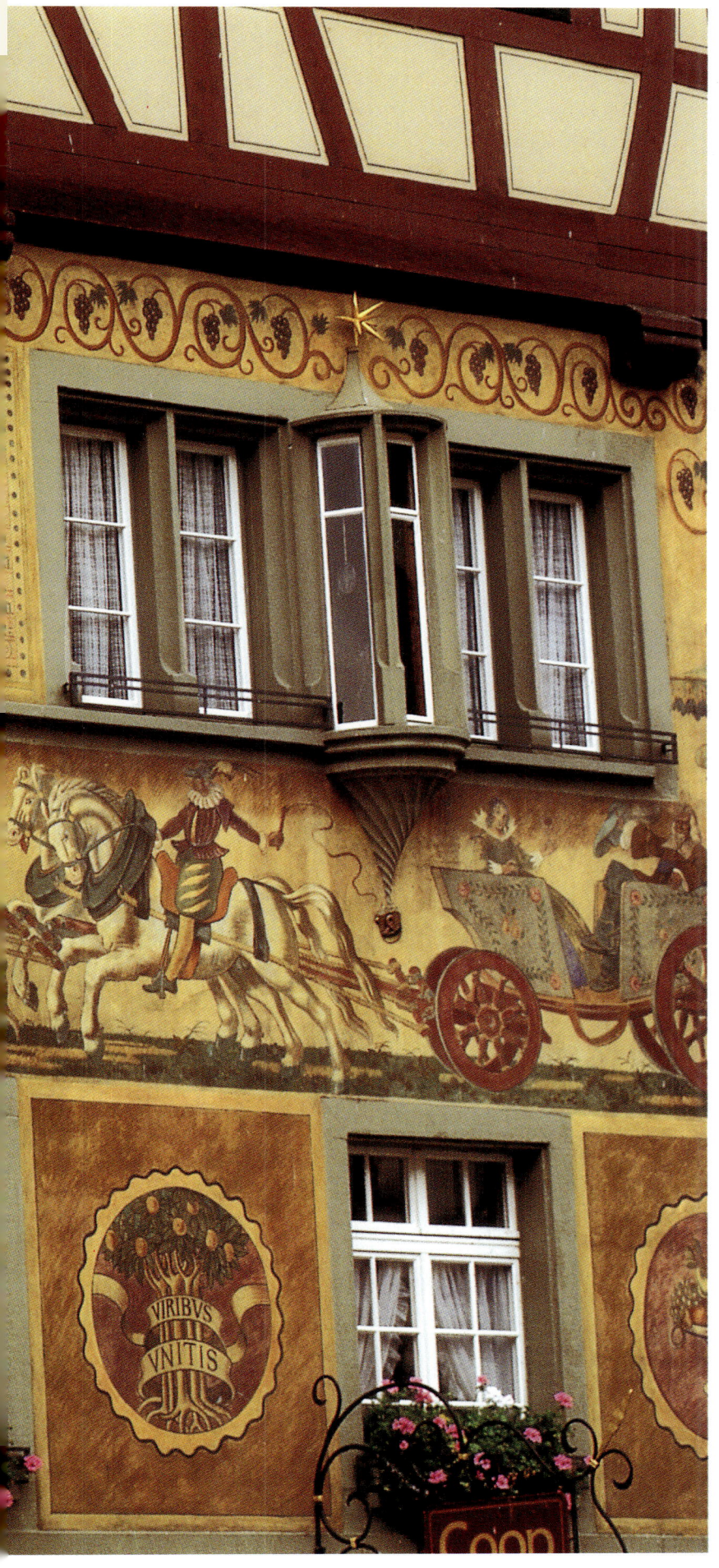

mountain where, from two observation points overlooking a sheer drop to the valley below, there are amazing views as far as the Black Forest and Vosges mountains.

Here in the bowels of the Eiger you need no expert knowledge of mountaineering and its history to fully appreciate the daring exploits of great international climbers who attempted to scale this mountain, one of the Alps' most challenging peaks. The sheer north face route was identified in 1938 and conquered thirty years later by Walter Bonatti in a solitary winter ascent. Another source of 'quick bucks' for Swiss mountain folk is the Matterhorn, especially since the landmark climb of 1865 in which Whymper reached its summit: the tragic accident during the descent, when four of the party plunged thousands of feet to their death, is said to have done more to make Zermatt world-famous than the spectacular first ascent itself.

For over a century the cogwheel mountain train from Zermatt to the Gornergrat (over 9,842 feet high) has carried tourists up to enjoy breathtaking views of the Matterhorn, Weisshorn and Monte Rosa. In the nearby Rhone valley, Sion - capital of the canton of Valais - has some of the oldest historical remains in the country: with Roman walls, medieval buildings and a Gothic cathedral, it offers a stratified overview of two thousand years of the nation's history.

Switzerland unfolds in a landlocked space confined by mountain chains and crossed by deep valleys: practically at the centre of the Alpine region is the St.Gotthard Pass, providing a passage over mountains which form the real backbone of the whole alpine system. The Rhine, Rhone and Ticino, the three major rivers which flow from this region, link Switzerland with Northern Europe, the Mediterranean and the Adriatic and connect a nation of mountain-dwellers with the foremost sites of European civilization.

It was at the foot of the St.Gotthard that the first nucleus of the Helvetian Confederation was formed in 1291, when the

three regions of Uri, Schwyzand Unterwalden joined in an anti-Hapsburg alliance, the origin of the Swiss nation as we know it today. This development marked the start of the long struggle against feudal power, on the fringe of the vaster democratic movement initiated by the 14th-century urban communes. The foundations of the Confederation were thus laid in the confined territory of central Switzerland, hemmed in to the south by the steep cliffs of the St.Gotthard, to the north and west by the Aare, which winds its way through the foothills of the Jura, and to the east by the shores of Lake Zurich. At its very heart was Lucerne and the Lake of the Four Cantons. Lucerne was on the famous Flanders Road, used by waggons and troops in transit between the Netherlands with the Mediterranean, and it acquired strategic importance after the St.Gotthard Pass was opened in 1230. The city's development dates from this period: permanent reminders of its medieval and Catholic past are to be seen in the streets and churches grouped on the two banks of the Reuss, at the point where the river leaves the Vierwaldstatter See and flows under the Kappelbrucke, the covered bridge which is Lucerne's best known symbol.

The charm of narrow old streets and plentiful evidence of Hapsburg and Catholic culture - not so commonplace in Switzerland - are also to be found in Zug, situated on the northeast shore of the Zugersee. Not far away is Einsiedeln: this town grew up around a splendid Benedictine abbey, still a centre of pilgrimage which provides the backdrop for religious mystery plays and other performances staged every summer in the large 18th-century square.

In the old heart of post-Reformation Switzerland, in which Calvinist, Zwinglian and Lutheran movements mixed and mingled, certain cities did not join the Reformation. The power map of the time reflected either their closeness to Catholic states or their loyalty to the Hapsburgs, weakened but still present

18 *Bern, capital of Switzerland and chief town of the canton of the same name, stands in a protected position on a sharp bend in the Aare river, at the foot of the Alps. The medieval part of the city still has old towers and row upon row of houses with arches. Modern Bern has instead spread out over the hills on the opposite side of the river. Bern was already an important settlement in the days of the Holy Roman Empire and subsequently enjoyed considerable independence. It joined the Swiss Confederation in 1353. Until 1848, Bern shared its role of confederal capital with Zurich and Lucerne.*

19 top *Isolated amid Protestant cantons, Fribourg has long been the spiritual centre of Roman Catholicism in Switzerland. A centre of art and culture, the city is of mainly medieval origin, its handsome Gothic buildings encircled by fortifications that still include fourteen towers and long stretches of old walls. It stands on the border with Alemannic- and German-speaking regions and, although French is the canton's official language, it upholds a proud tradition of bilingualism. Depicted here is the tower of St. Nicholas' Cathedral, built 1470-90.*

19 bottom *Montreux has been a popular international tourist resort since the late 1800s. Pleasantly located on the northeastern edge of Lake Geneva, facing the Savoy Alps, it is known for its elegant houses, luxury hotels and - of course - its casino. It has gained particular cultural prominence for its jazz festival, held here each year in June and July, an event highly rated on the international jazz scene.*

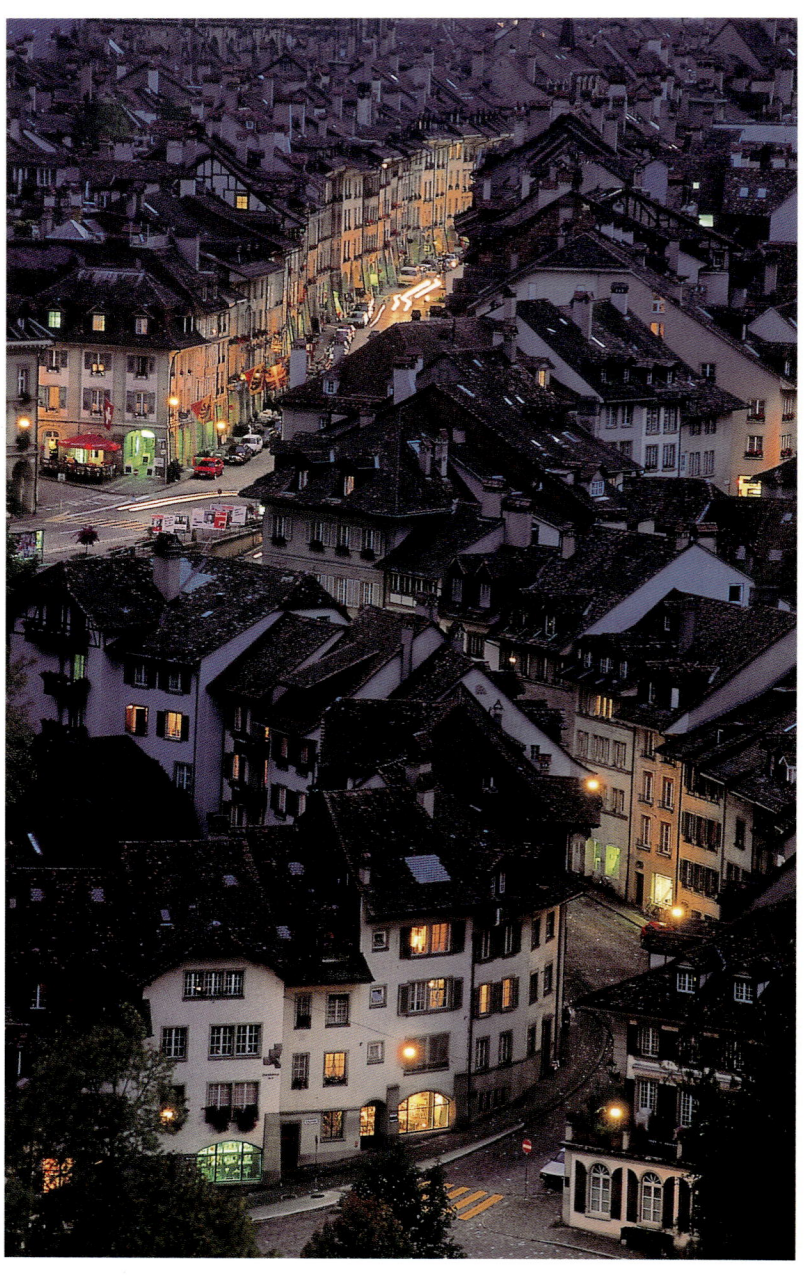

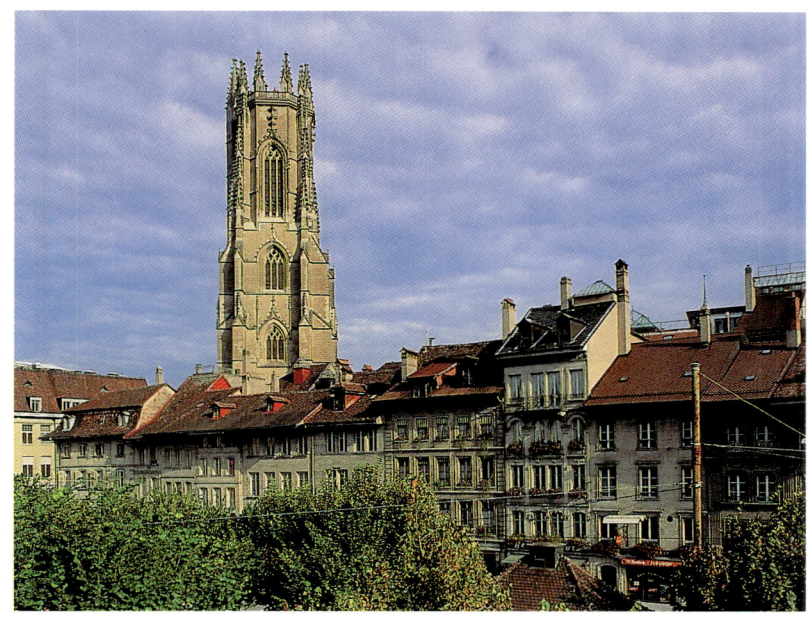

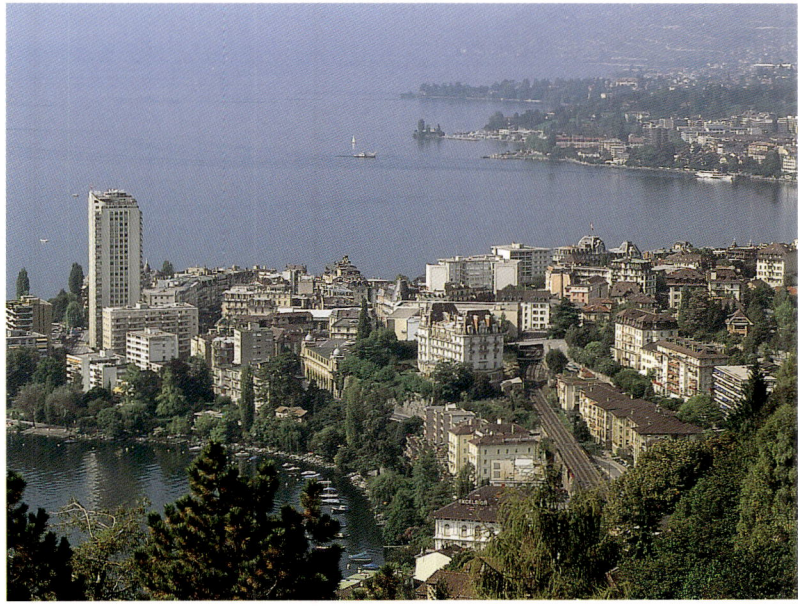

20-21 Two skiers pause for a while near the Keschhutte: rearing up behind them is the rugged summit of Piz Kesch (11,214 feet), one of the best known peaks in Upper Engadine.

22-23 Only a short way from Geneva and the hectic pace of the city, the rural face of Switzerland is revealed; here, since time immemorial, the land and changing seasons have continued to govern the way of life. Vineyards stretching as far as the horizon pattern the gently sloping hillsides.

24-25 For centuries visitors to Switzerland have never failed to be impressed by its many cathedrals of ice and rock. Perhaps the most stunning of all are the Eiger (13,025 feet), Monch (13,488 feet) and Jungfrau (13,642 feet), three giants whose snow-capped peaks preside over the huge Aletsch Glacier, in the Bernese Oberland.

even during the troubled years of religious conflict in the early 16th century. Located between Calvinist Geneva and Lutheran Bern, Fribourg offers very noticeable evidence of its Catholic past: its churches, Catholic university, monasteries and Jesuit college are tangible signs of the efforts made by the church of the Counter-Reformation to check the spread of Protestantism by nipping it in the bud. The religious issues of the 16th century radically changed outlook and traditions, the power structure and the everyday life of ordinary people. To the small political alliance established to defend the independence of rural and mountain communities, the Protestant Reformation meant an influx of dynamic cosmopolitan ideas, broader insights. It brought new lifeblood to the ethical principles seemingly present throughout the history of the Swiss people; it created a new awareness of longstanding values based on freedom, political and economic initiative, enterprise, purposeful and productive use of national capabilities and characteristics. From this time on the history of Switzerland can be likened to the movement of a pendulum, swinging freely from the snowy Alps and sources of the Rhine to the seeds of great ideals and grand initiatives which flowered as the republican spirit. Magnified by the Reformation, these ideals were "exported" to other parts of Europe and North America. The foundations were thus laid for the internationalism of Calvinist stamp to which many Swiss cities directly or indirectly owe their open-minded outlook on the world and its affairs.

Looking back through the centuries, the image of freedom as conceived and practised in Switzerland merges with that of a country of long-established, rock-solid liberal democratic traditions, a country that has always provided an inviolable sanctuary for refugees of every nationality. For evidence of this we need look no further than the events of our own century: in the early 1900s emigrés from Russia - among them Lenin, Trotsky and Zinovyev -

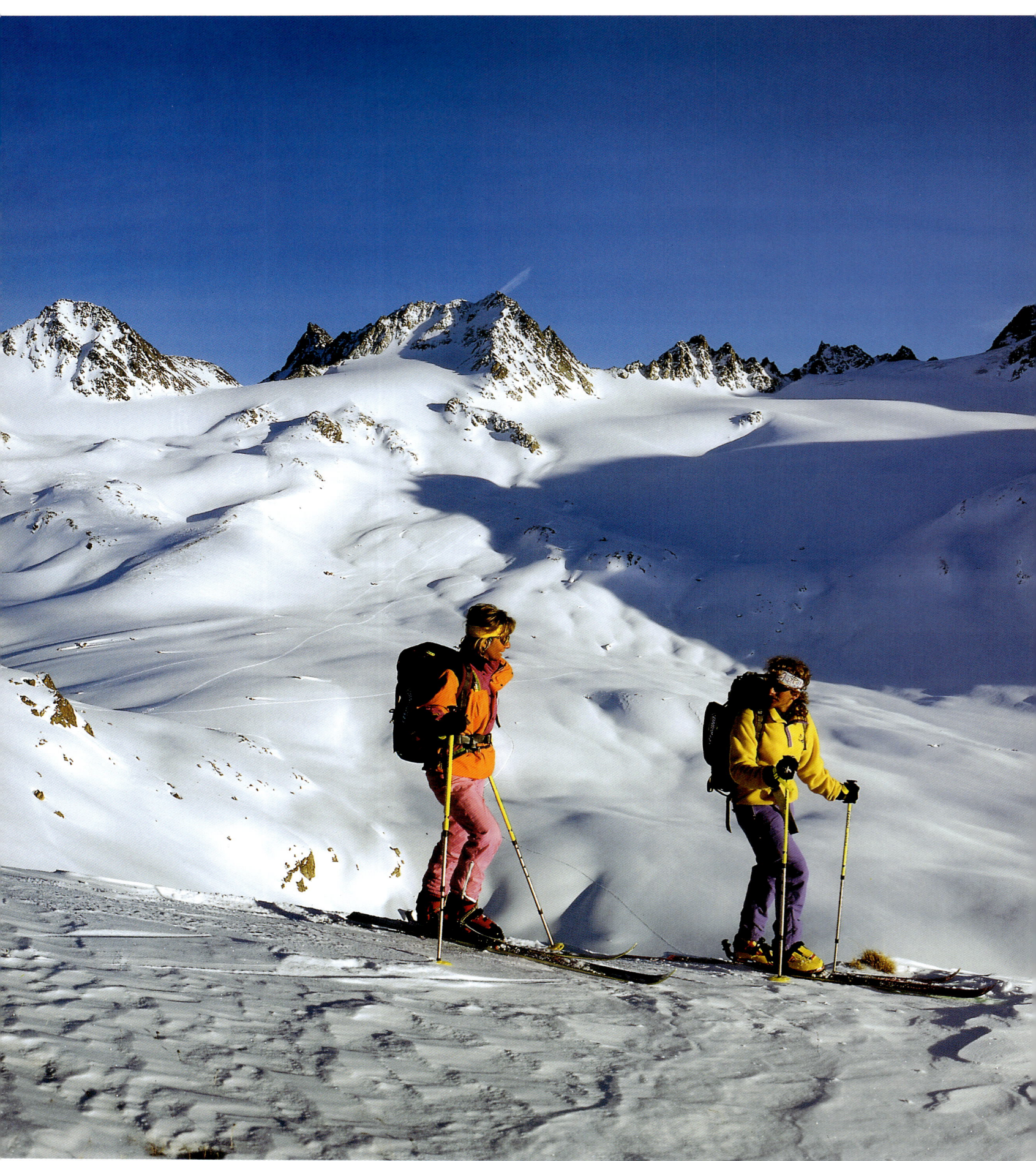

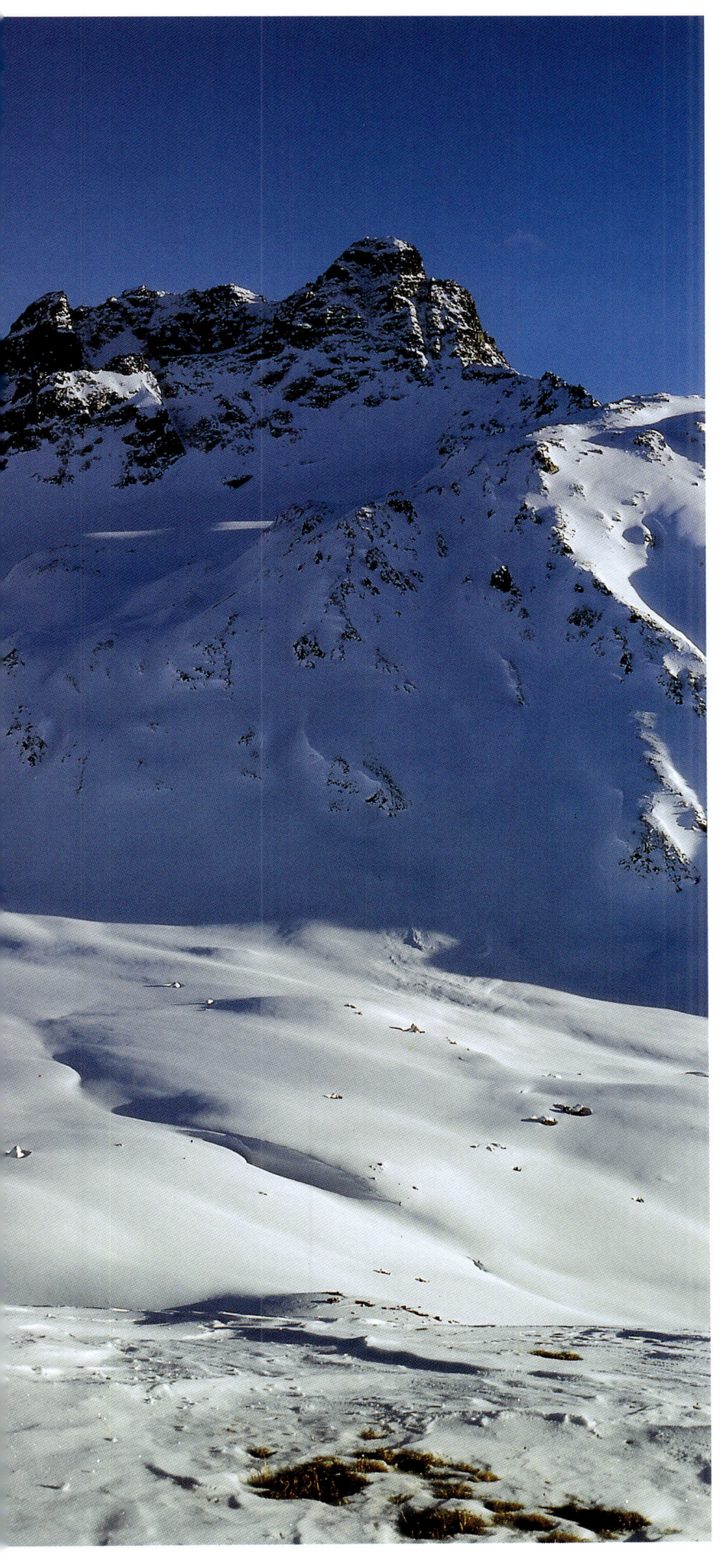

spent long periods here; from 1925 onwards opponents of Italy's Fascist regime found refuge across the border in Switzerland; and supporters of democracy forced to flee Chile after Pinochet's coup d'état in 1975 were safe from persecution here. But not all the cantons of Switzerland adopted an "open-door" policy to the outside world, ever more precious as the situation in the outside world deteriorated.

Zurich has always offered asylum to victims of persecution. In World War One a mix of communists, pacifists and other dissidents of diverse political leanings gathered in the city. For most of them flight had not been a matter of life or death as was the case for tens of thousands of refugees in World War Two. It was in Zurich, during the troubled years of the First World War, that Tristan Tzara, Hugo Ball, Marcel Janco and Hans Harp started the Cabaret Voltaire, the first group of the Dada movement. With a deliberately destructive approach to conventional culture, its members set out to convey their despair over the war and the need to discard the canons of 19th-century aesthetics in favour of a newly invented, revolutionary kind of art. Zurich became an avant-garde outpost of the art capitals of Europe, primarily Paris and Berlin.

Zurich's theatrical productions also occupied an important place in European cultural life: during the Nazi period, when German actors and playwrights - emigrés or refugees - found asylum in the city, the Schauspielhaus played a key role: works by Brecht, Zuckmayer, Durrenmatt, Tennessee Williams, Faulkner, Wilder and O'Neill were performed for the very first time on its stage. Zurich is still a city of undisputed international importance. Based in this world-leading centre of business and finance are countless networked multinational organizations - even the "gnomes" are now plugged into the information superhighway - which enable brokers armed with computer networks, faxes and impeccable financial guarantees to control business in every corner of the globe.

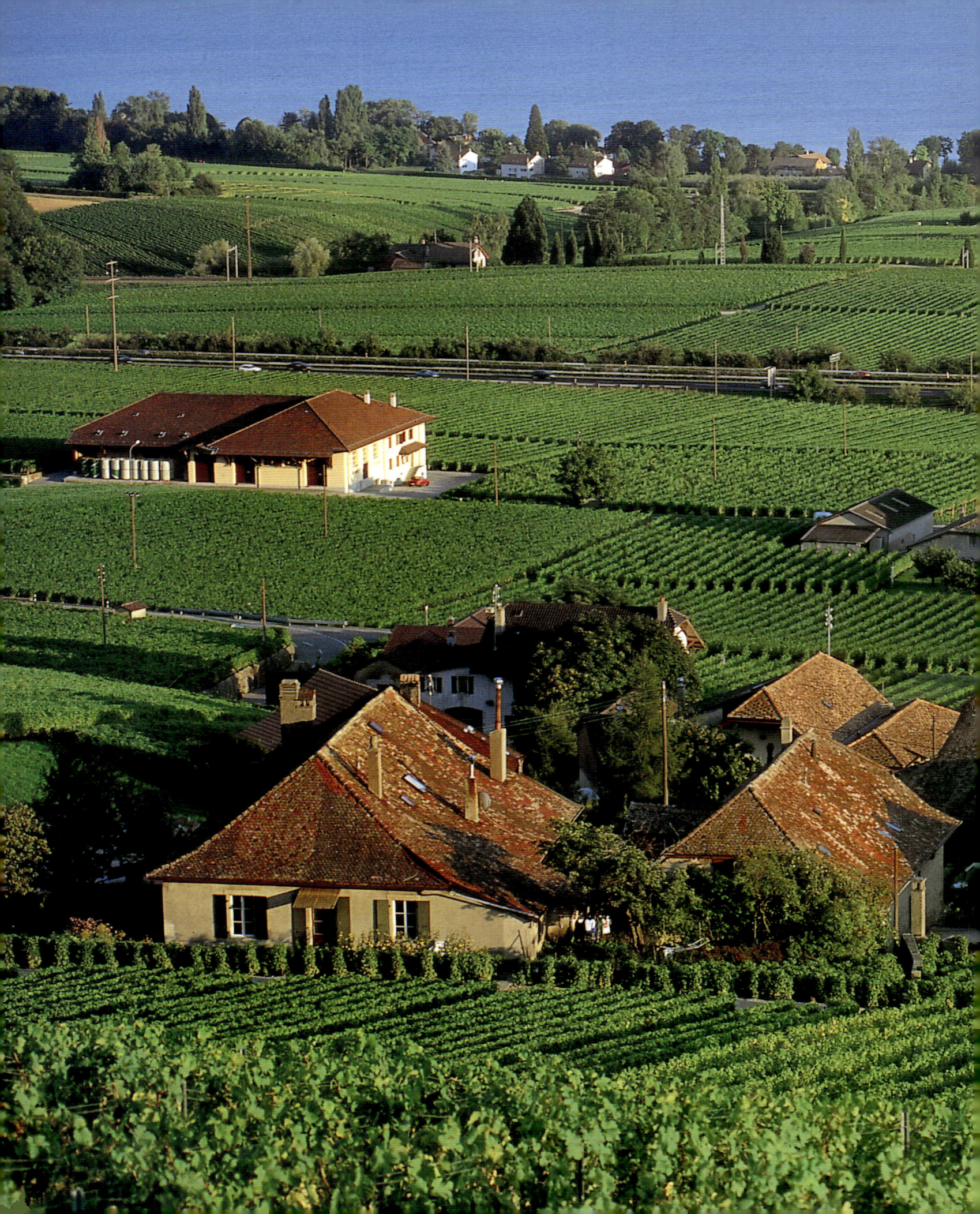

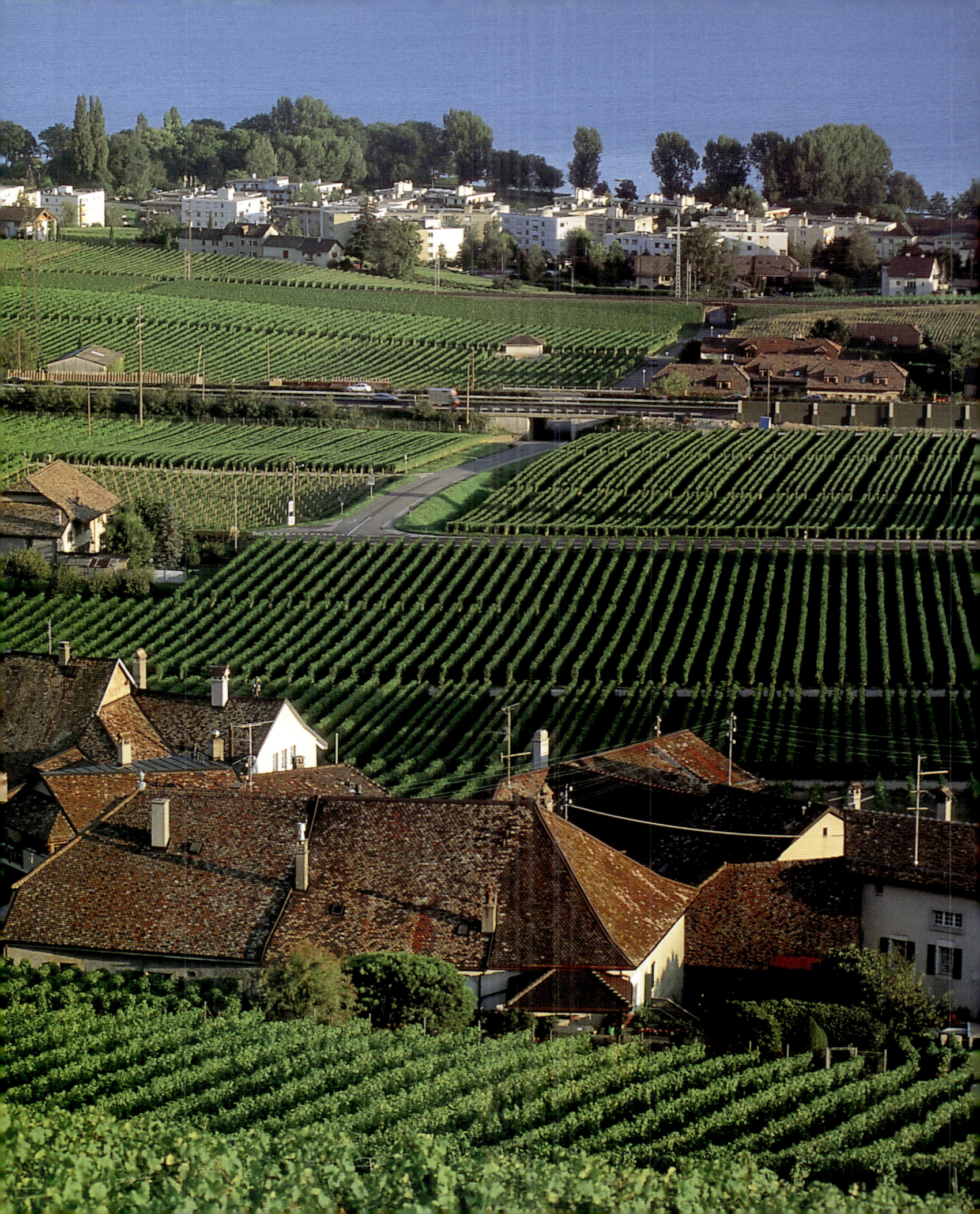

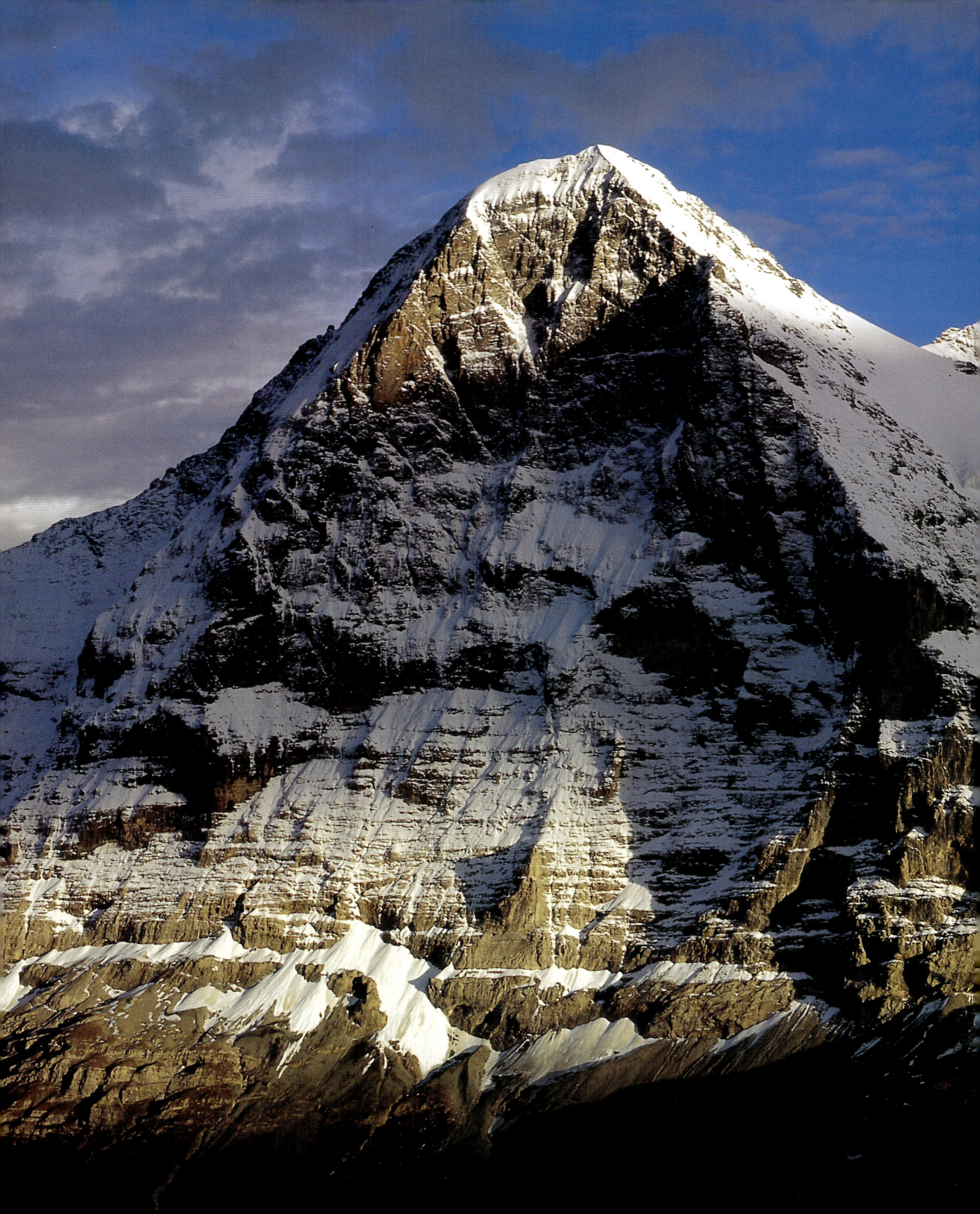

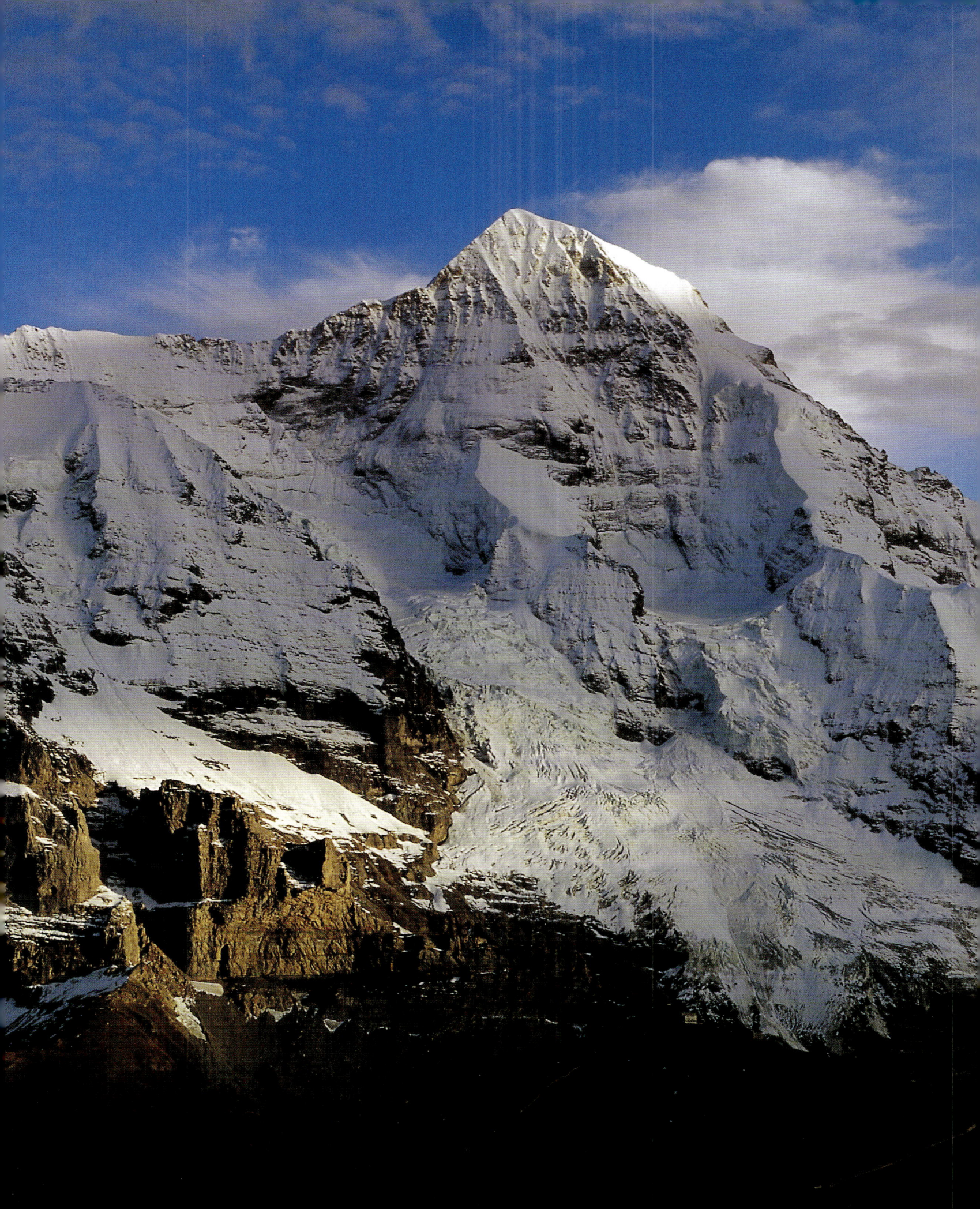

Enchanted Valleys, Lofty Peaks

26 Many Swiss scenes are like paintings of rare beauty and perfection. And no-one could fail to be charmed by such sights as gently rolling hills, vast expanses of woodland and pastures dotted with isolated farmhouses and the red and white cattle of the famous Simmental breed, named after a verdant valley of the Bernese Alps (in the photo above) through which flows the Simme river, a tributary of Thun lake (below).

27 According to legend, the tormented spirit of Pontius Pilate still restlessly wanders on the rocky heights of Mount Pilatus (6,995 feet) - rising on the west side of the Lake of the Four Cantons, near Lucerne - which affords a breathtaking view of no fewer than fourteen lakes and the Alps all around. An amazingly steep cog railway carries visitors up to Pilatus Kulm (seen in this photo), climbing 5,348 feet in just 3 miles.

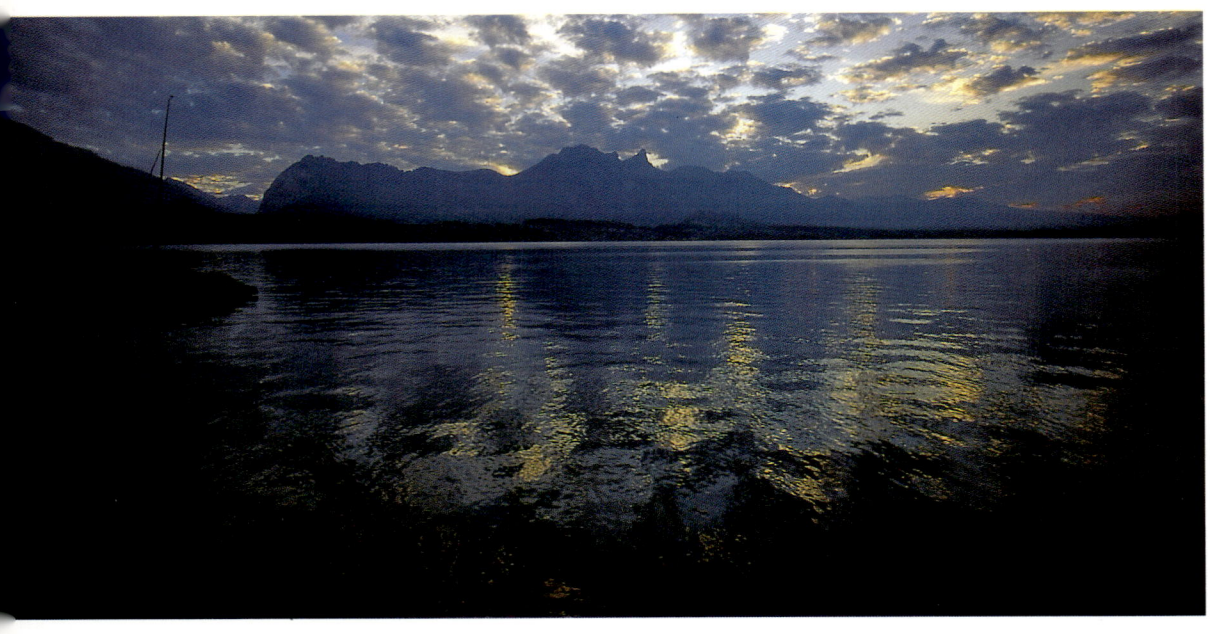

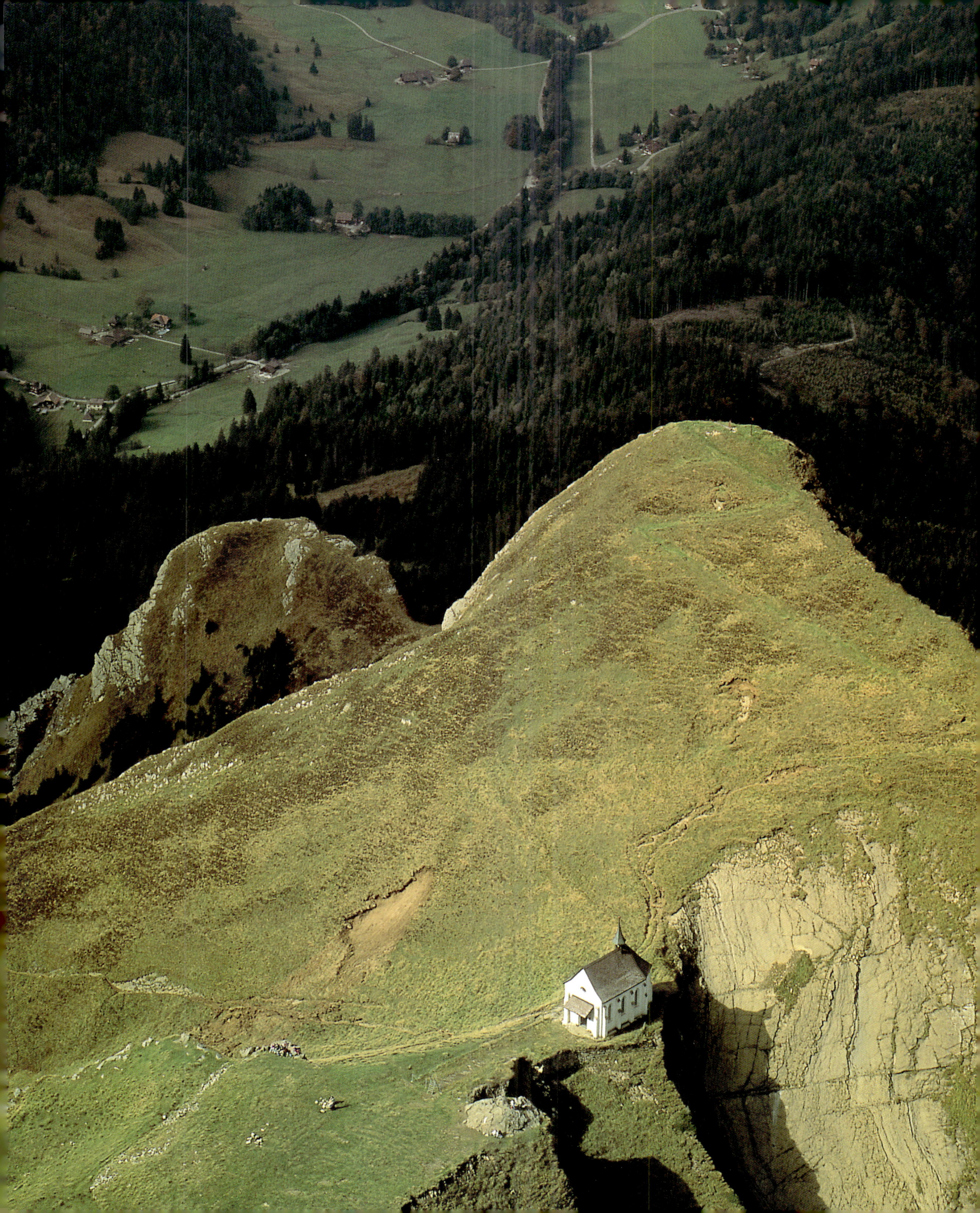

On the roof of Europe

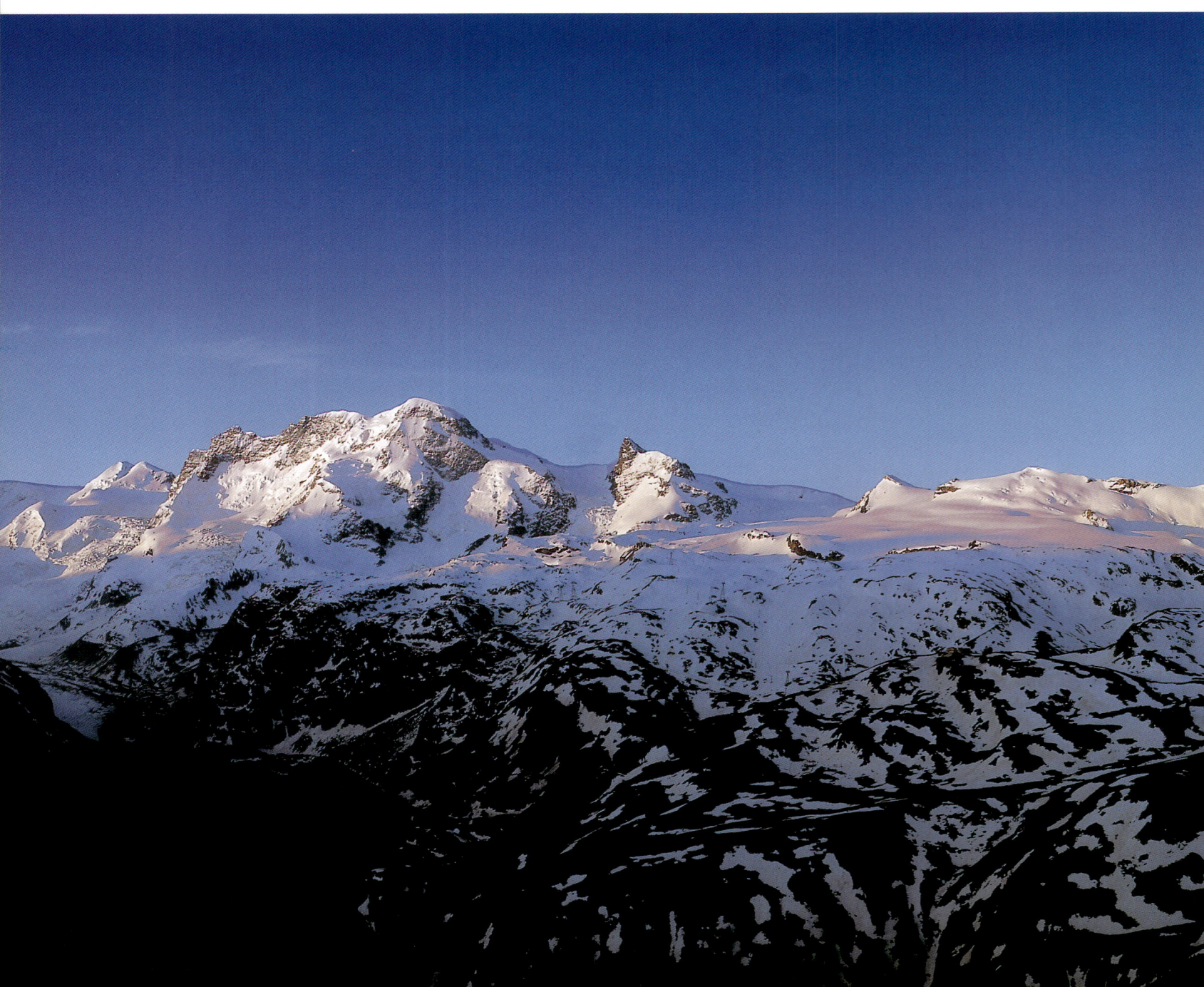

28-29 *Monte Rosa and the challenging pyramid of the Matterhorn were at the forefront of 19th-century climbing exploits. In 1855 Charles Hudson and the Smith brothers conquered Dufourspitze, the highest summit of the Monte Rosa massif (15,203 feet). Ten years later (July 14, 1885) British climber Edward Whymper reached the top of the Matterhorn from the Swiss side; just two days later, Antonio Carrel also conquered the Matterhorn, taking the more gruelling route up the Italian face.*

30-31 *North of the River Rhone, the Valais region extends across the Bernese Alps in an immense panorama of silent white peaks: many of these mountains - including the Finsteraarhorn, shown in this photo - rise to heights of over 13,232 feet.*

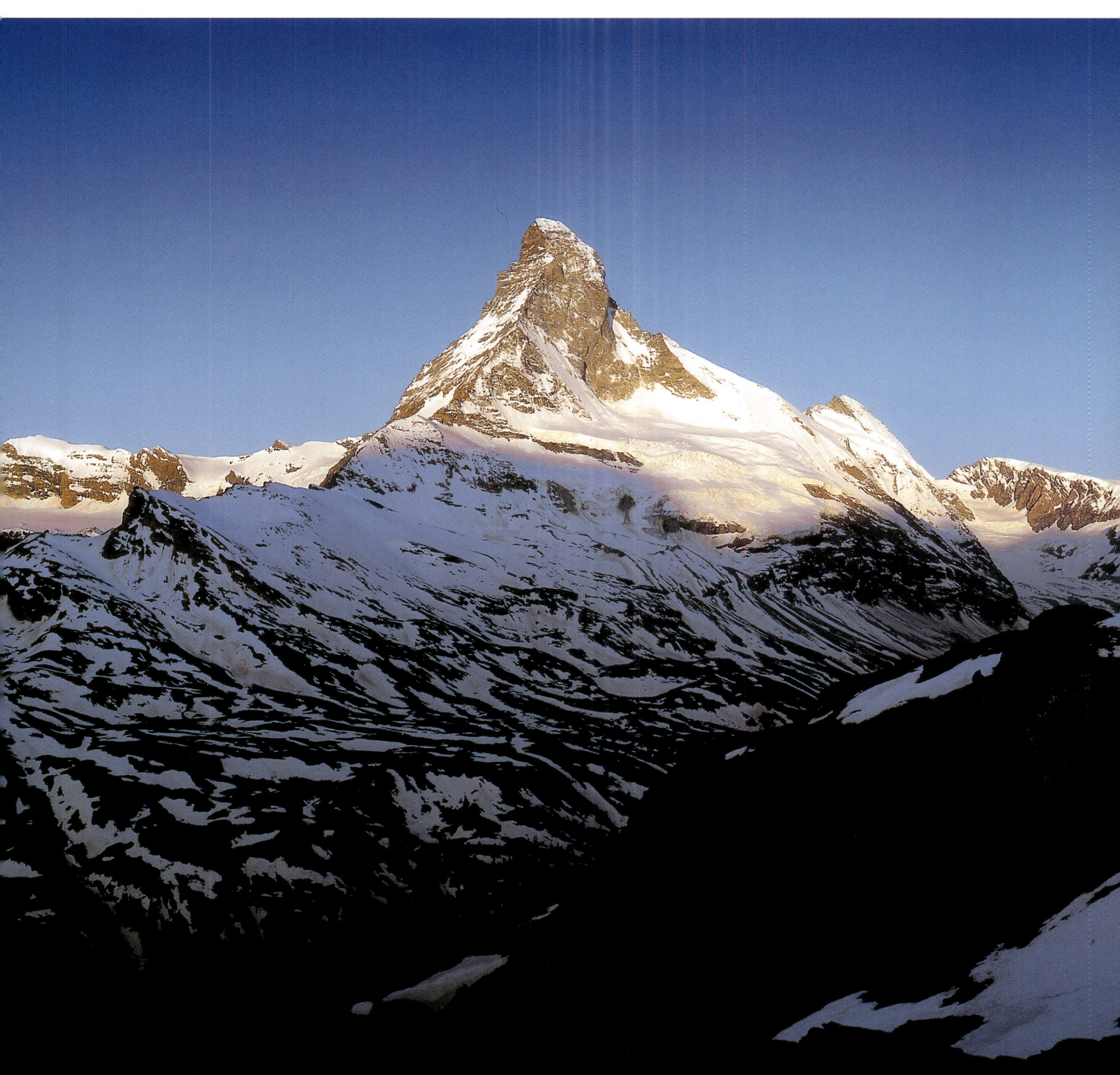

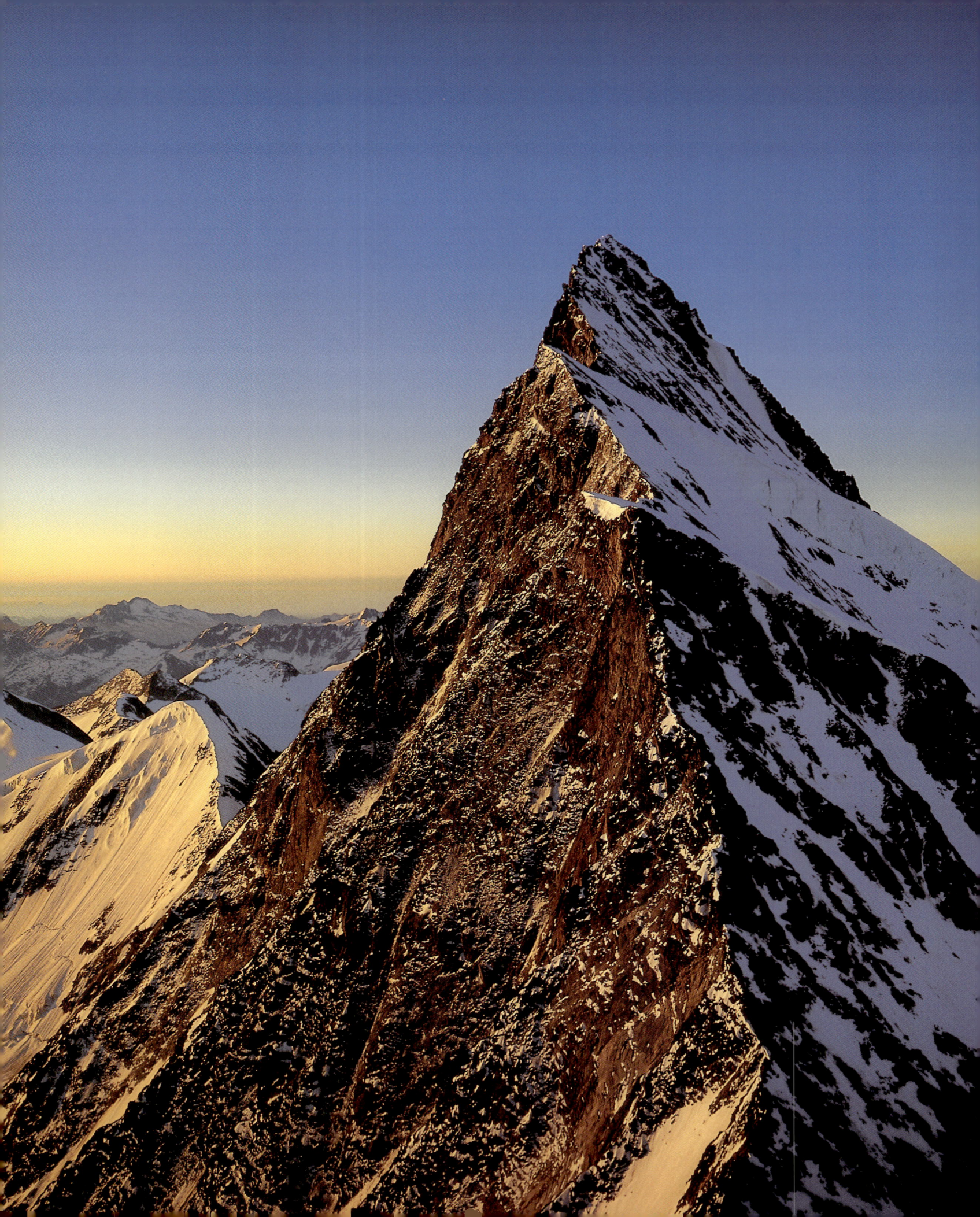

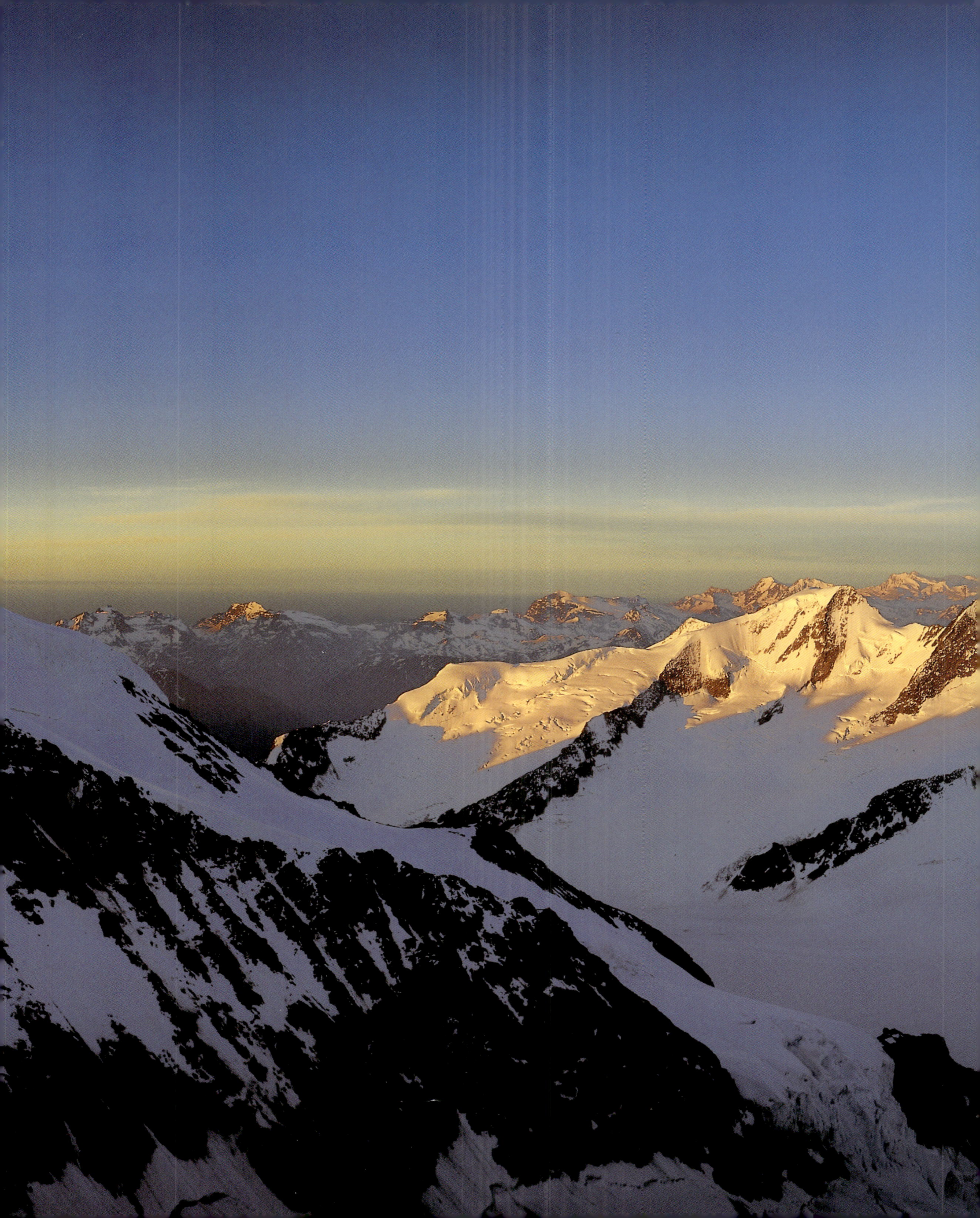

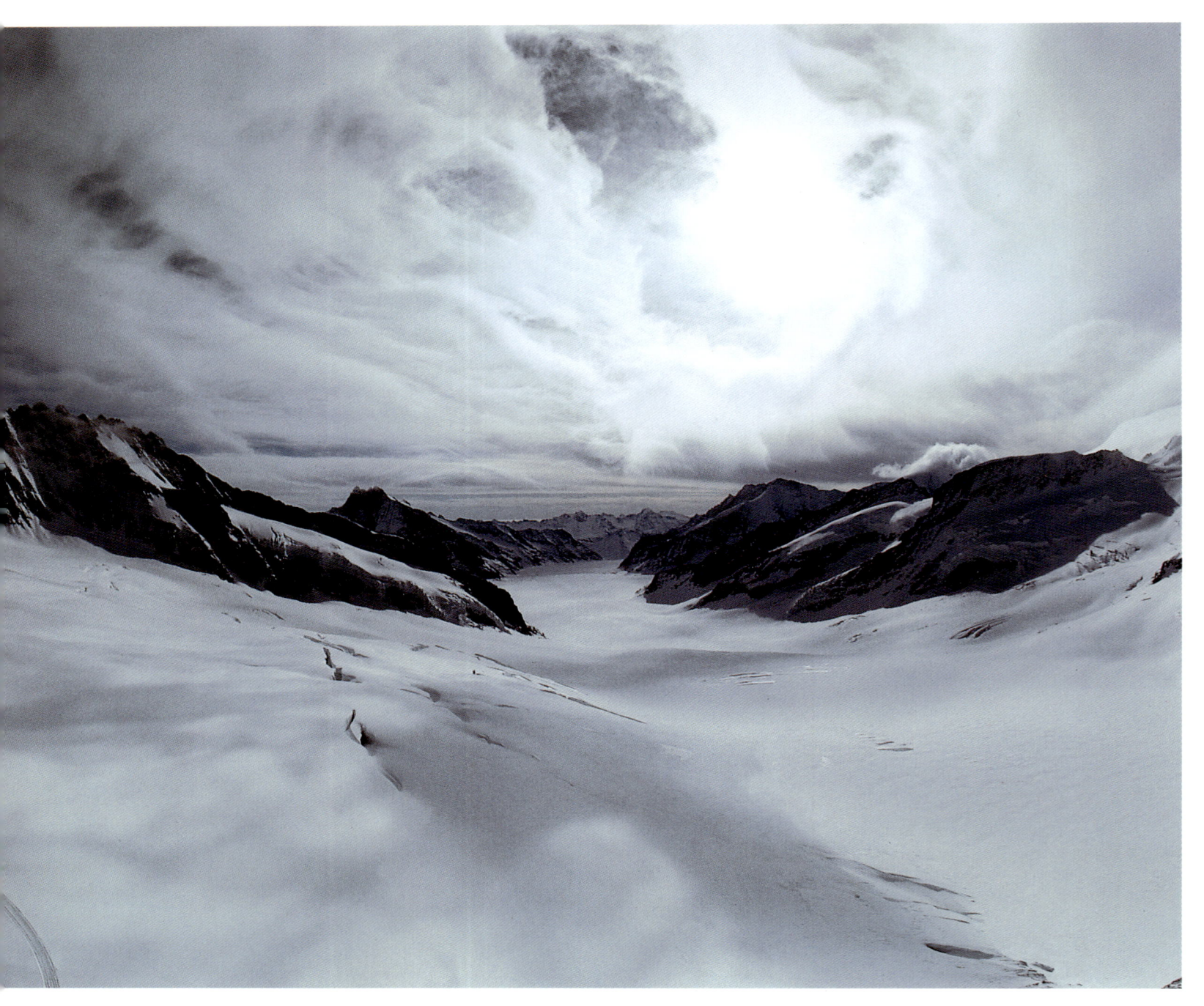

32 The Jungfrau (13,642 feet) is the jewel in the crown of the Bernese Oberland; it is also an exceptionally thrilling challenge to mountaineering enthusiasts. The Jungfrauhoch pass (11,329 feet, seen in this picture) can be reached by train on one of the world's most stunning railways: inaugurated in 1912, it is 6 miles long (including 7 kms. of tunnels).
The view from the pass is breathtaking, extending from the Aletsch glacier as far as the Vosges mountains and the Black Forest.

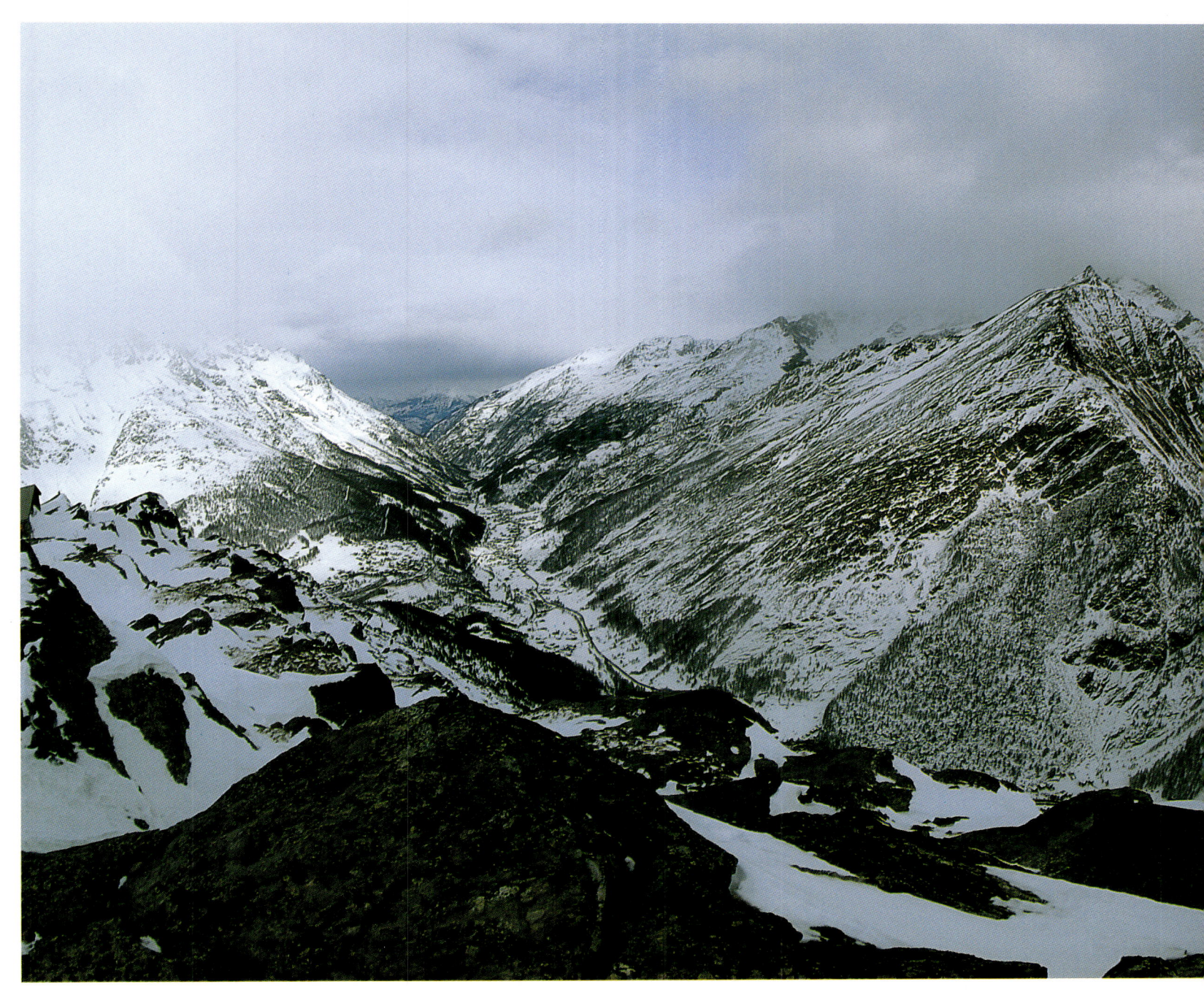

33 Fronting the Fee glacier, the valley of the Saas river is set against a spectacular backdrop of high mountains. The history of the valley has been marked by the strong Catholic faith of its inhabitants, inculcated by the curate Johann Josef Imseng who came to the tiny village of Saas Fee in 1836, when it was no more than a few houses in the midst of pastureland. More recently Saas-Almagell, the mountain village at the bottom of the valley, became famous as the birthplace of the ski champion, Pirmin Zurbriggen.

Magical snowscapes in Maggia Valley

34 The village of Bosco Gurrin is the highest in the Ticino canton (4,941 feet); situated in the Bosco Valley, just a few miles from the Italian border, it is the only place in the canton where German is spoken. Its population - descendants of a Walser colony, settled here after emigrating from the Valais region in the 13th century - has preserved the dialect, traditions and building techniques of their forefathers.

35 For centuries the population of the Maggia Valley lived in constant fear of heavy floods. Even today the thunderous noise of spectacular waterfalls crashing down the mountainside from great heights echoes through the valley. But water no longer represents a threat: the flow of the Maggia river, fed by the great glaciers of the Ticino Alps, is now regulated by the hydroelectric power plants along its course.

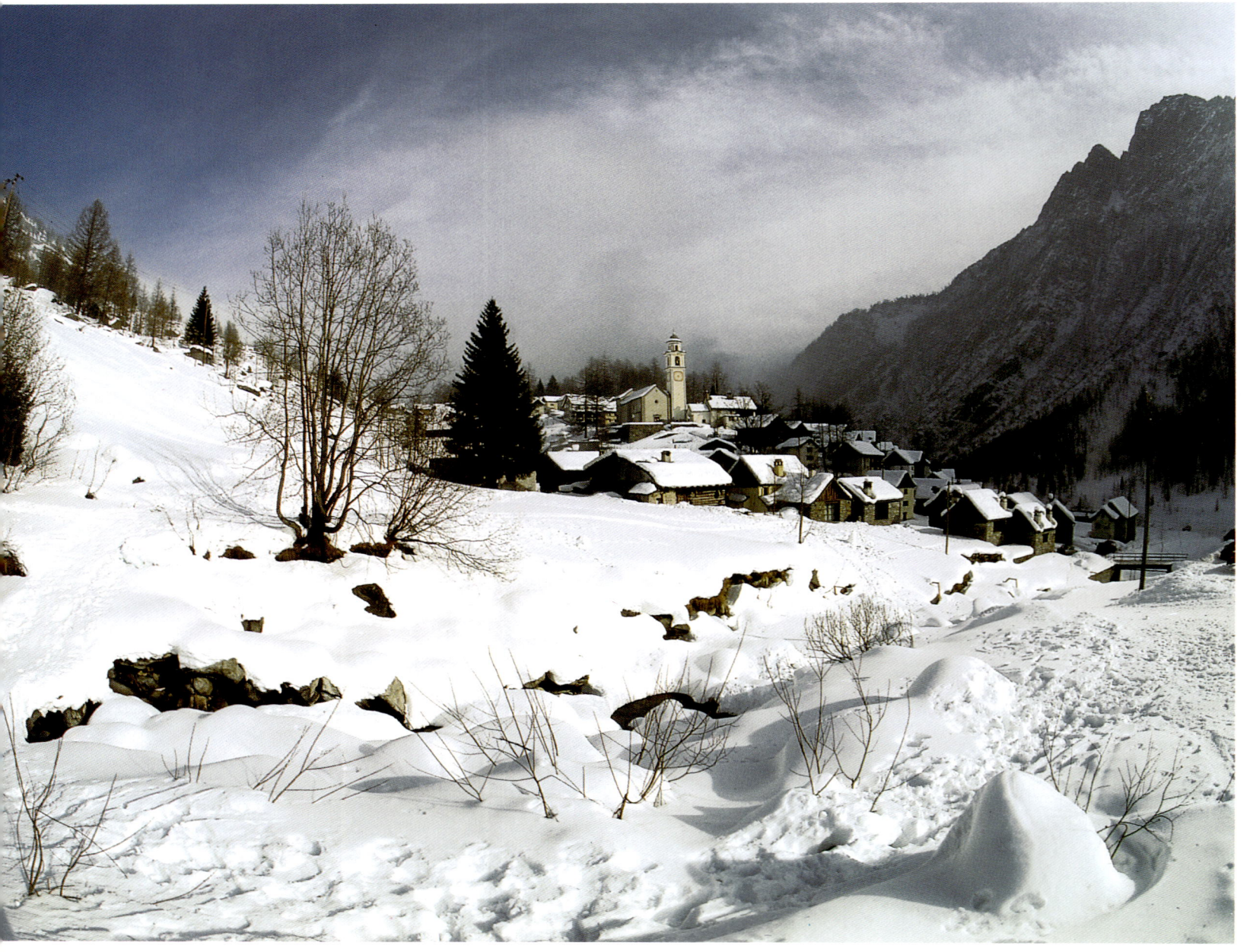

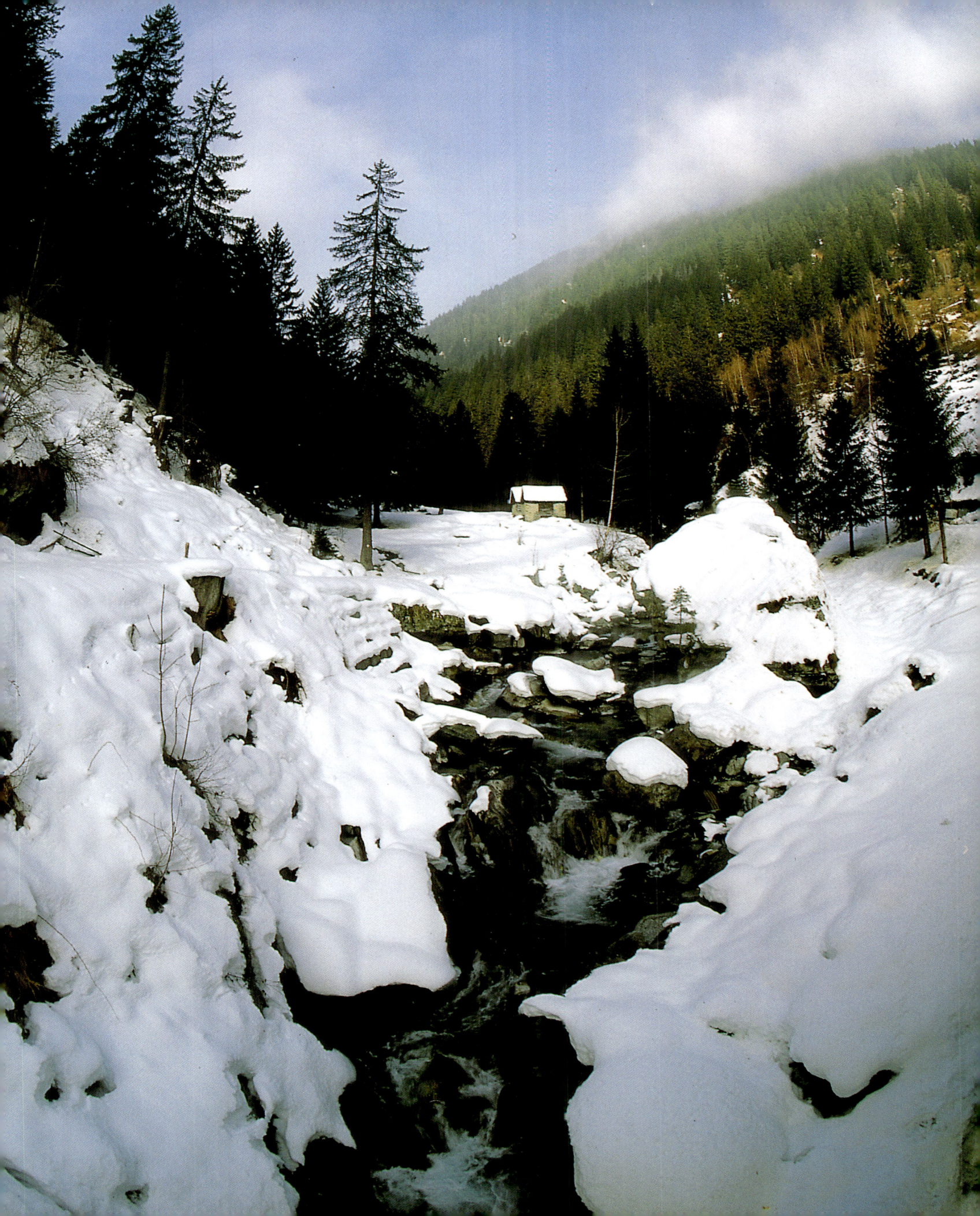

The giants of central Switzerland

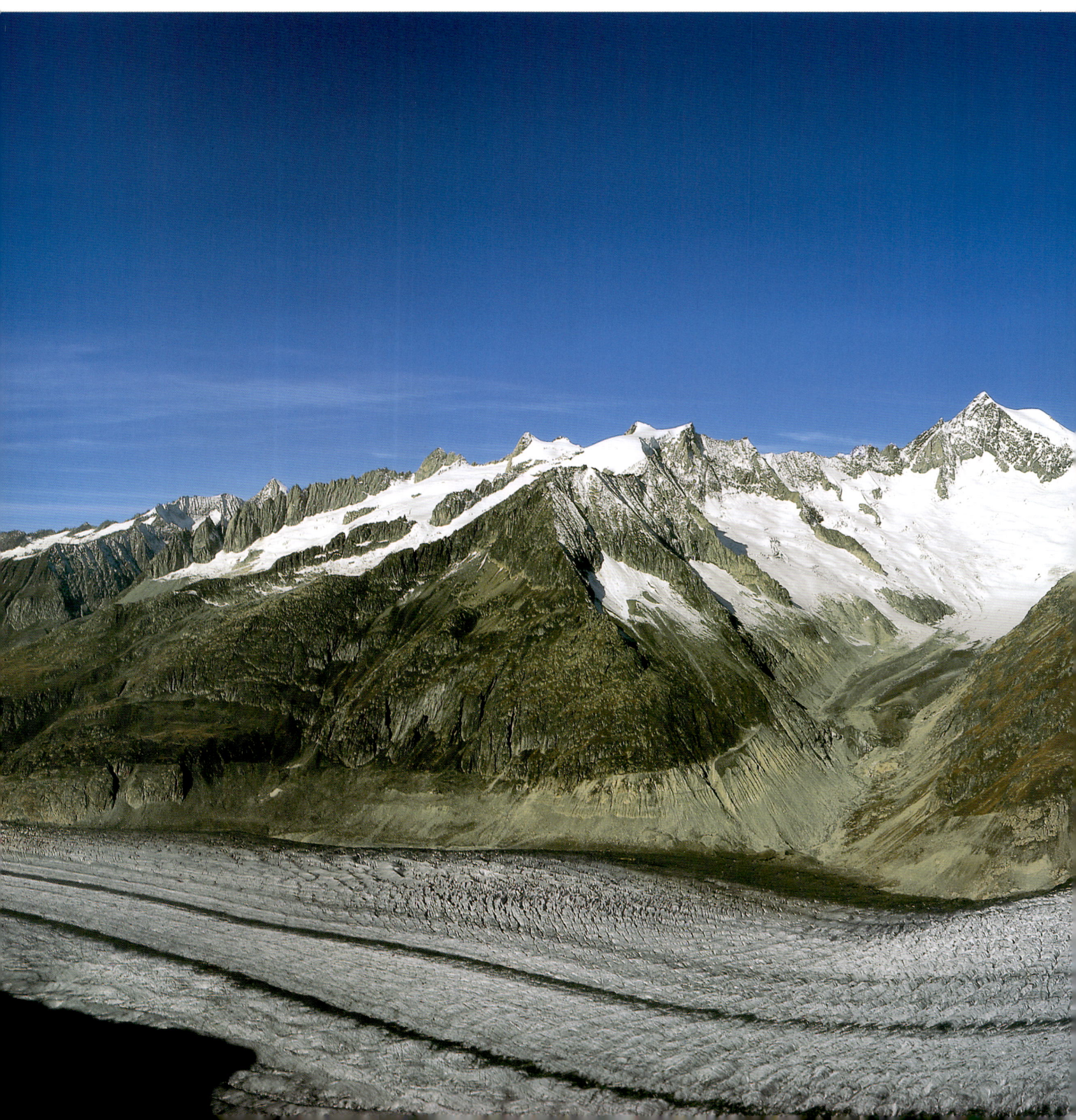

36-37 *The Aletsch Glacier (seen here from the peak of the Eggishorn) is the largest in the Alps: it starts beneath the massif of the Jungfrau and curves its way for 17 miles amid amazing pinnacles of ice and deep crevasses, before reaching its terminal moraine.*

38-39 *Huge spurs of ice edge down the mountain slopes from the great massif of Blumlisalp (12,031 feet). The snows of the Bernese Alps are attracting increasing numbers of skiers who spurn the crowded downhill trails in favour of ski mountaineering, cross-country skiing and ski jumping.*

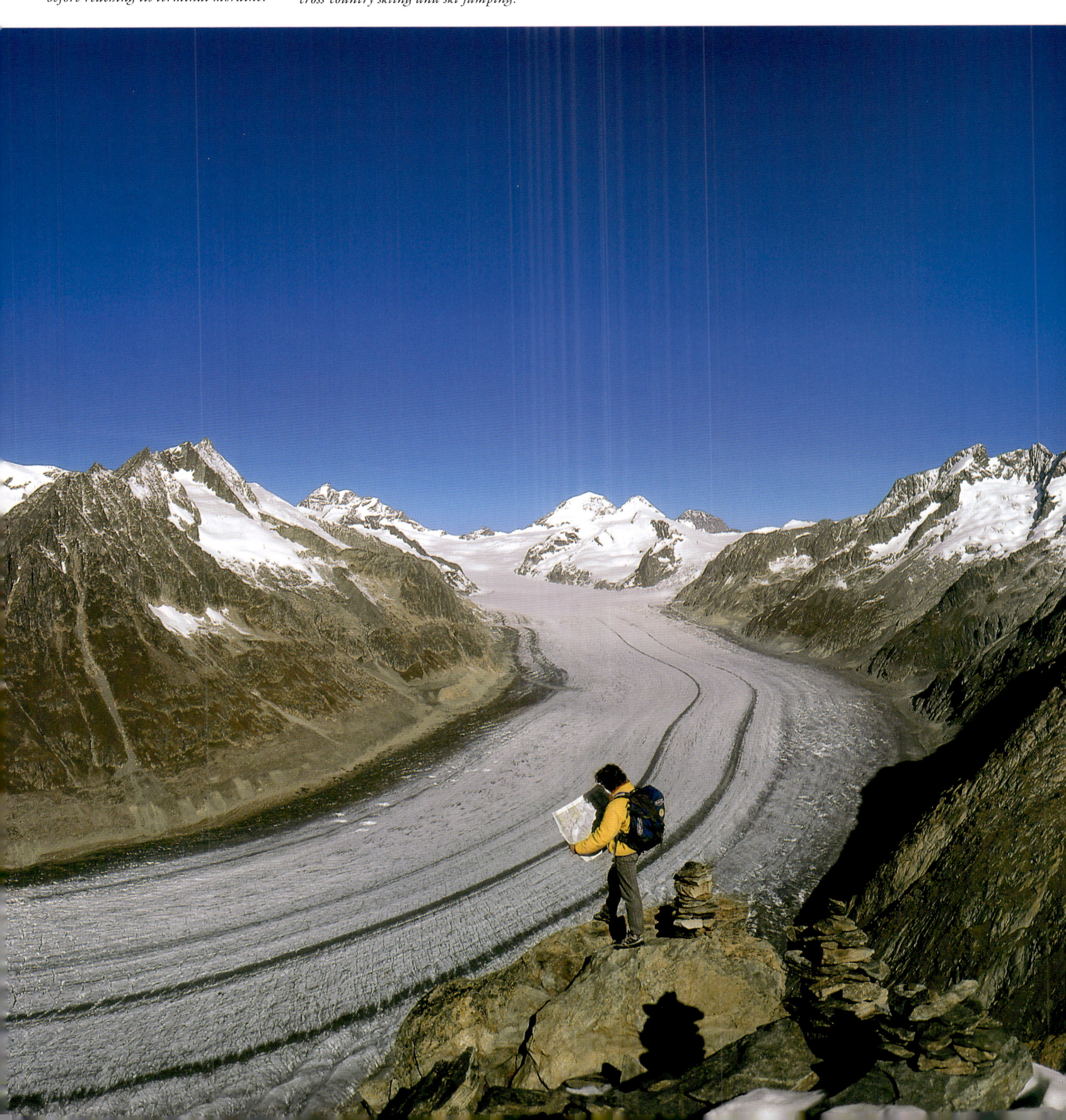

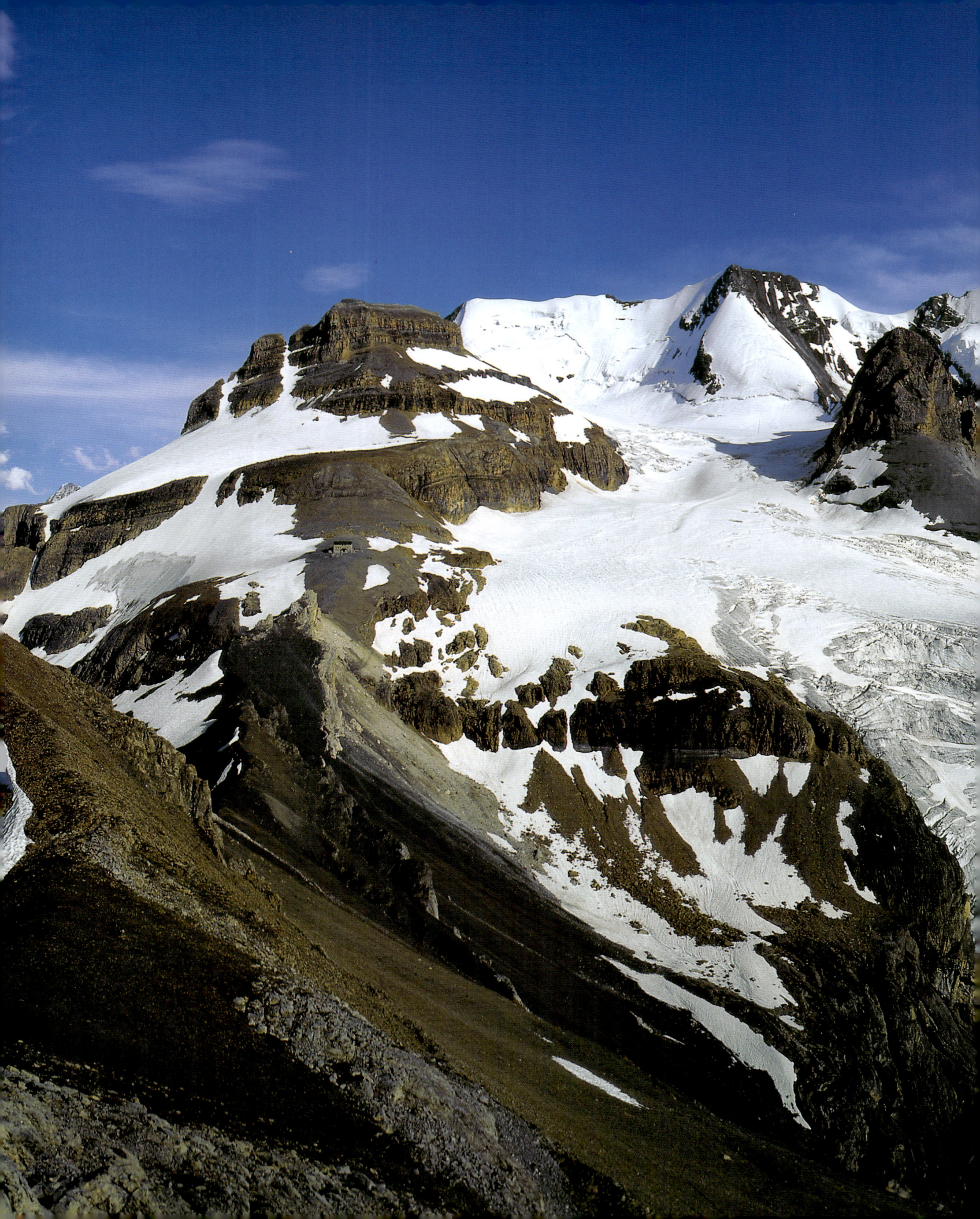

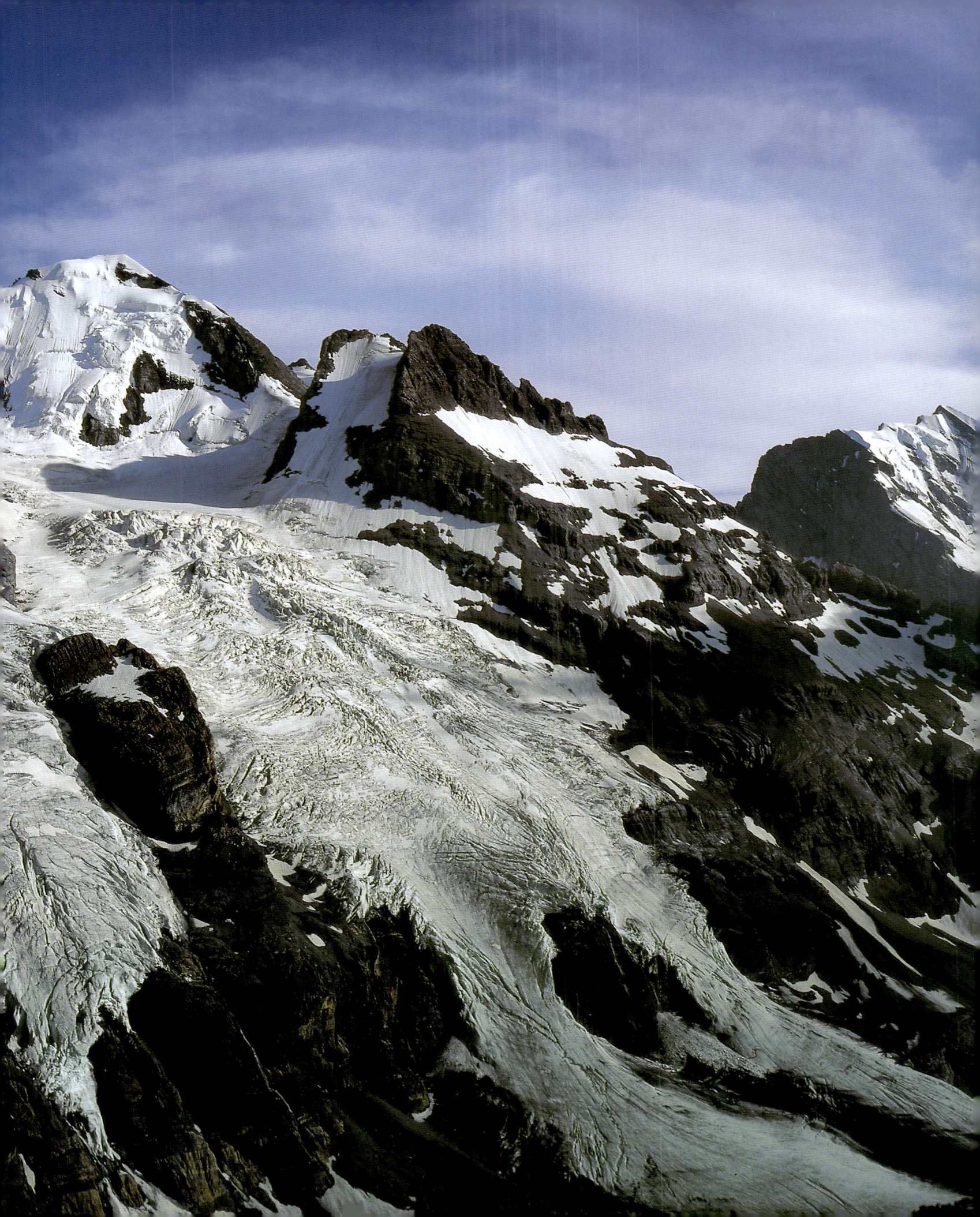

40-41 *The peaks of the Monch and the Eiger - seen here from the south face - are, together with the Jungfrau, the most stunning scenic splendours of the Swiss Alps. Legend has it that the monk (Monch) was entrusted with the task of* *protecting the young girl (Jungfrau) from the menacing ogre (Eiger): mountain folk of olden days clearly regarded the rock giants towering above them with a mixture of awe and fear.*

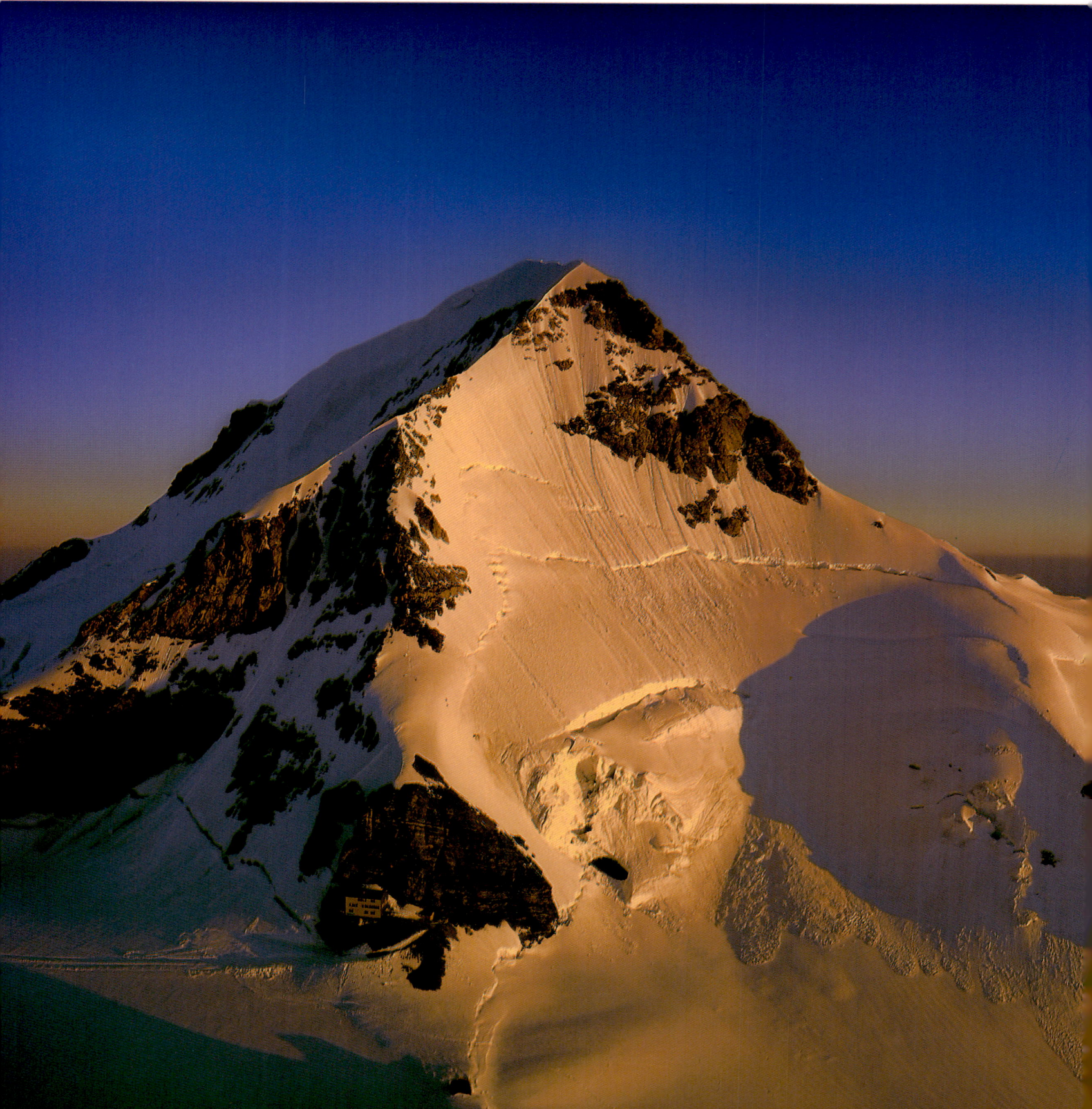

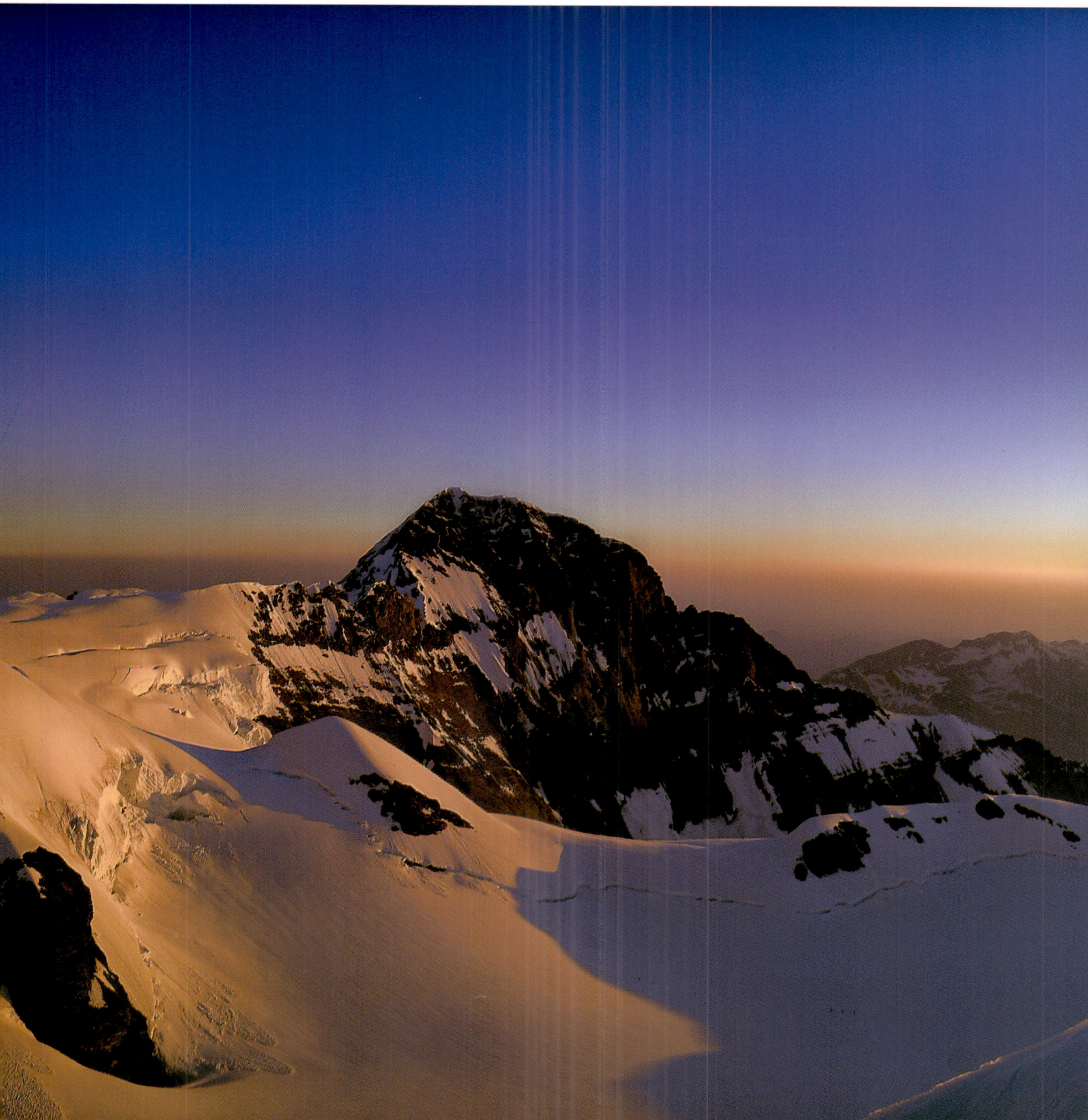

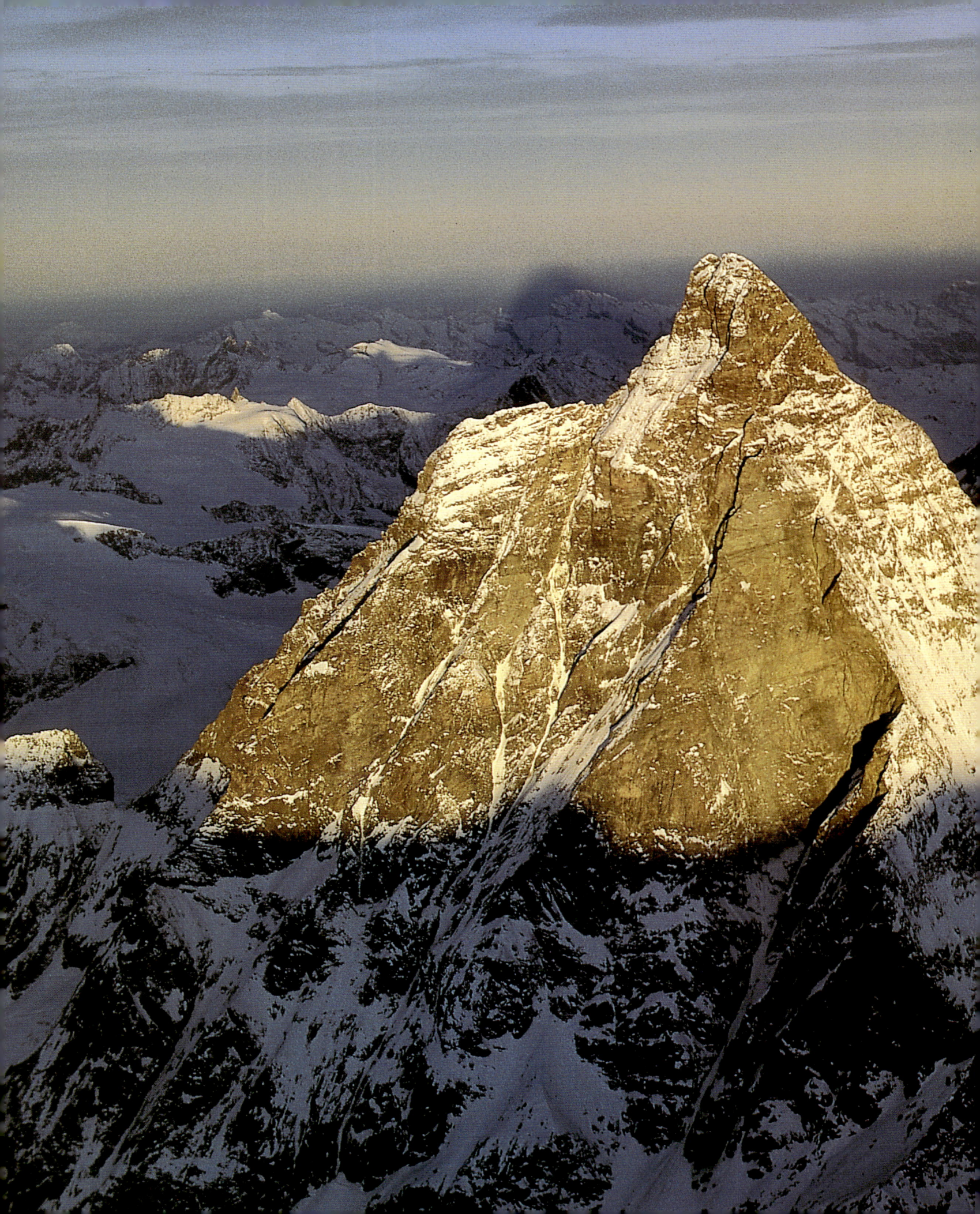

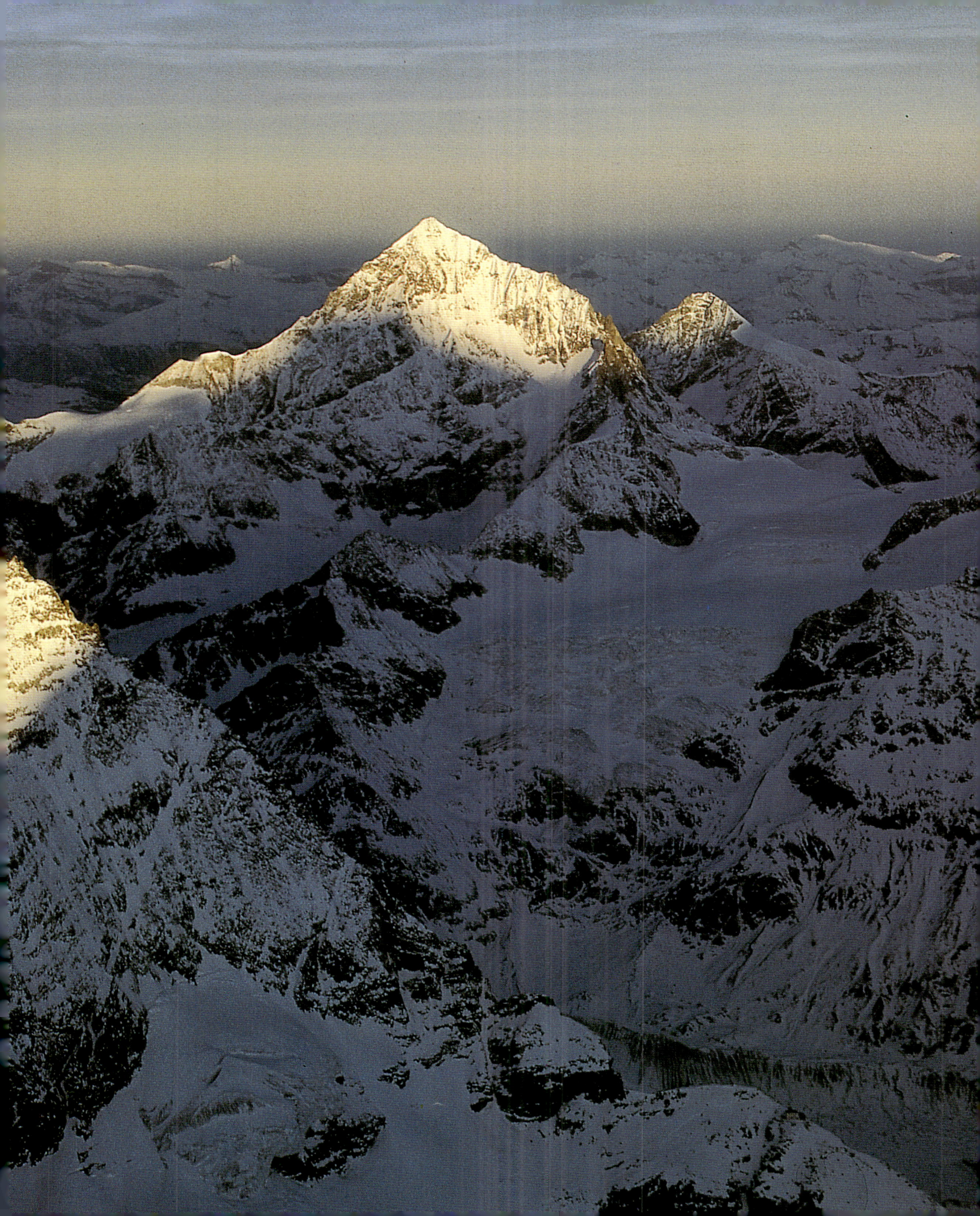

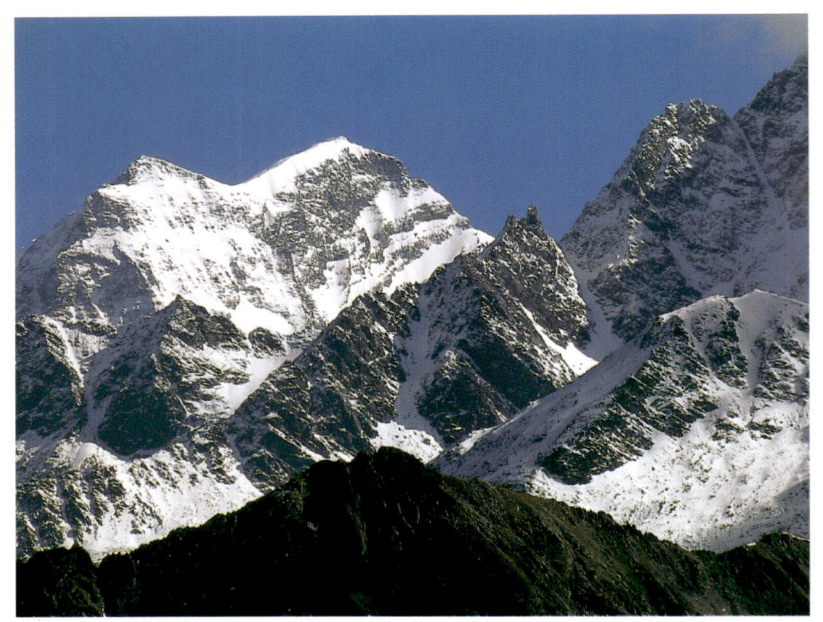

44 top and 45 bottom *Soaring to a height of 12,401 feet, the Lotschentaler-Breithorn is one of the highest peaks in the Bernese Alps. These breathtaking views of the mountain were taken from the village of Kandersteg.*

44 bottom *One of Switzerland's oldest roads - and the scene of important events in the country's history - leads up to the Grand St.Bernard pass, site of the celebrated hospice founded by Bernard of Aosta in the 11th century and still run by monks (of the Augustinian order). The adjoining museum contains documents telling of the historic figures who passed this way, from the Celts to Napoleon Bonaparte. The monastery has been a place of refuge, prayer and study since medieval times.*

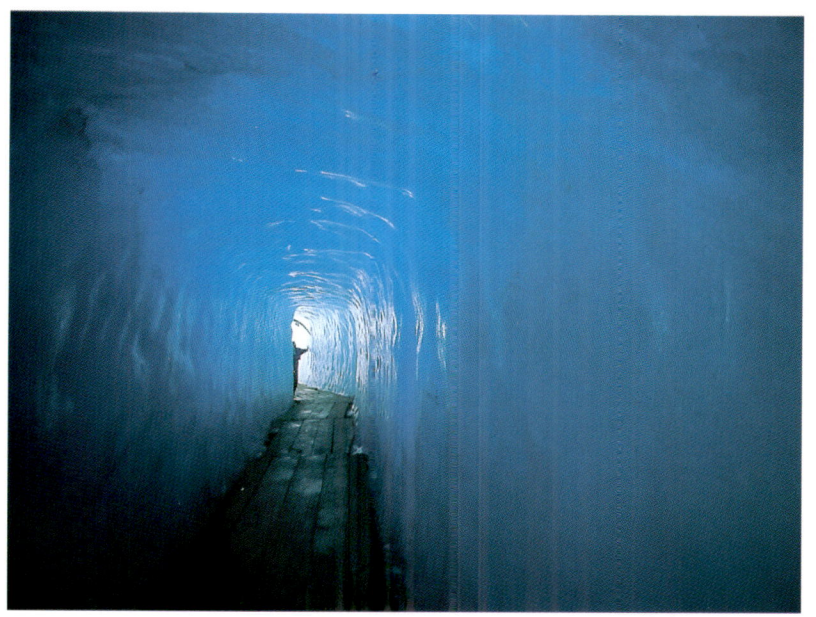

45 top *Spectacular views are not the only attraction for people who venture onto the high mountains of central Switzerland. There are more thrills to be had in tunnels carved out of walls of ice: guided by the almost unreal pale blue light filtering into a passage, it is possible to penetrate into the heart of these towering giants, beneath millions of tons of solid ice.*

46-47 *The Goschenertal valley, with its wild scenery, is on the Italian/Swiss border, at the point where the St. Gotthard rail tunnel starts. The valley comes to an abrupt end at the dam across the Goscheneralpsee, a huge artificial lake at the foot of the Dammastock.*

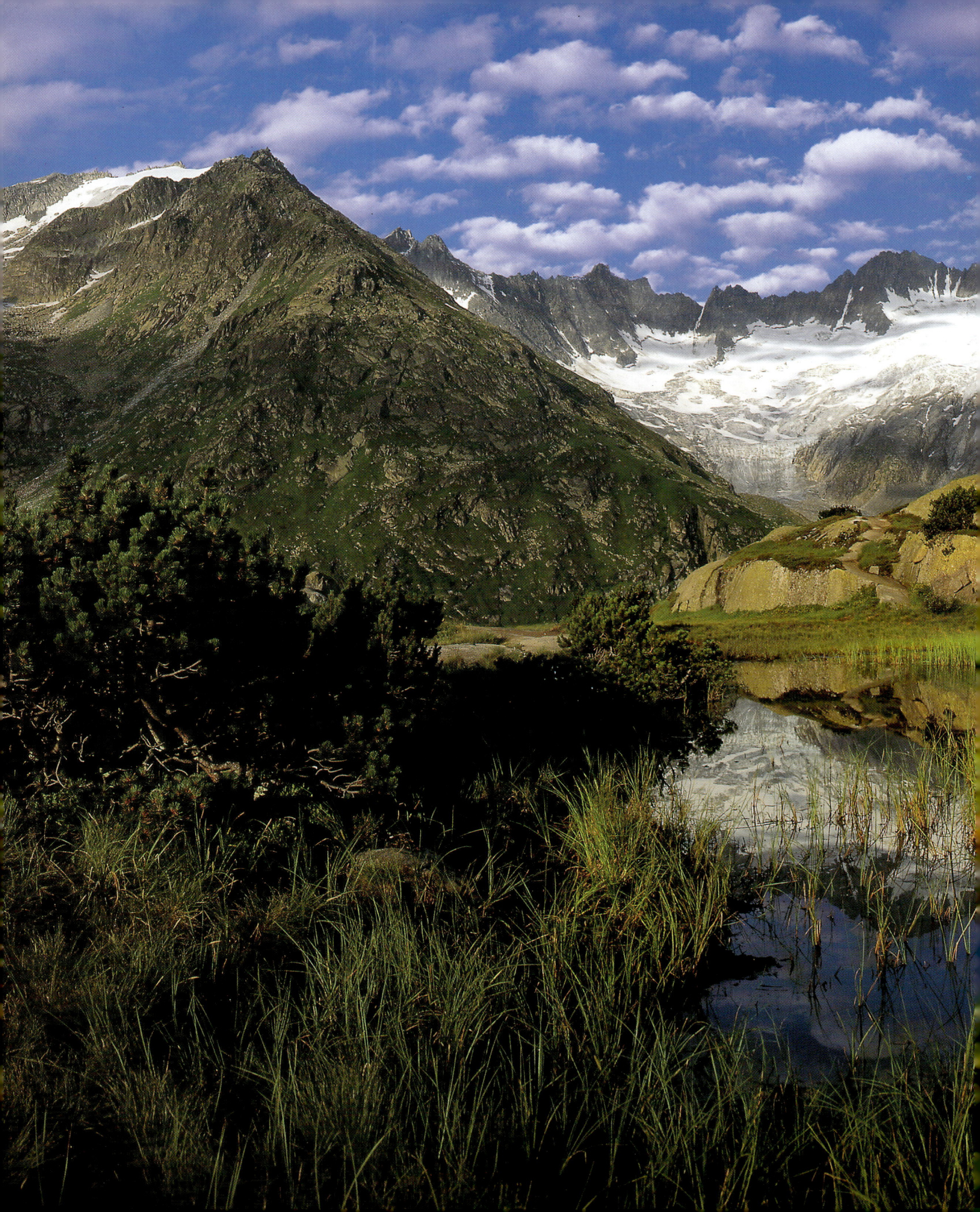

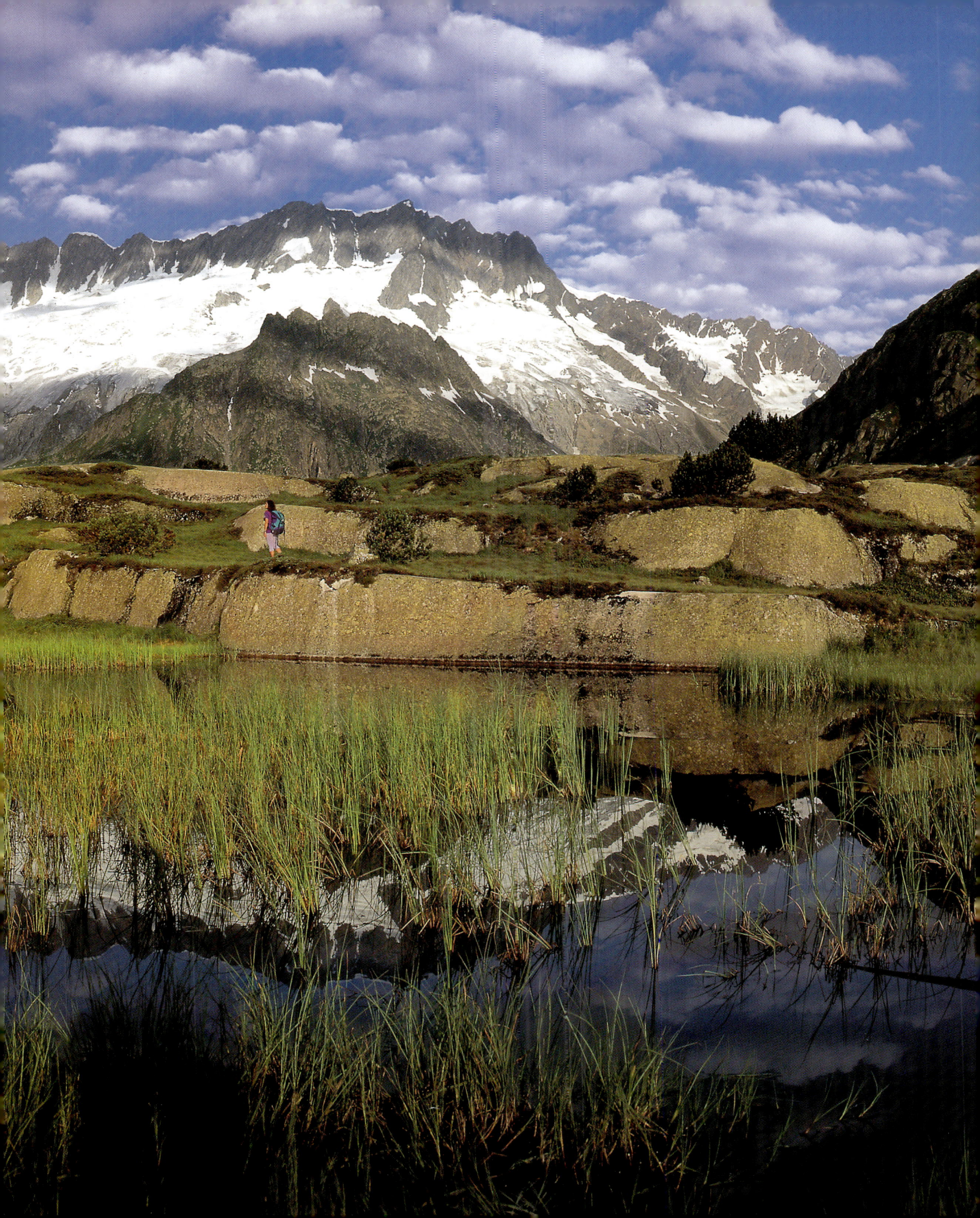

The austere charm of Switzerland's valleys

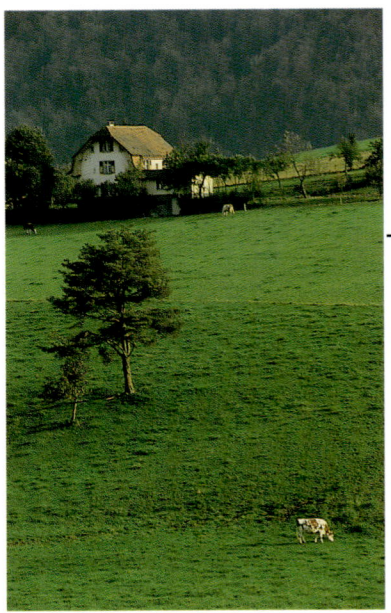

48 *The Simmental valley offers picture-postcard views with the most appealing features of the Alpine landscape: lush green meadows, a lonely chalet with its typical overhanging roof, a forest and cottonwool clouds floating past a towering ridge of the Bernese Alps.*

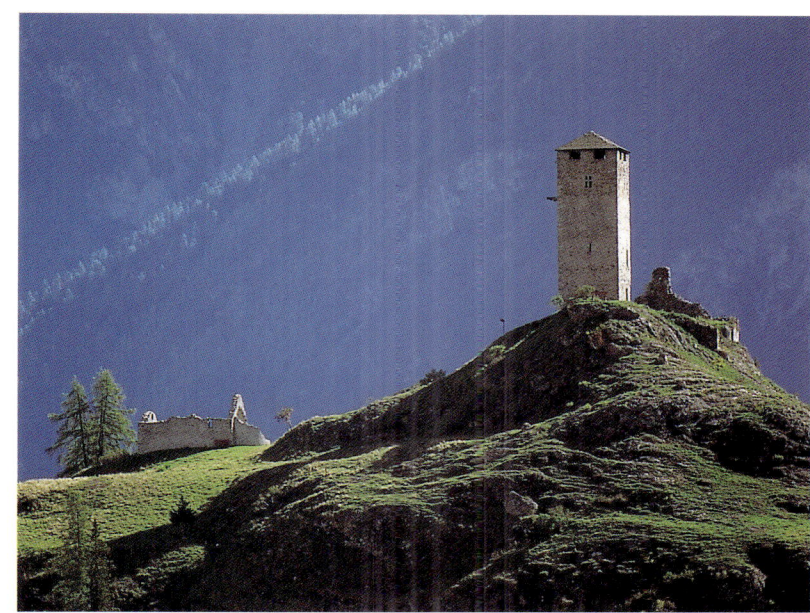

49 *Nietzsche was right when he said Engadine combined qualities of both Italy and Finland: Italy is present in the valley's culture, its musical language and the harmony of its buildings while the fragrance of resin that fills the air of woods and lakes - an irresistible lure for lovers of solitude - is reminiscent of Finland.*

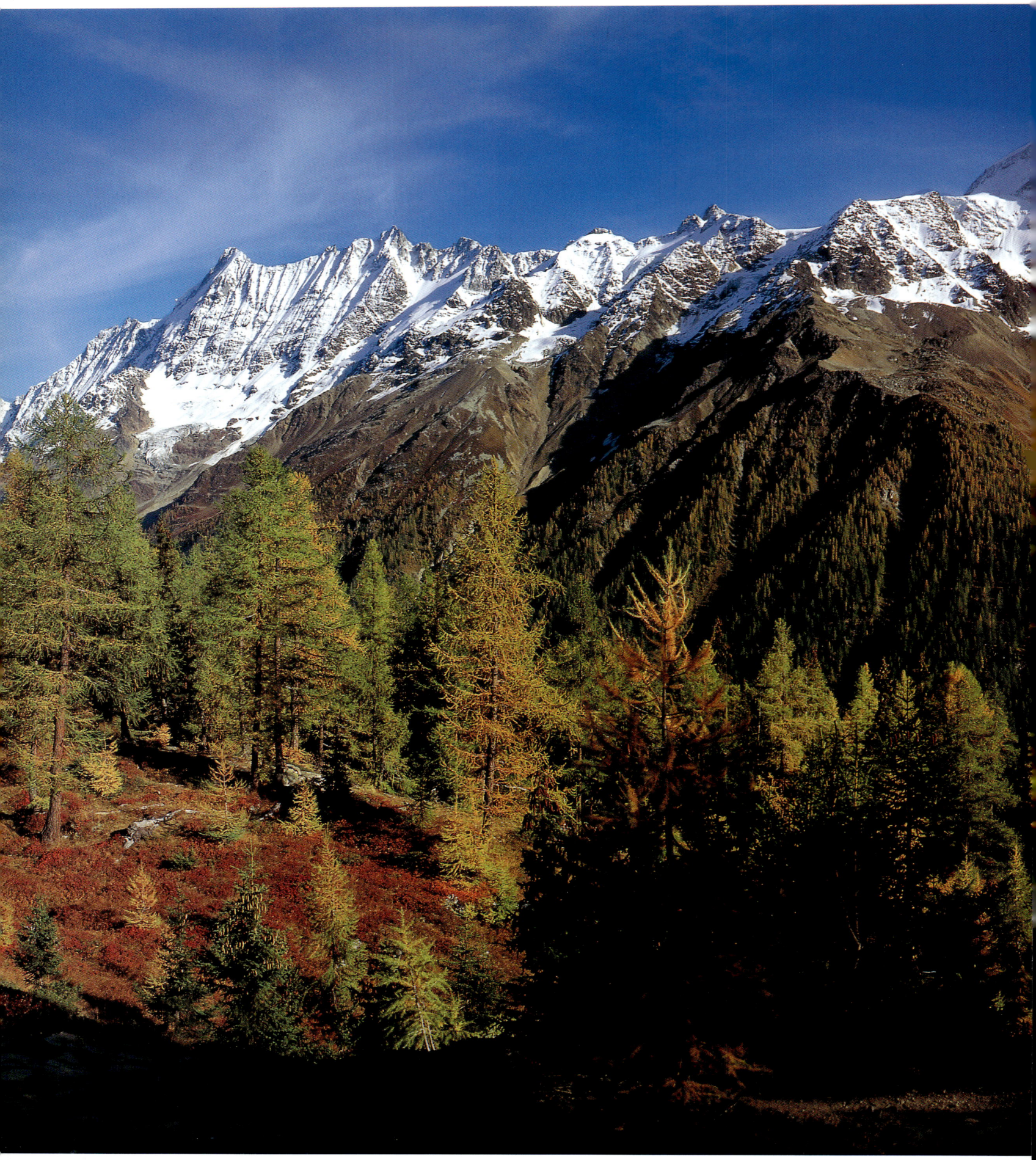

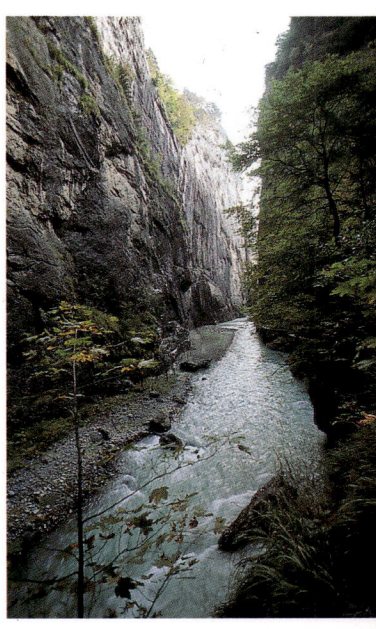

50-51 *Autumn colours transform the Valais region: the snow-capped peaks of the Lötschentaler-Breithorn range create a band of dazzling white between wooded slopes and sky.*

51 top *Flowing here beneath the protective wall of a steep mountain gorge are the waters of the Simme river.*

51 centre *Wind and rain have carved the bizarre Euseigne pyramids out of the rocks of the Val d'Hérens.*

51 bottom *A tiny church in the St.Bernard Valley.*

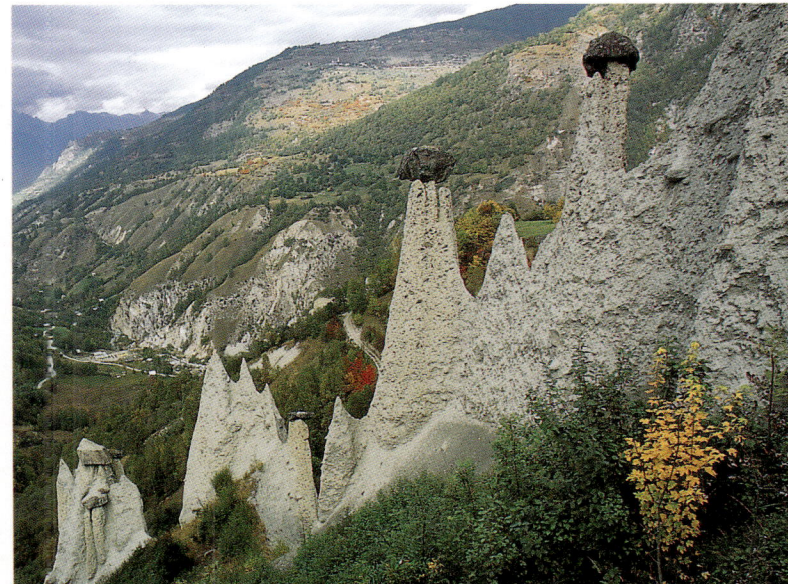

52-53 *Presiding over Bellinzona is the 14th-century Montebello Castle, with its keep and turreted walls. With its three fortresses (the Great Castle and Sasso Corbaro Castle in addition to Montebello Castle) Bellinzona is also known as the city of castles; it is capital of the Ticino canton and a flourishing centre of industry and culture.*

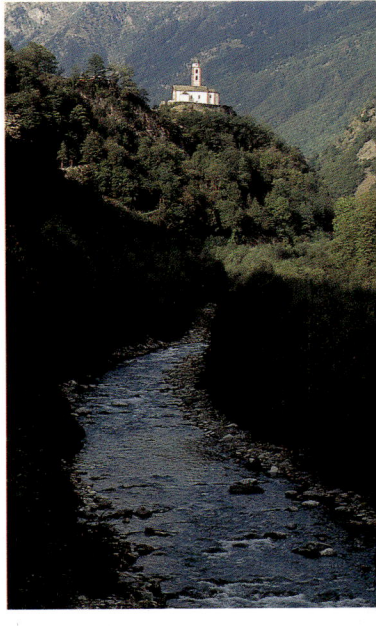

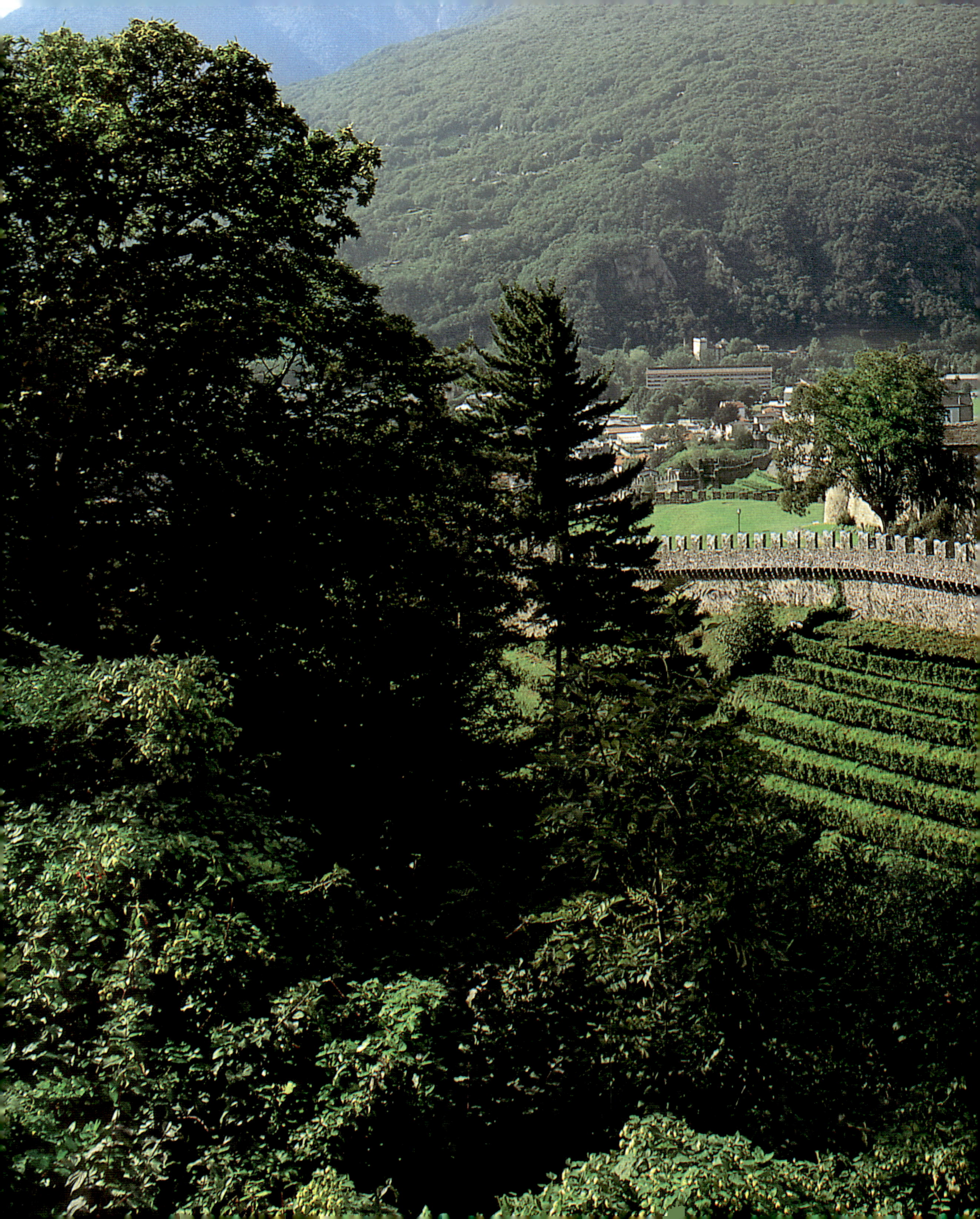

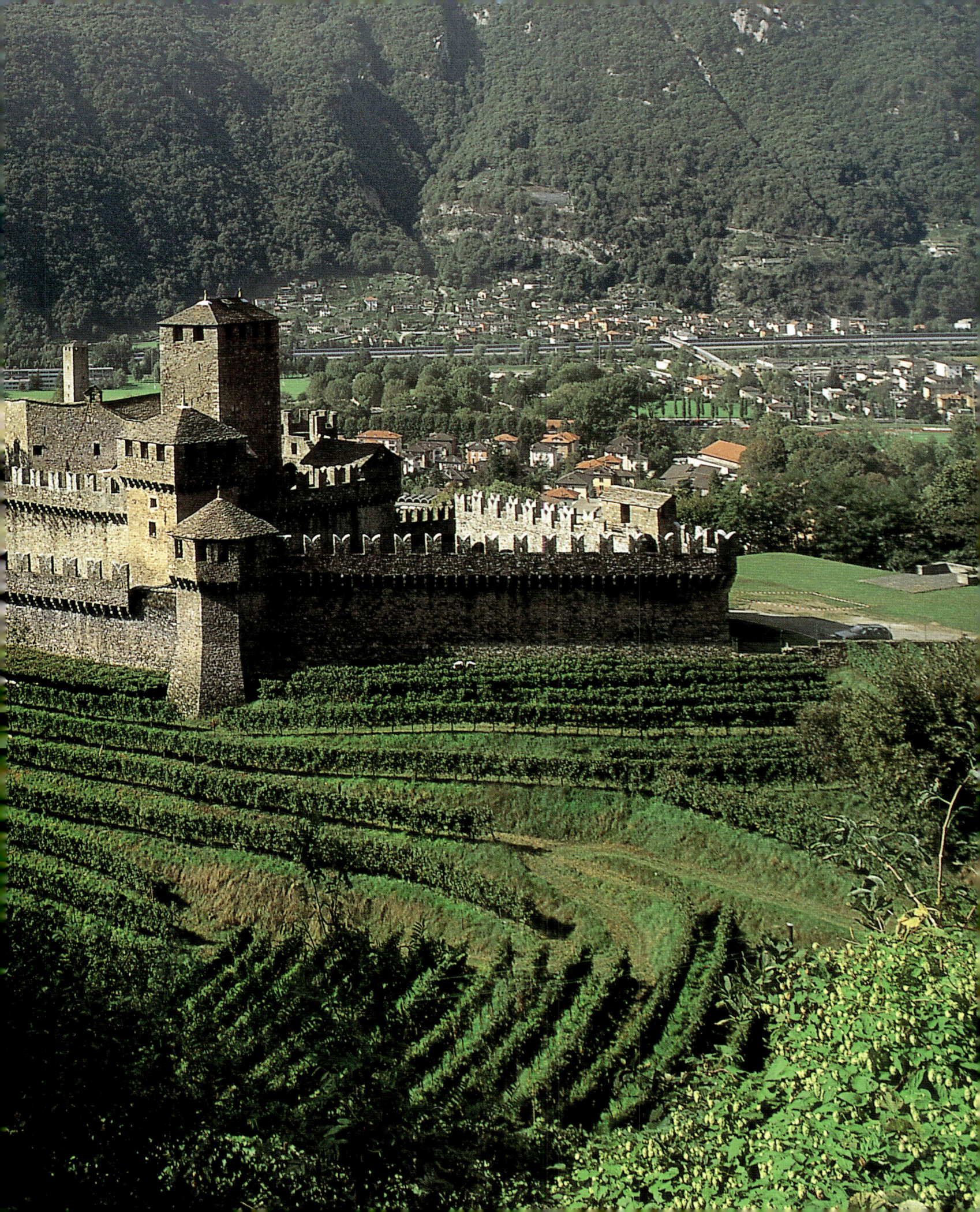

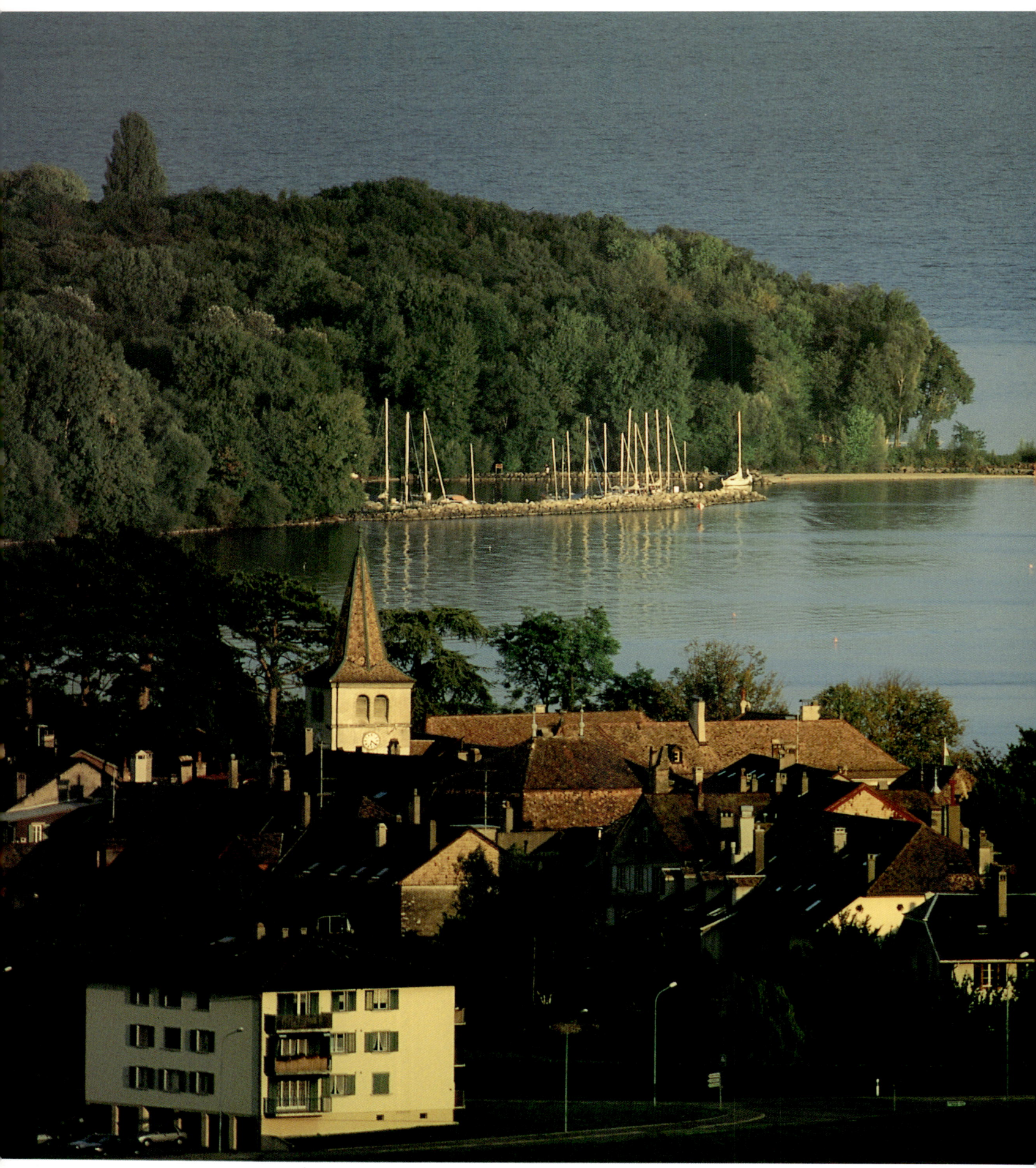

The lakes, pearls of the Alpine landscape

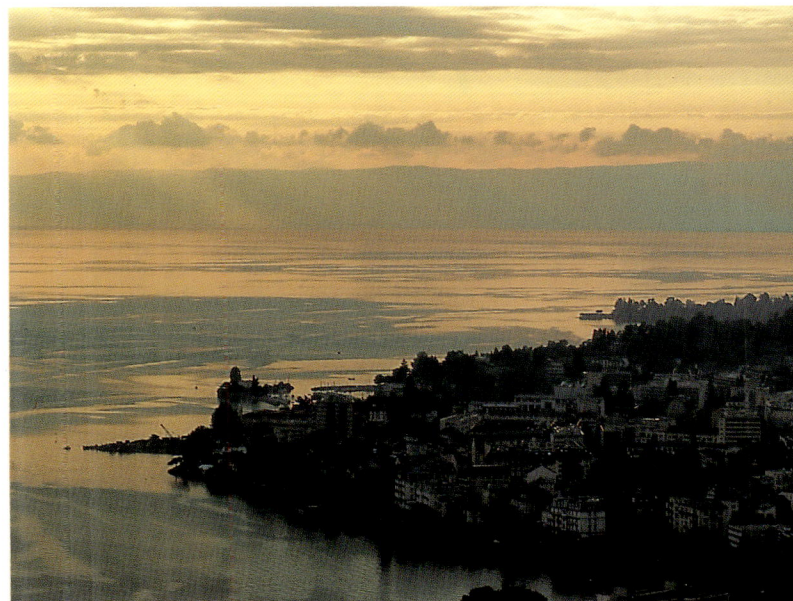

54-55 and 55 top *Lake Geneva (also known as Lake Léman), shaped like a half-moon, is partly in Switzerland and partly in France. Its northern shore, and particularly the stretch between Lausanne and Montreux, is known as the Swiss Riviera, thanks to the very mild climate. The calm waters of the lake are set against a backdrop of gently undulating hills covered with vineyards, and picturesque villages line its shores. Already in the 18th and 19th centuries the lake was a destination favoured by prominent men of letters, among them Voltaire, Rousseau, Byron, Shelley and Victor Hugo.*

55 bottom *At sunset, lights animate the waters of Lake Zurich, which washes the shores of three cantons: Zurich, St.Gallen and Schwyz. Its main tributary is the Linth river, which emerges from it as the Limmat.*

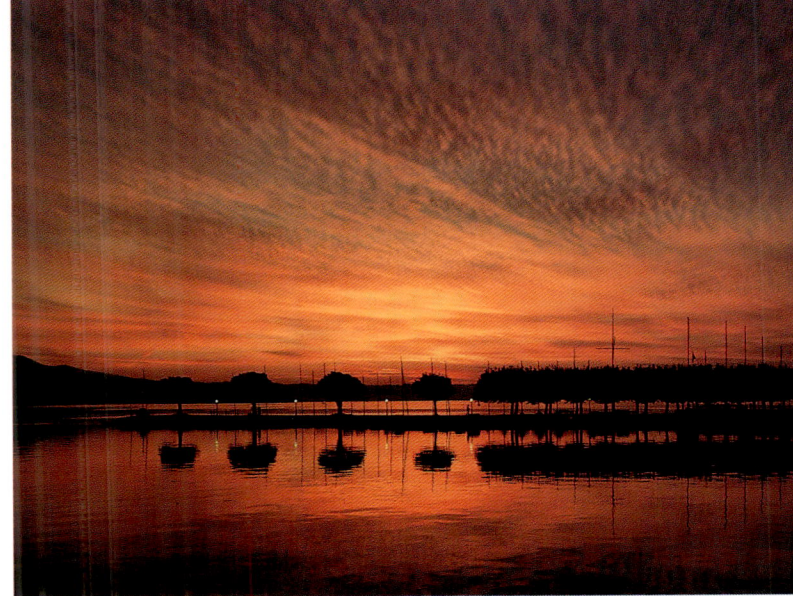

56-57 *Lake Lugano (top left), Lake Constance (bottom left) and the Lake of the Four Cantons (to the right) each has its own distinctive features, as do the people who live along their shores. Projecting towards Lake Como and Lake Maggiore in nearby Italy, Lake Lugano is known for its irregular shape and magnificent scenery. Lake Constance (Bodensee), connecting Switzerland with Germany, is the starting-point of the Rhine's long journey across Europe to the sea. The Lake of the Four Cantons (Vierwaldstattersee, also known as Lake Lucerne) is the heart and soul of Switzerland and its history.*

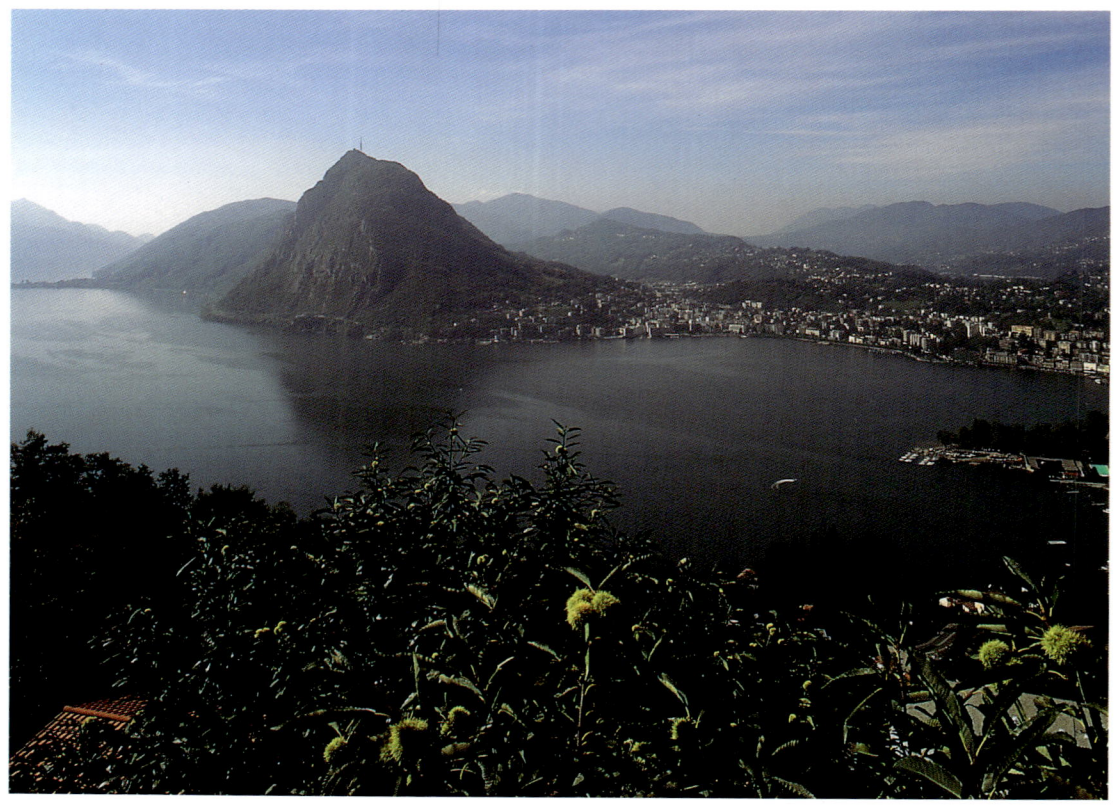

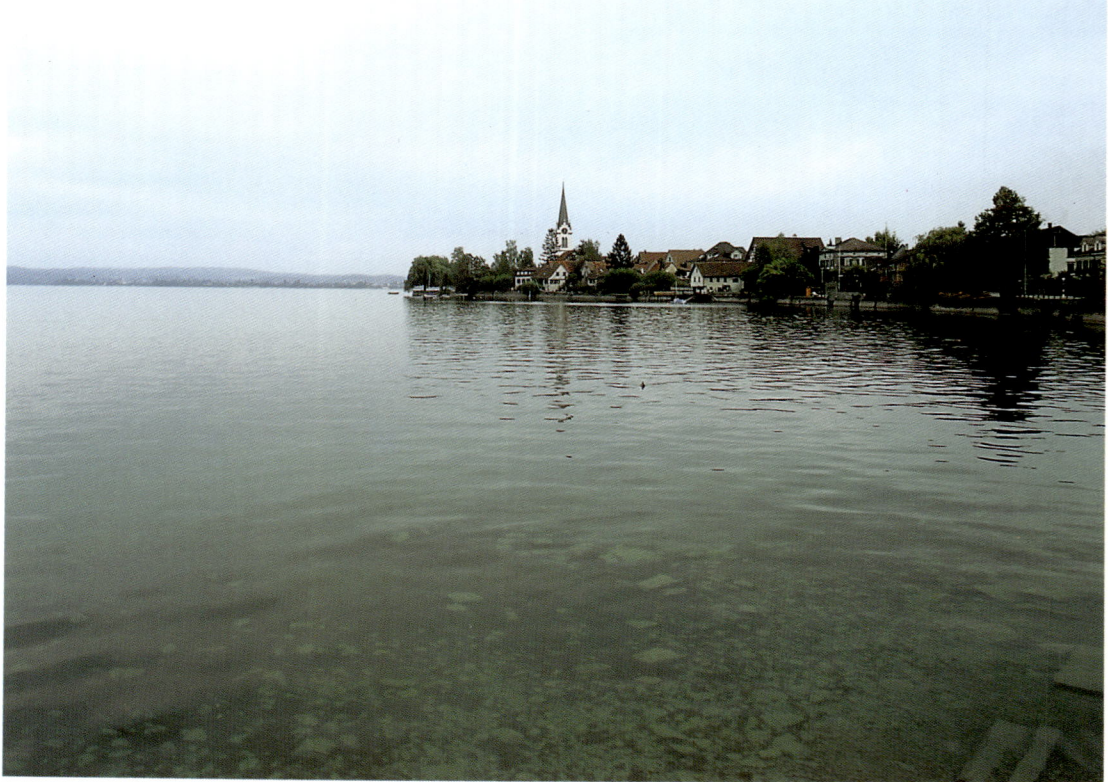

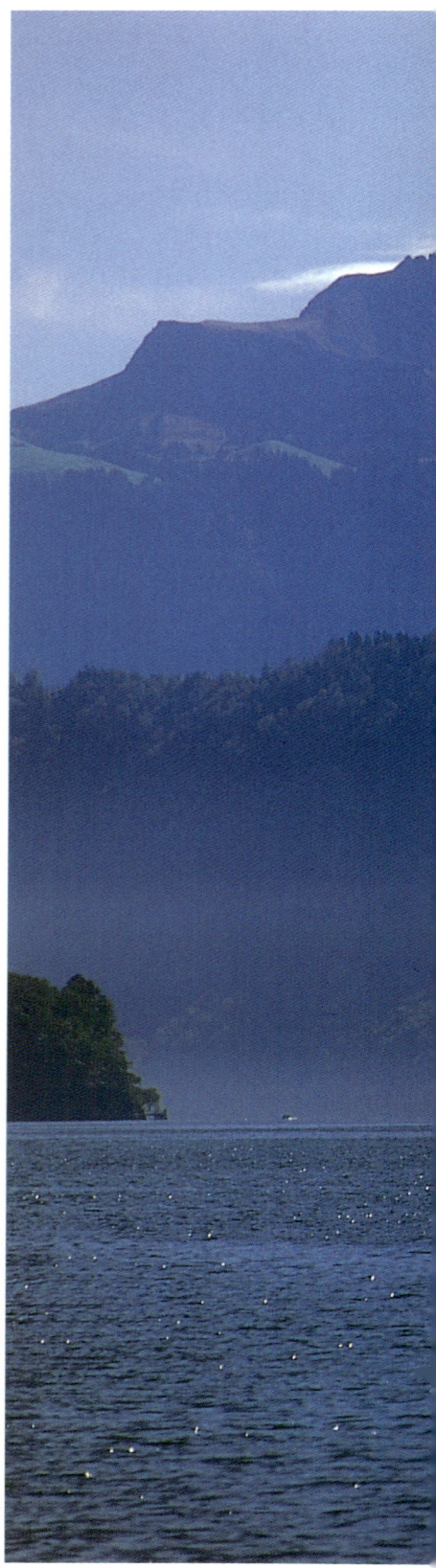

58-59 *The cantons of Uri, Unterwalden, Schwytz and Lucerne - the original core of the Helvetian Confederation - surround the Lake of the Four Cantons, unrivalled among Swiss lakes for its beauty and grandeur. The cross formed by the arms of the lake can be clearly seen from the top of Mount Pilatus, with extensions and passages spreading out through unspoilt rural and mountain scenery. Picturesque little towns and villages at the foot of mountains seem to be beckoning to passing tourists, and the boats and sailing yachts skimming across the lake are a further temptation to linger.*

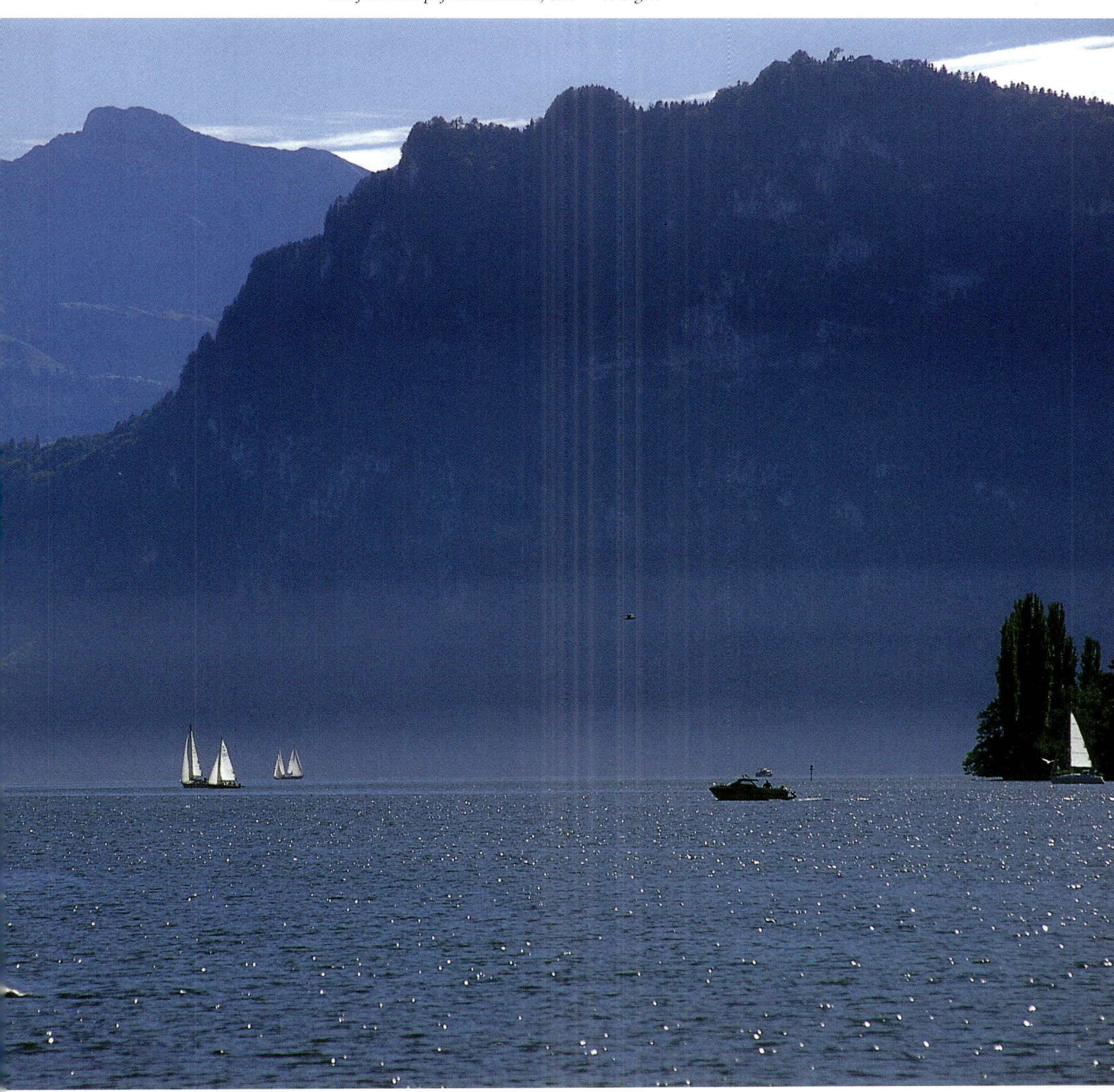

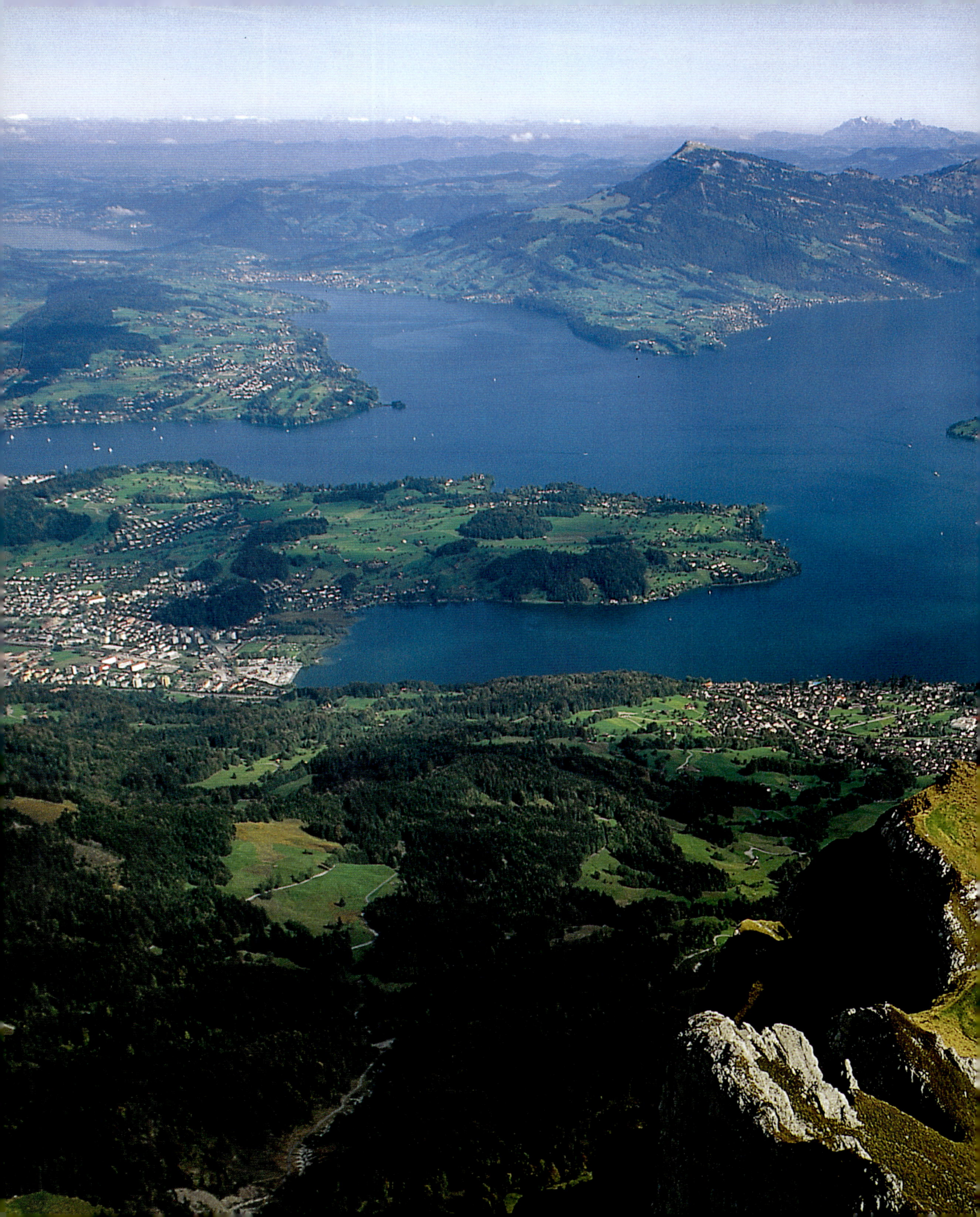

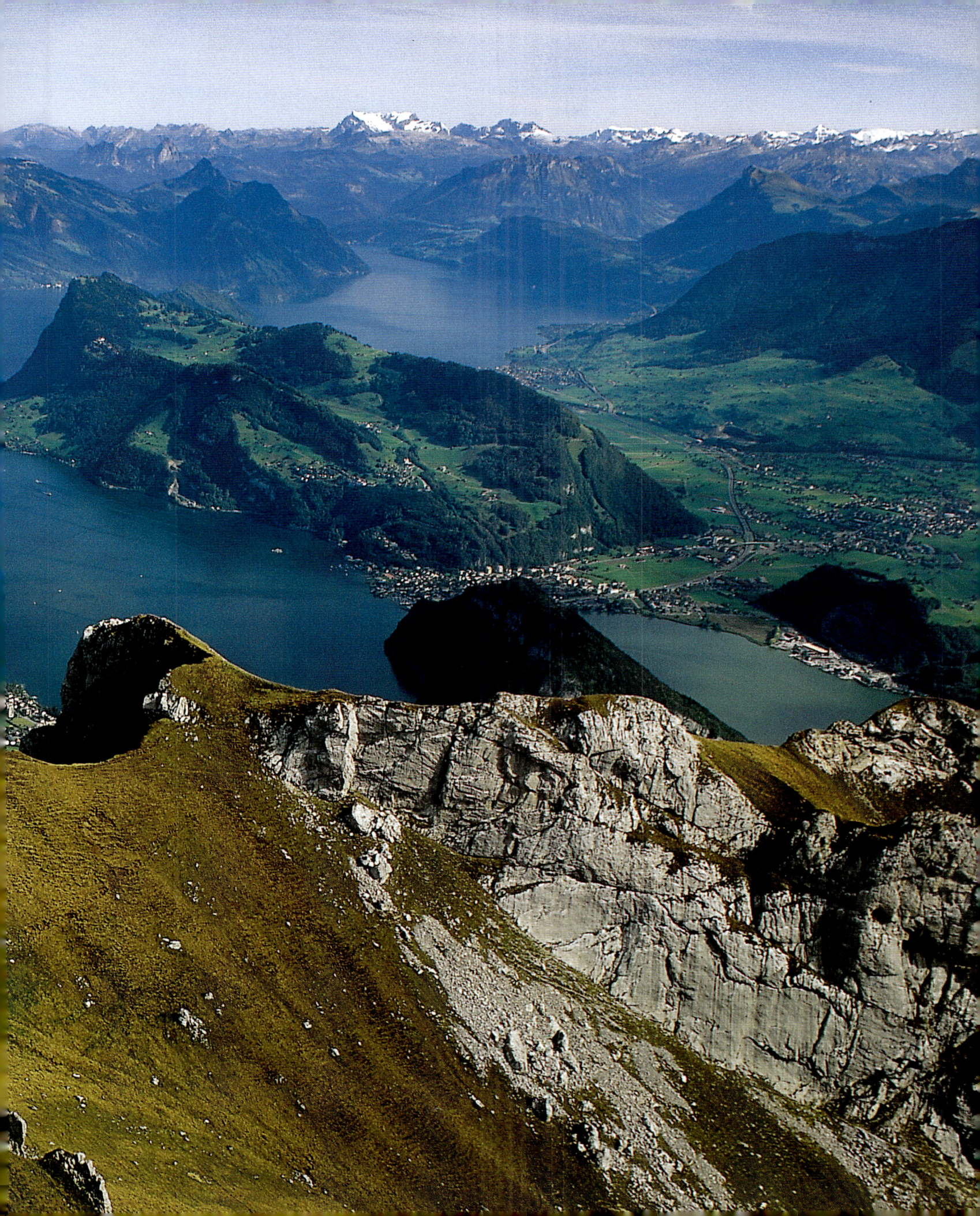

Cradles of Swiss Civilization

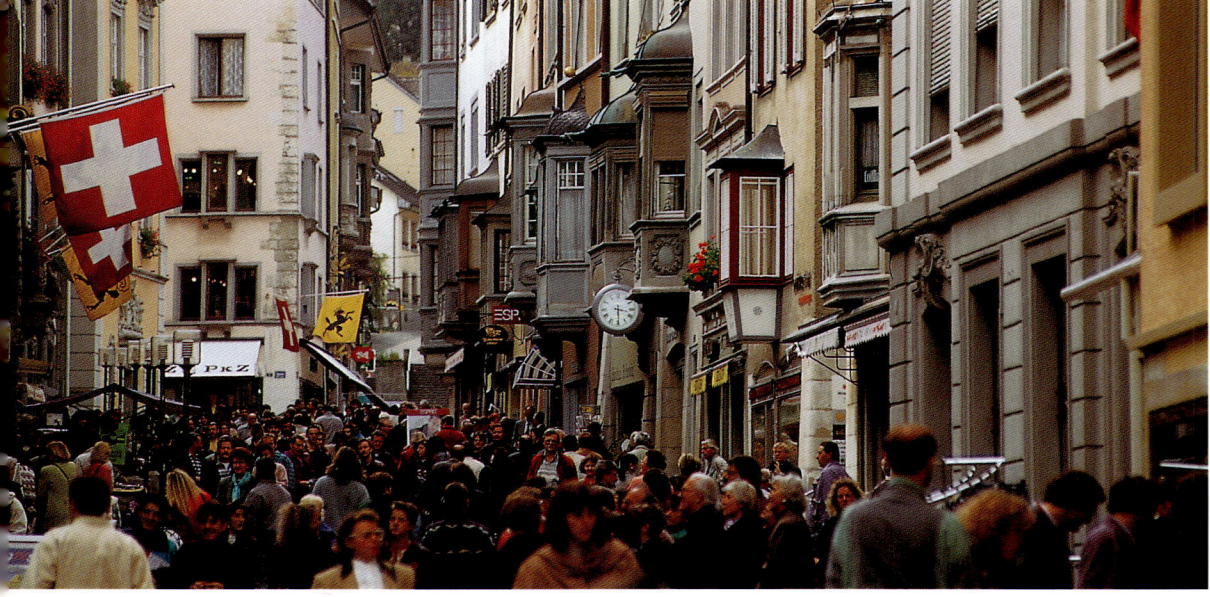

60-61 *Together with Basel, Schaffhausen is the main point of entry into Switzerland from the north. The medieval character of the city has been carefully preserved in its winding streets, age-old towers, fortified buildings and quaint overhanging windows (known as erker). The old city shows no sign of having suffered from the rapid industrialization of its surrounding area. Not far away are the Rhine Waterfalls (Rheinfall), an incredibly spectacular sight: the river, over 329 feet wide at this point, drops down from a height of about 66 feet, creating the largest waterfall in Europe.*

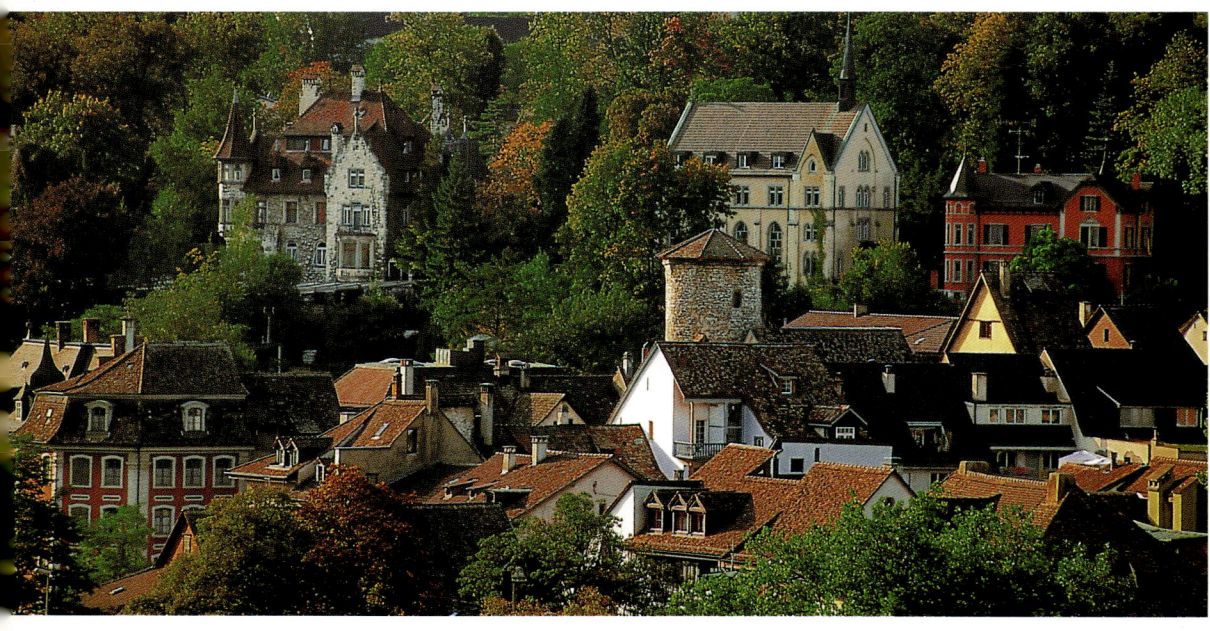

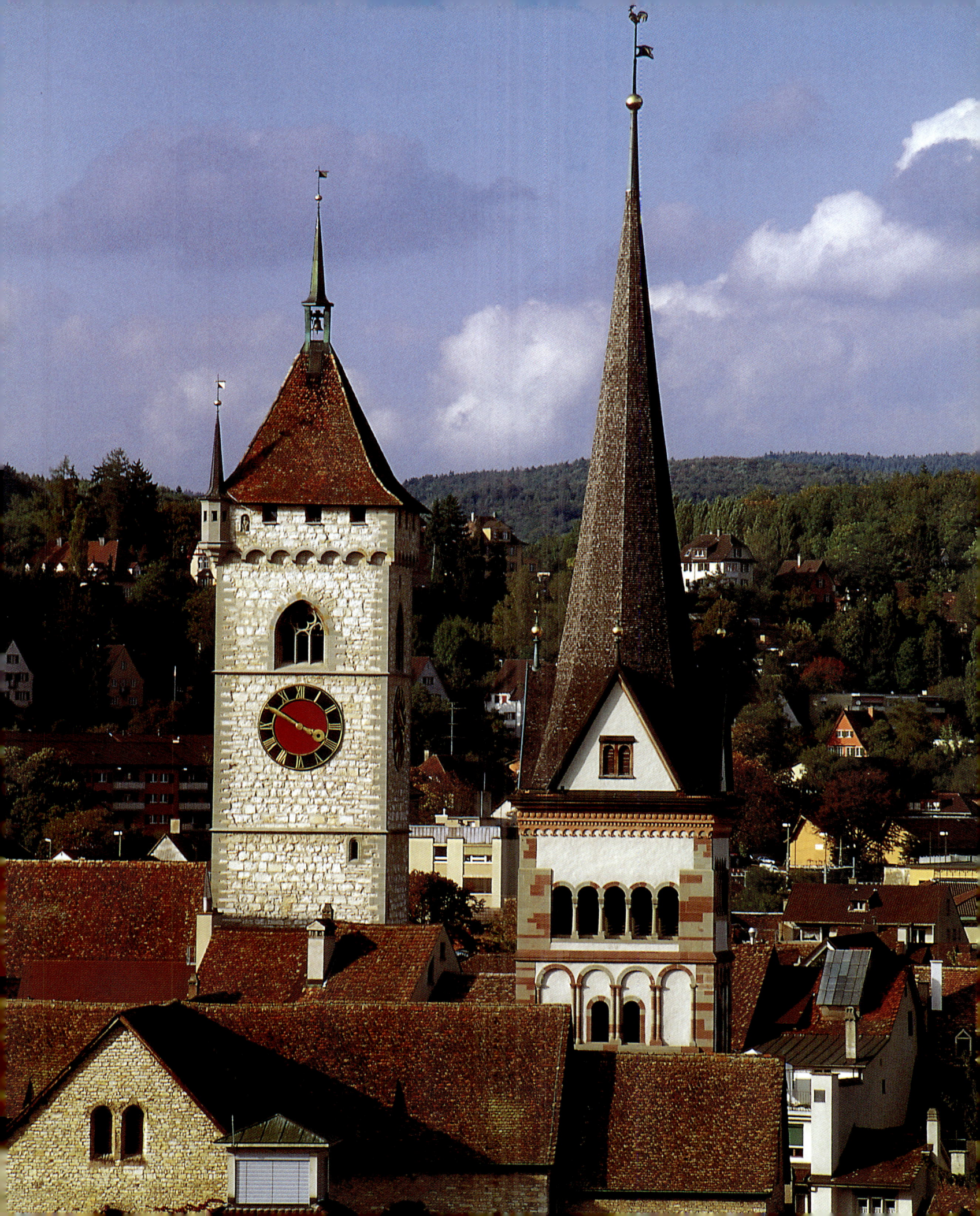

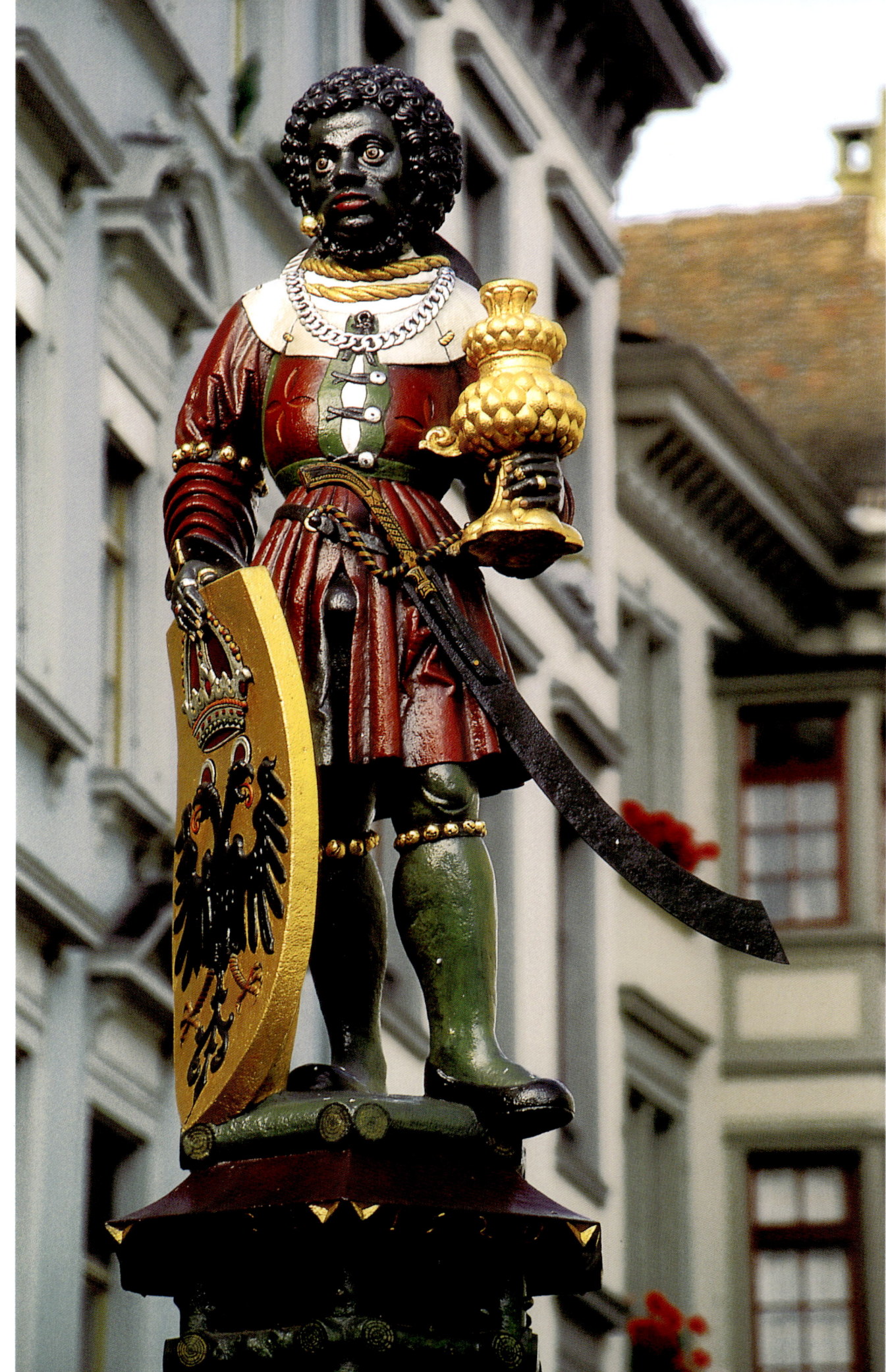

Schaffhausen, a scaled-down Nuremberg

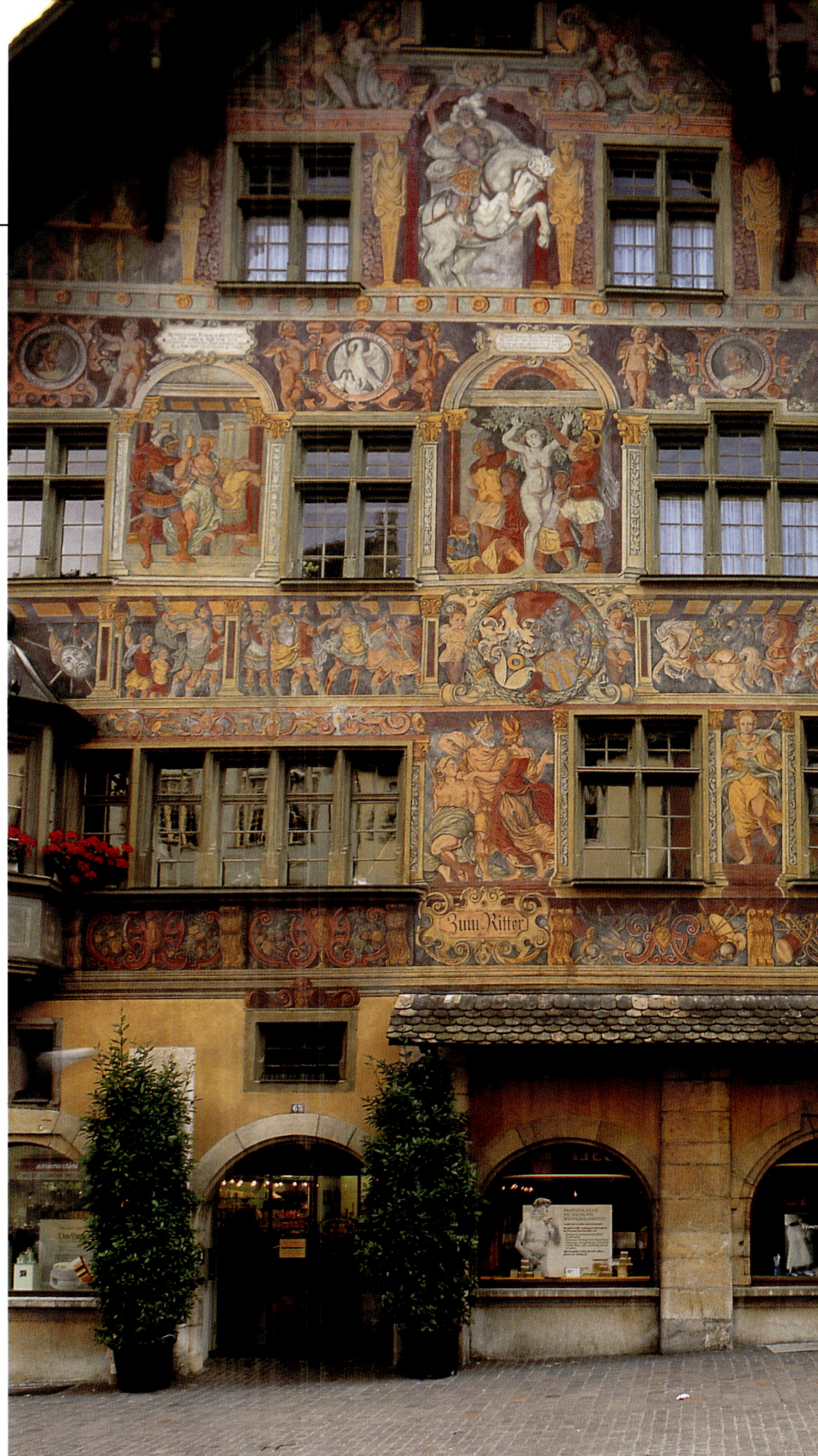

62 In Schaffhausen's centrally located Fronwagplatz a statue of one of the three Magi decorates the so-called Mohrenbrunnen fountain. In his right hand the figure holds a shield bearing the imperial insignia: it was intended as a tribute to Austria and the Hapsburgs, a conciliatory gesture only a few years after Schaffhausen had obtained its independence from Hapsburg domination and joined the Swiss Confederation.

63 Vordergasse is the busiest shopping street in Schaffhausen. At no. 65, just beyond the town hall, is the Haus zum Ritter (Knight's House), with frescoes by Tobias Stimmer (1570) depicting allegorical scenes and military episodes from ancient Roman history. An overview of the work of this important painter from Schaffhausen, who trained in the workshop of the Holbein brothers, can be seen in the Museum zu Allerheiligen.

Bern, at the helm of the Confederation

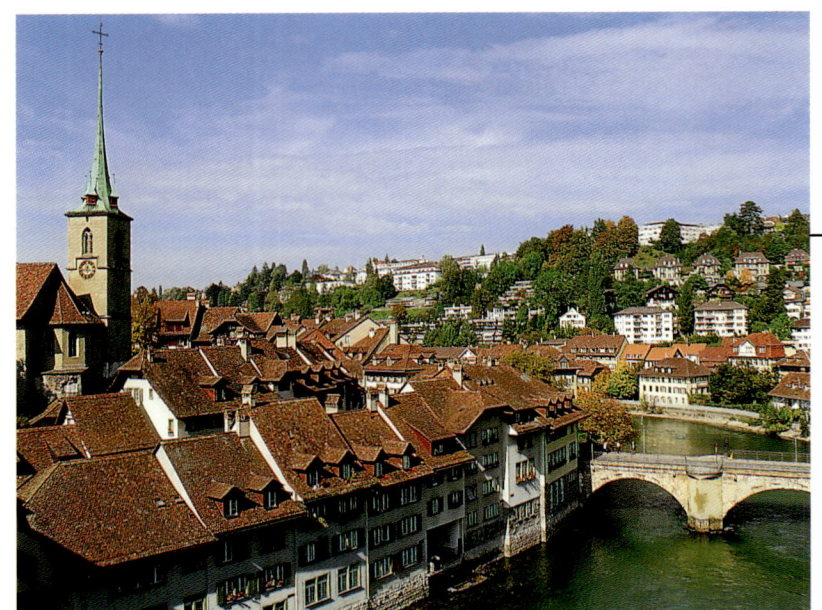

64 Surrounded on three sides by the Aare river, the "old city" of Bern centres on three parallel streets; leading off them is a maze of narrow streets and small squares, containing some of Bern's famous eleven old gilt fountains, the work of a local artist, Hans Gieng (1544-46). Lining the streets are 4 miles of arcades: with brightly lit shop windows and colourful stalls of fruit and vegetables, they are an attractive feature of the urban scenario as well as a convenient shelter on rainy days.

65 top *The Town Hall (Rathaus) was built in the 1500s to a project by Heinrich von Gengenbach. A double flight of steps leads up from the ground floor, once used as a granary, to an elegant porch with ogival arches which gives access to the council chamber.*

65 bottom *Markgasse is the most central and pleasant stretch of the main thoroughfare and, with its long row of arcades and handsome 17th and 18th-century buildings, it looks much as it did several hundred years ago. A prominent landmark at the end of the street, behind the Schutzenbrunnen - a fountain with the figure of a musketeer (1543, Hans Gieng) - is the city's most emblematic monument, the Clock Tower (Zeitglockenturm); it was first built in 1191 as the main gateway into Bern.*

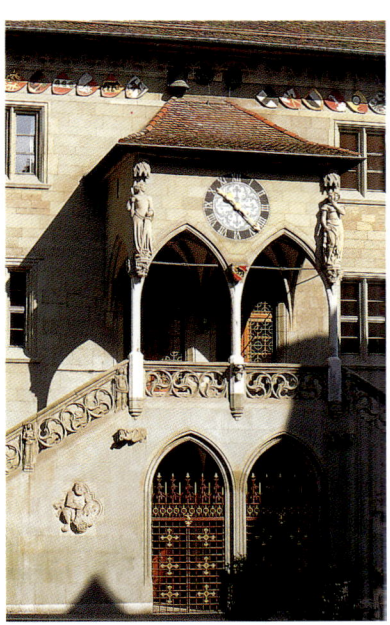

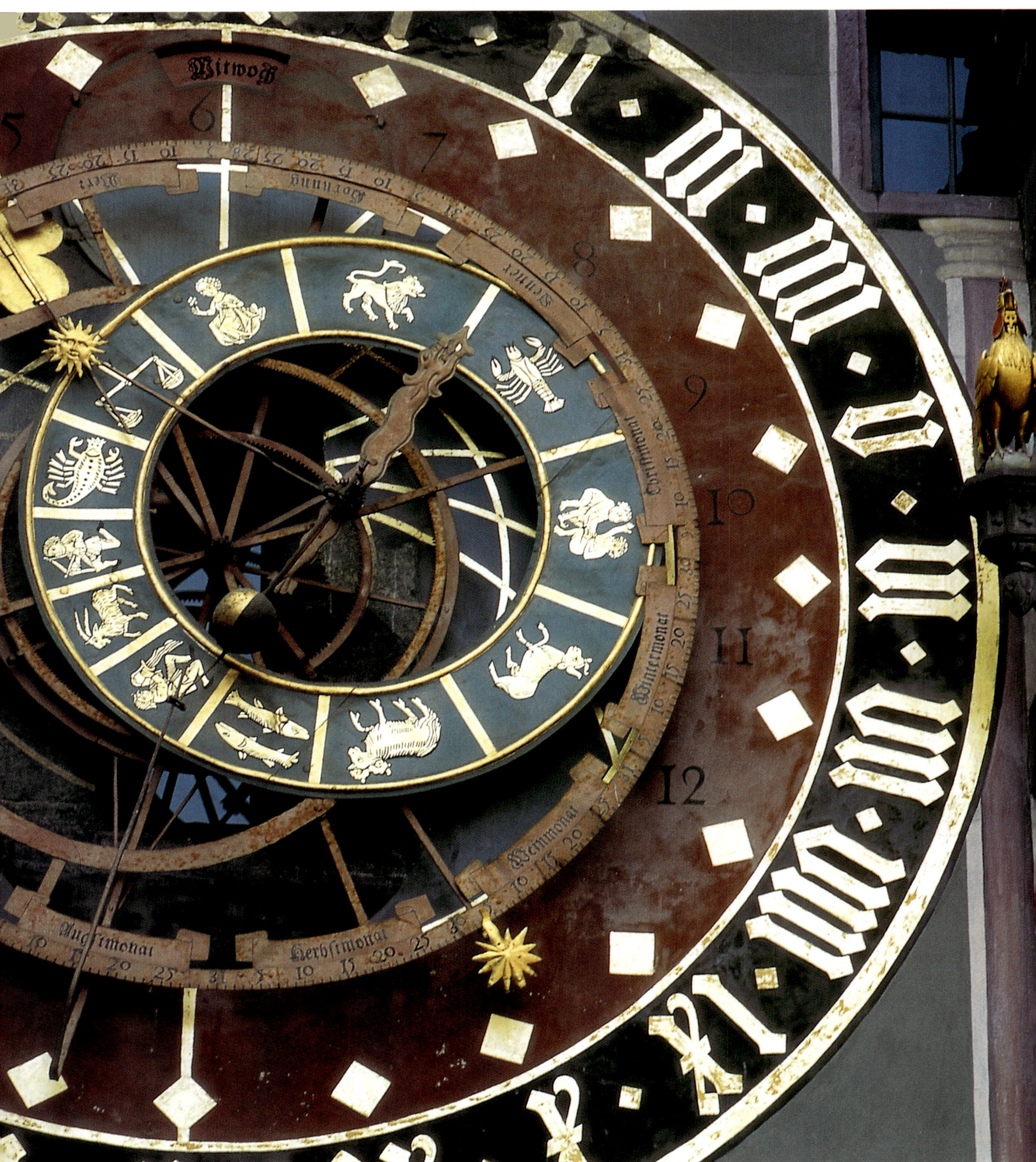

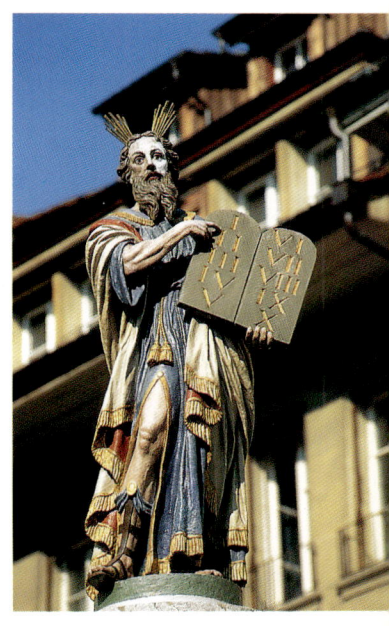

66-67 *Decorating the front of the old tower is an elaborate astronomical clock which shows the hours of the day, days of the week, months of the year and position of the Zodiac in relation to the Earth, situated, according to the ptolemaic system, at the centre of the universe. The clock was made by Kaspar Brunner in 1527-30.*

67 top *An ornamental feature of the attractive cathedral square is the Mosesbrunnen, an 18th-century copy of the 1544 fountain with a statue of Moses holding the tablet with the Ten Commandments.*

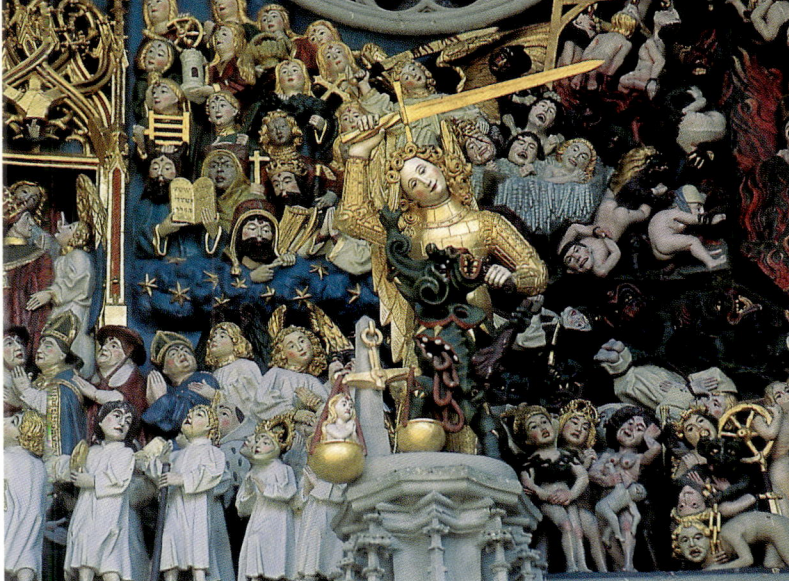

67 centre *The chosen and the damned, wise and foolish virgins, crowns, swords and gilt crosses on multi-coloured statues: all these are to be found in an unusual representation of the Last Judgement which decorates the tympanum of the Cathedral of St. Vincent, in Bern. The church was built under the direction of the Ensinger family, a well-known family of masons who also contributed to the cathedrals of Ulm, Strasburg and Milan.*

67 bottom *According to legend, Bern was founded on the site where Berthold, duke of Zahringen, killed a bear in 1191. Since then this animal has been the symbol of the city. Some people think the 'bear connection' ("bar" in German) explains the etymology of the name Bern; others say its source was instead the legendary Dietrich von Bern, whose heroic deeds are related in epic poems.*

Basel, city with a German heart

68 right *Red sandstone from the Vosges gives an original look to the cathedral, on the left bank of the Rhine. The elegant structure of the building shows the influence of various architectural styles, from Romanesque to Gothic. Elements of particular interest are to be seen on the left side, enhanced by the painted majolica tiles decorating the pitched roof.*

68 left *Red is also prominent on the façade of Basel's imposing city hall (Rathaus) but in this case it is part of a wall painting. Restoration work done in 1901 changed the appearance of the building but did not detract from its original features: it even enhanced the series of early 17th-century*

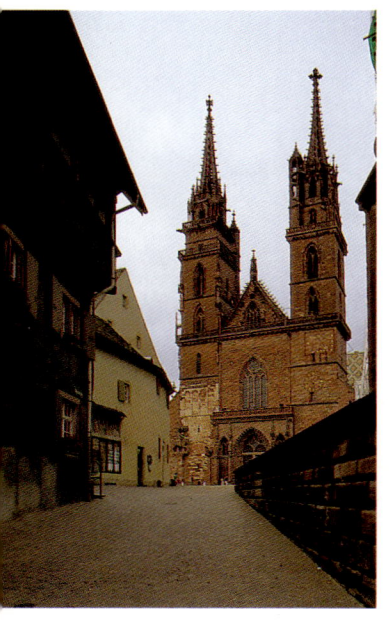

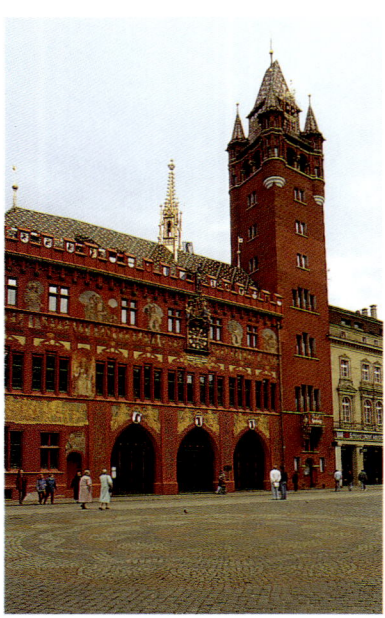

frescoes by Hans Bock, depicting episodes from local history. The clock, surmounted by a standard-bearer with the banner of the city, dates back to the 1500s.

68-69 *From the 1500s to the present day the undercurrents of many great European movements, events and aspirations - in cultural, artistic and religious spheres - have merged in Basel: the city is renowned for the Ecumenical Council held here, for the university founded by Enea Silvio Piccolomini where lecturers have included Paracelsus and Euler, Burkhardt and Nietzsche, for printing works famous since the days of Erasmus (several of his works were printed here by the publisher Froben, who helped spread the values of Christian Humanism throughout Europe). As Switzerland's only port on the Rhine, Basel has always been linked to the main business and trade centres of central-northern Europe and, with its advanced chemical industry and important network of banks, it itself plays a major role in both manufacturing and service sectors.*

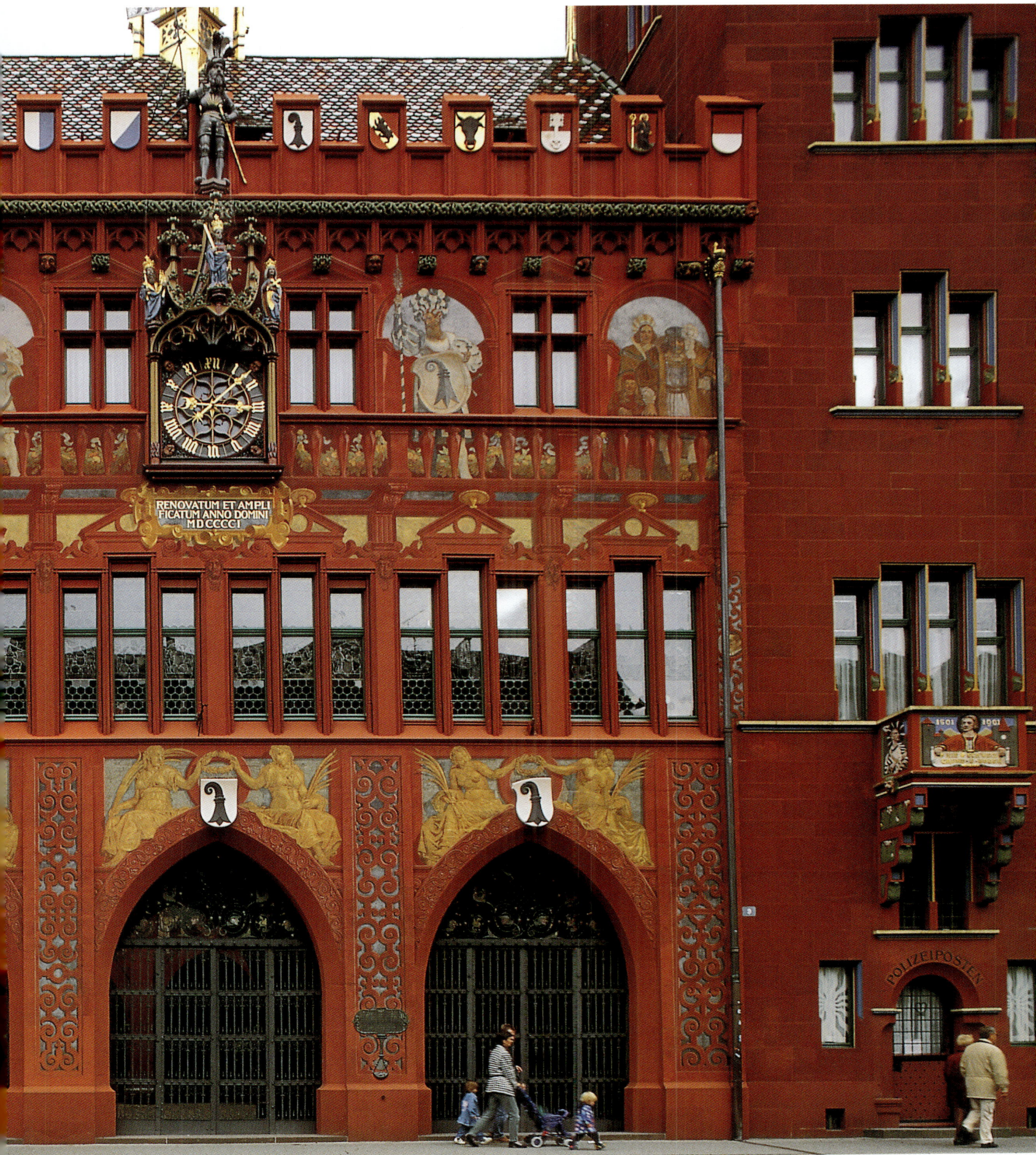

St. Gallen, on Austria's borders

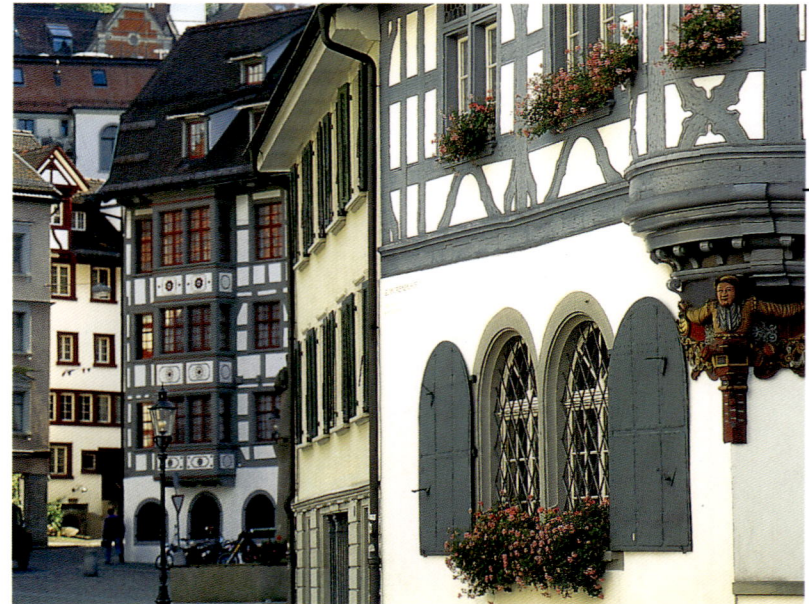

70 top *Today St.Gallen is the main cultural and economic centre of eastern Switzerland, thanks also to its flourishing lace and embroidery industry. Lining the streets of the historic centre, now a pedestrian precinct, are age-old buildings with façades brightened by colourful decorations in wood.*

70 bottom The abbey library (Stiftsbibliothek) is endowed with one of the finest collections of old books and manuscripts in Europe (about 100,000 in all). The most important works preserved here include incunabula, manuscripts and xylographic codices from the scriptorium of the abbey, decorated with priceless Carolingian illuminations. The main room of the library has a ceiling decorated by J. Wannenmacher and an exquisitely crafted parquet floor and it is considered a masterpiece of rococo art.

71 A thousand years ago this old town was one of the foremost centres of culture in Christendom. It owes its name to Saint Gallus, the Irish monk and missionary who founded a hermitage here in 613. The cultural influence and prominence of the Benedictine abbey established on the site in 747 reached their height in the 11th century, when its school was one of the leading institutions in Europe.

Geneva,
cosmopolitan city

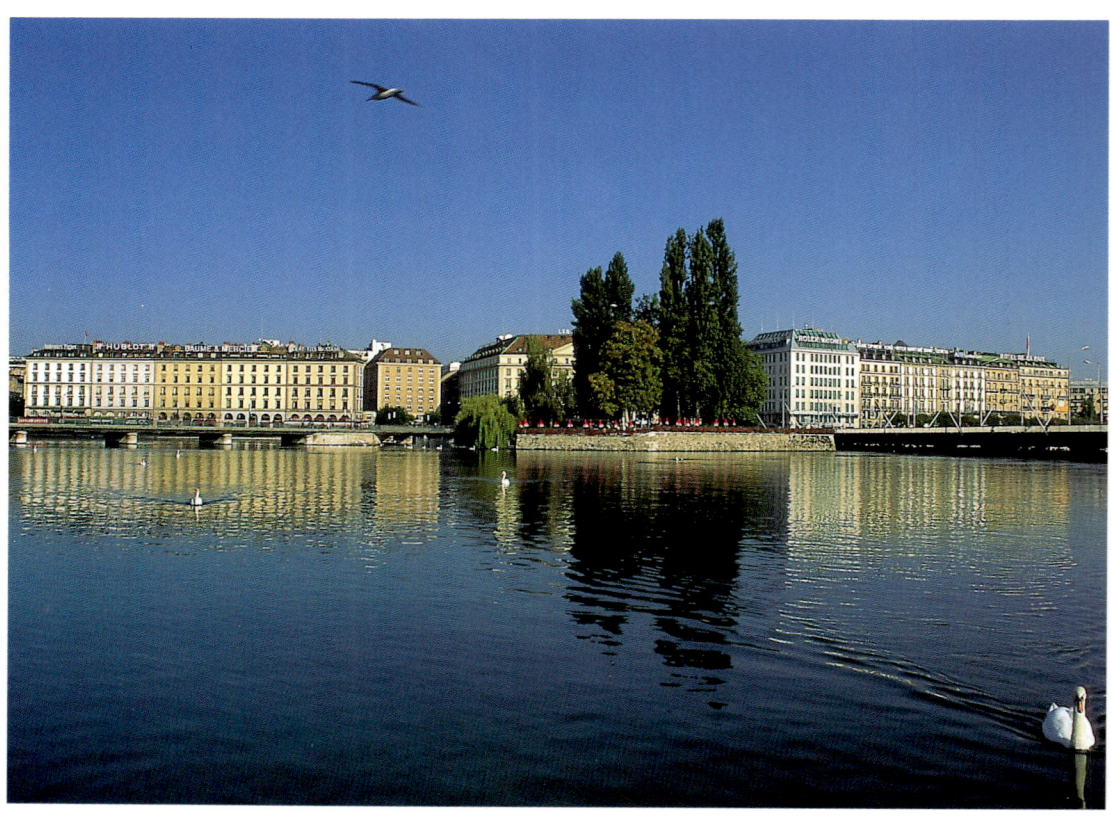

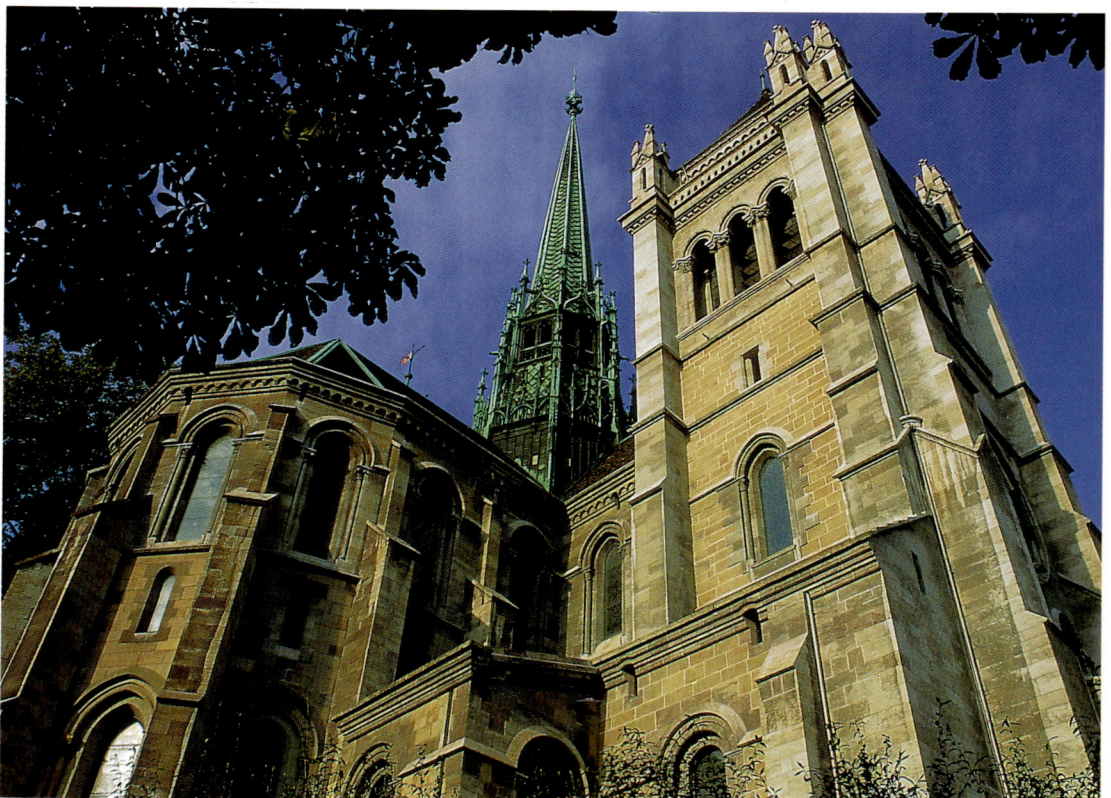

72-73 Geneva is situated on the shores of Lake Léman, at the point where the Rhone river leaves the lake. The city transformed by Calvin into a bastion of Protestantism, welcoming religious refugees from all over Europe, is now a prosperous cosmopolitan centre, home to important international institutions including the Red Cross, the International Labour Office and the Ecumenical Council of Christian Churches. The old core of the city, with its severe but not unpleasing architecture, centres on the Romanesque-Gothic cathedral. Modern Geneva is instead an elegant metropolis with plentiful luxury stores and jewellers' shops, beautiful houses set in large gardens with age-old trees, wide avenues fronting the lake and imposing modern buildings, for instance the city's prestigious university and the Palais des Nations, built between 1929 and 1937 to a project developed by five architects of different nationalities.

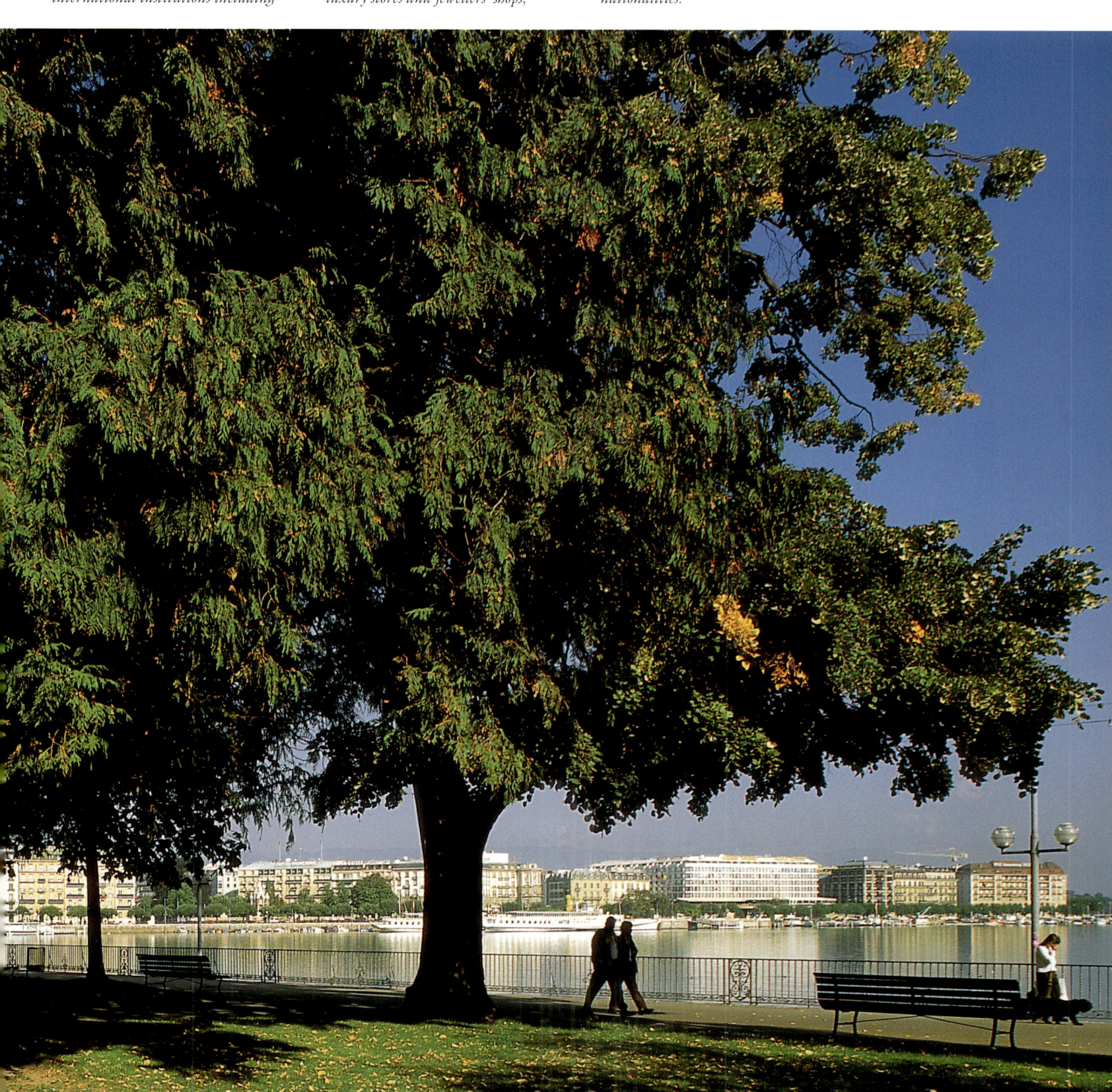

Lausanne, gem of the Vaud canton

74-75 *Spreading between the lake and hills, with both centre and suburbs wrapped in greenery, Lausanne looks like a garden city. Grand hotels line the waterfront which, with its beach and harbour, is the splendid setting of the smart residential district of Ouchy. High on a hill, in the heart of the city, the cathedral dominates the lakeside scenario. This masterpiece of Swiss*

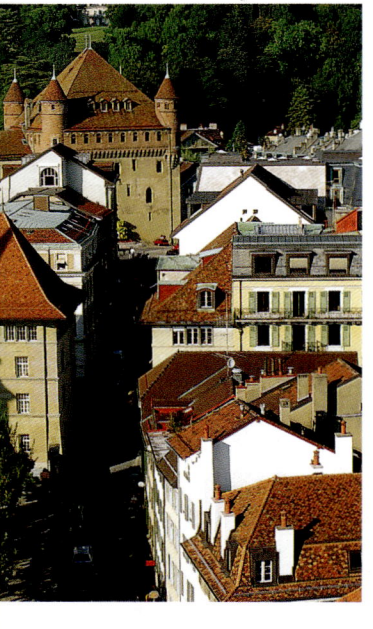

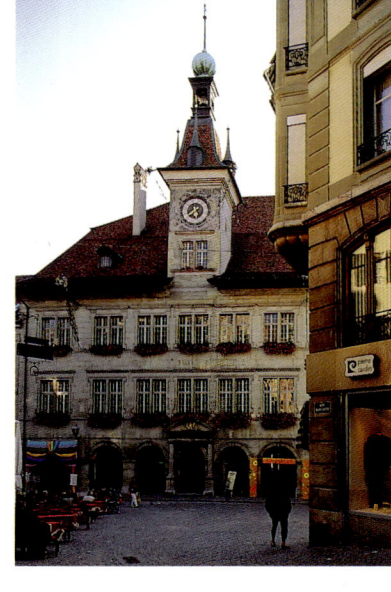

Gothic architecture was consecrated in 1275 by Pope Gregory X in a ceremony held in the presence of the emperor, with abundant pomp and circumstance. Right in front of the cathedral is Place de la Palud, taken over twice weekly, on Wednesday and Saturday, by local farmers who sell their produce at the bustling flower, fruit and vegetables market. Facing the square is the two-storey city hall, surmounted by a tower, with a portico. The castle, built as the episcopal see in the 1400s, now houses the cantonal government.

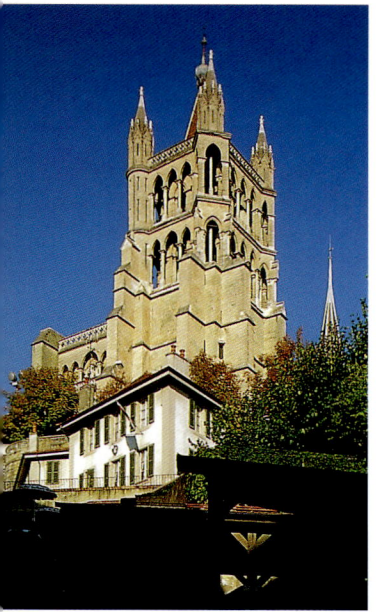

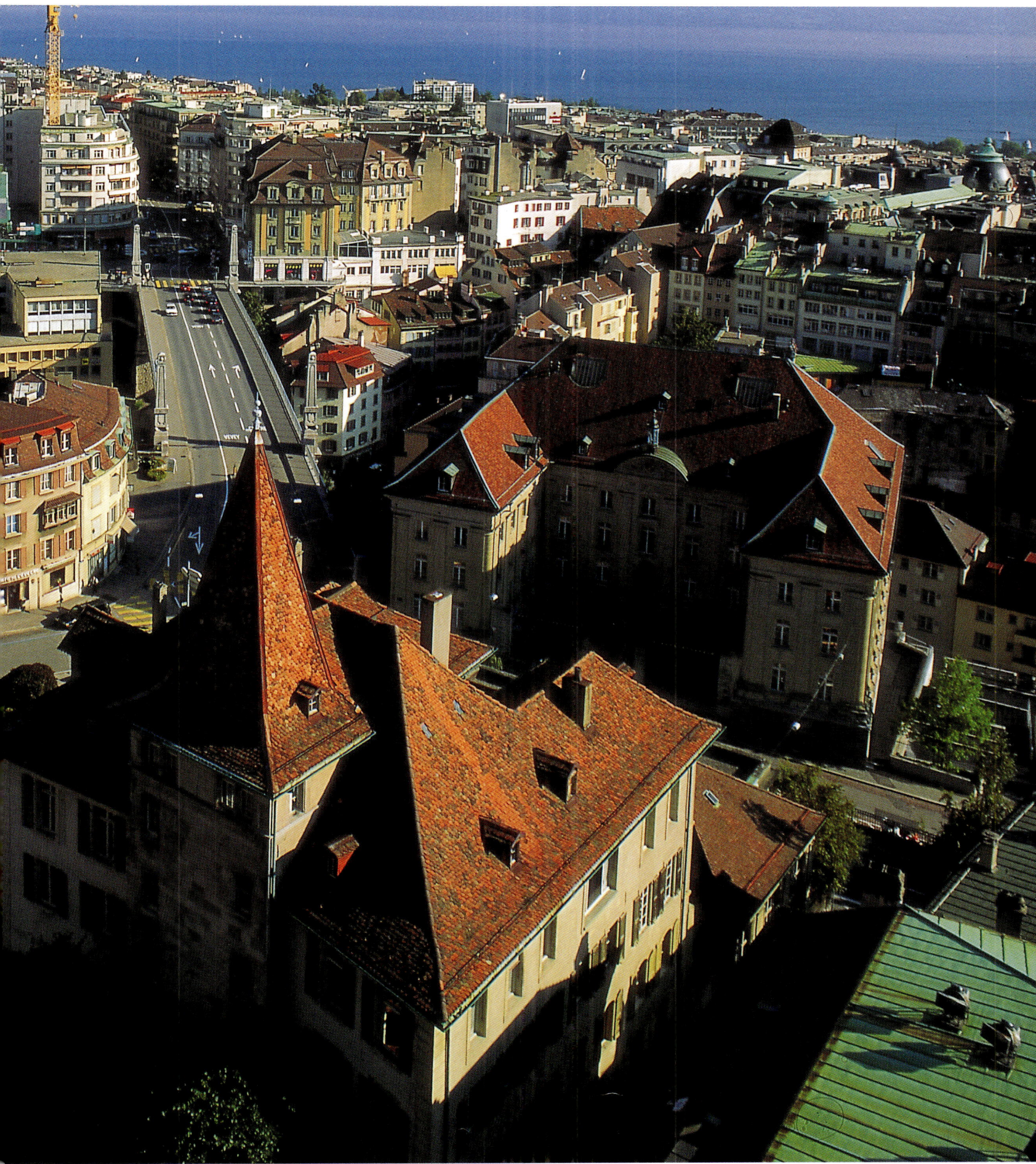

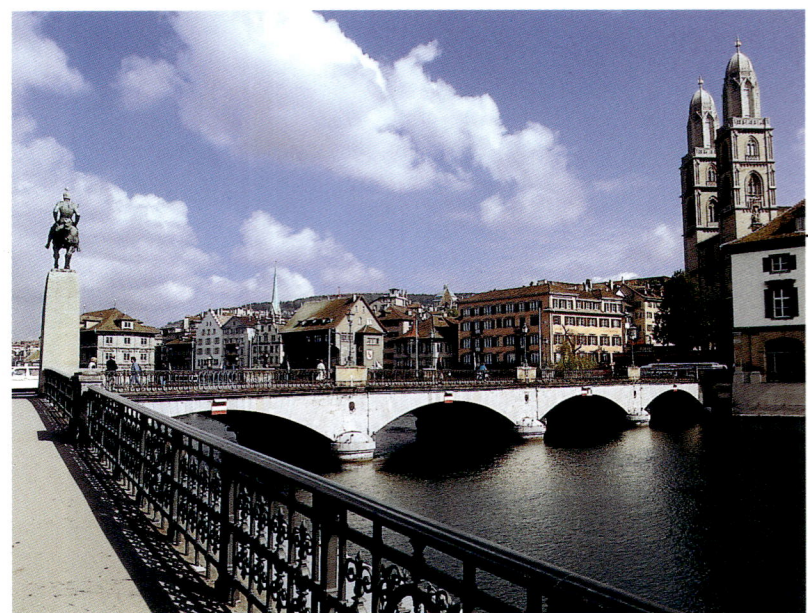

Zurich, capital of banking and finance

76 top *It would be totally misleading to present Zurich simply as a city of banks and money-dealers, a place where money is all that counts. There's no denying that Zurich is the place of work of many of the world's most influential financial operators. But this is only one side of Zurich. No less important is the city's manufacturing activity (it is Switzerland's foremost industrial centre). It is a modern city in every respect, also revealing the tensions typical of present-day urban life, less easily perceived in other more protected and "cushioned" cities and towns of Switzerland. The second bridge over the Limmat River, after it flows out of Lake Zurich, is the Munster Brucke, which connects two of the busiest parts of the city; close by, to the left, is the Fraumunster while the Great Cathedral of Zurich (Grossmunster), with its twin towers, is to the right.*

76 bottom *The pinnacles in the foreground belong to a somewhat bizarre medieval-style castle built in the early 1900s to house the Swiss National Museum (Landesmuseum); it contains a heterogeneous collection of documents, historic finds and works of art from the Stone Age to the present century.*

77 *Situated on the Limmat riverbank, the city hall is an austere building in Italian Renaissance style, actually built at the end of the 17th century. The peace treaty between Piedmont and Austria which brought the war of independence in Northern Italy to an end, was signed here in 1859.*

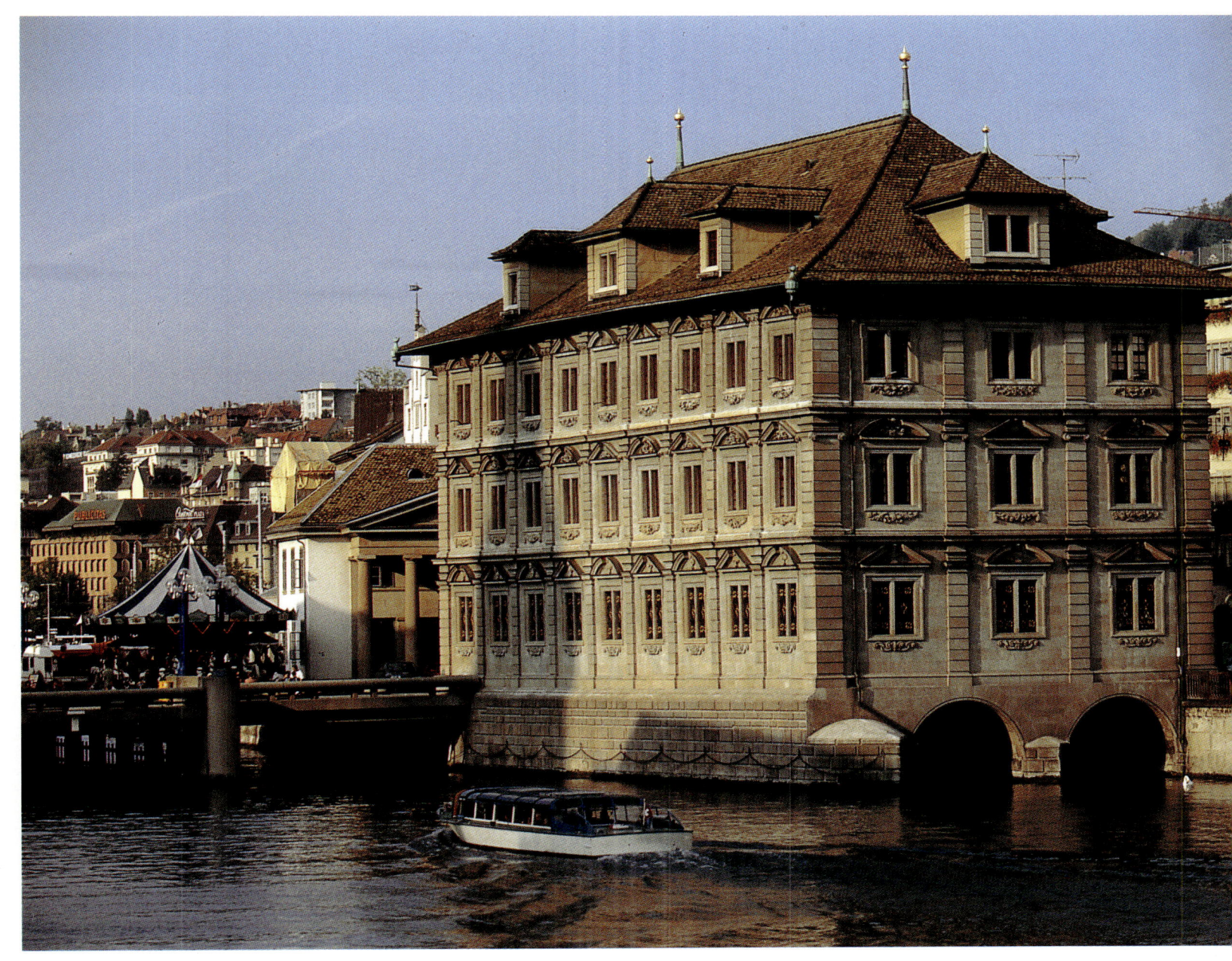

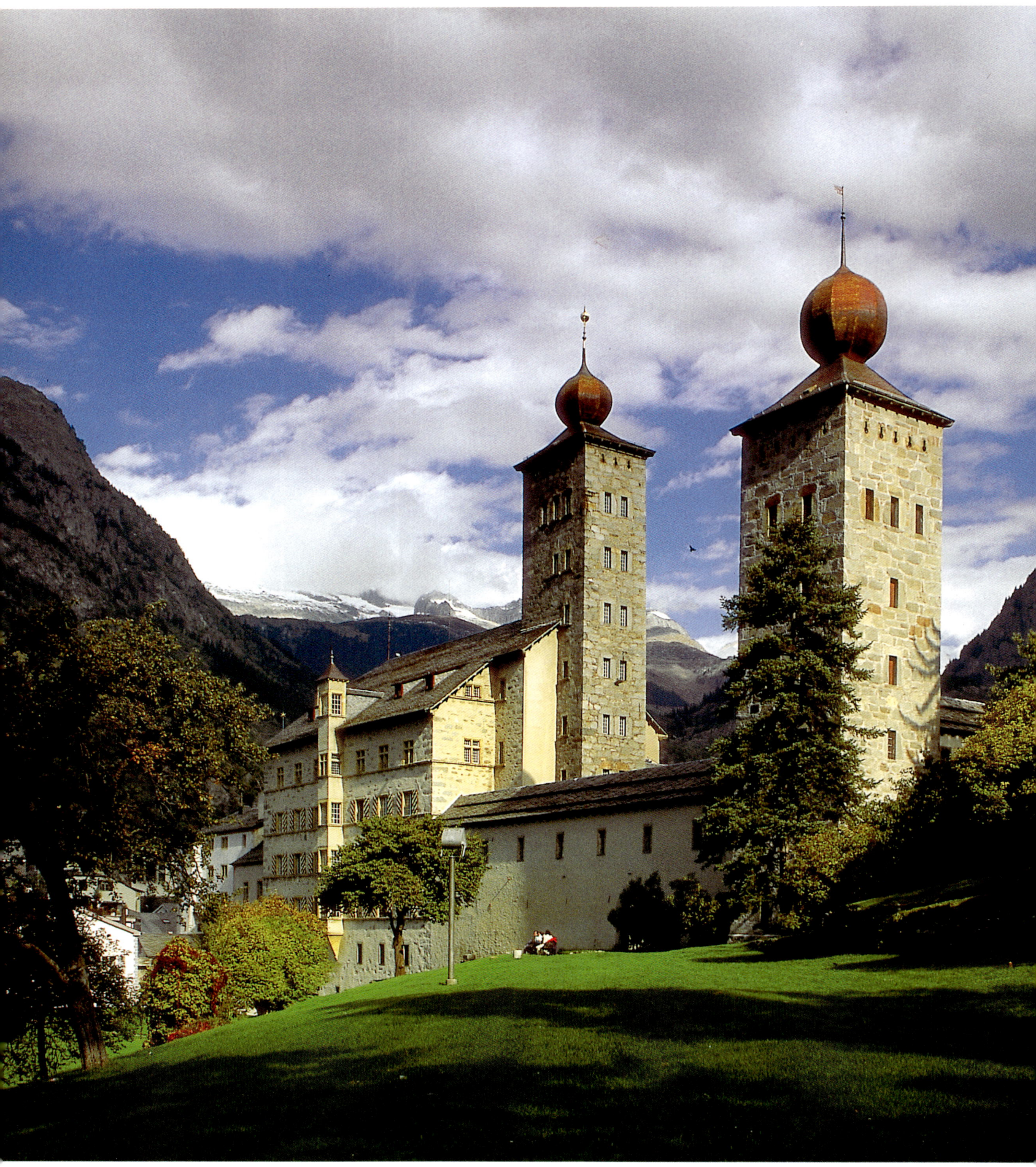

Sion, chief town of the Valais

78-79 *The main attraction for visitors to Brig - located in the Rhone Valley, at the foot of the Simplon pass - is Stockalper Castle, a prominent example of Swiss Baroque. Its high towers with bulbous domes are distinctly Alpine in derivation but the tone of the building is softened by typically Italian elements evident in the design of the inner courtyards with their elegant porticoes.*

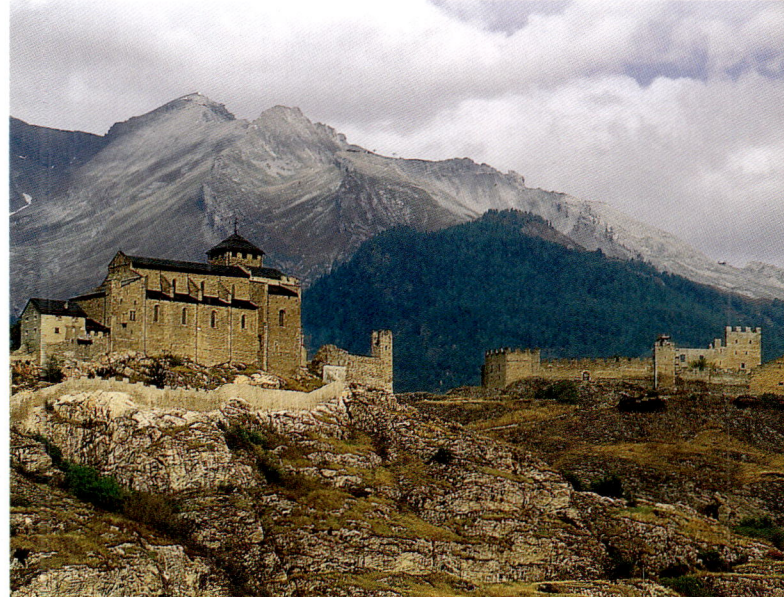

79 top *The houses of Sion - the Roman settlement Sedunum, capital of the canton of Valais - are spread over two rocky outcrops in the centre of the valley. Situated here are the ruins of Tourbillon Castle, built by a bishop, and the fortified church of Notre-Dame-de-Valère; a church has stood on this site since the 6th century but the present one dates back to the 12/13th century.*

79 bottom *On Sion's main street, the city hall (Hotel de Ville) has a splendid astronomical clock which, like the building, dates back to the late 1600s.*

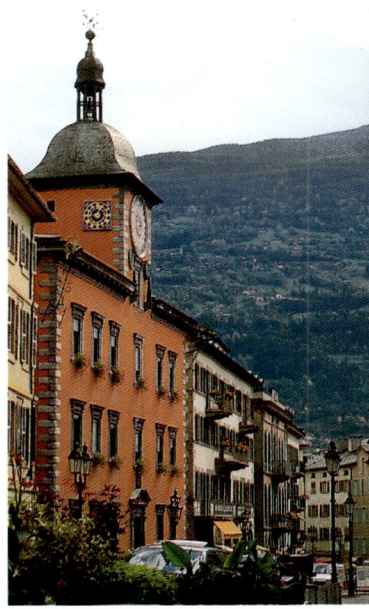

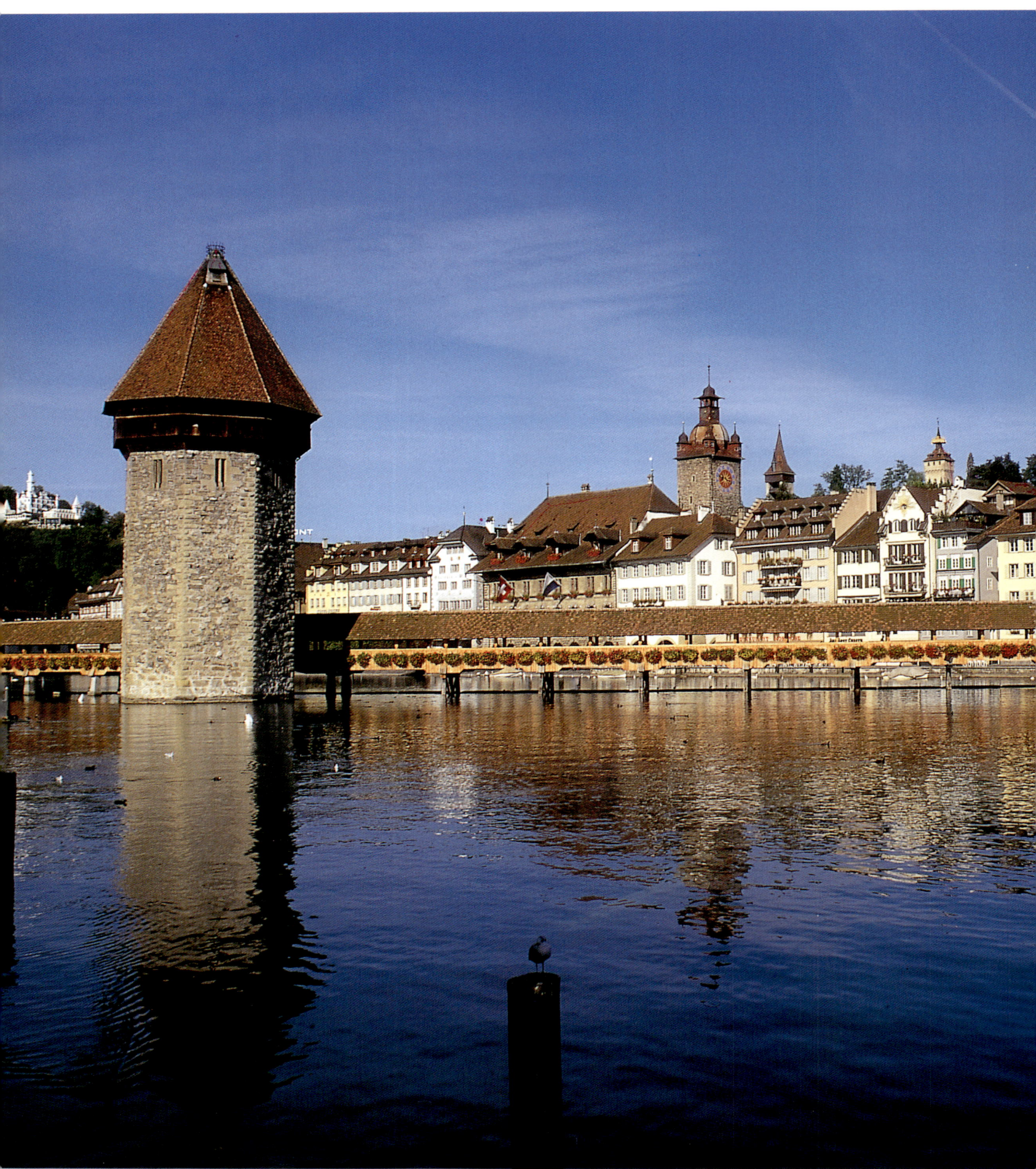

Lucerne, city of St. Leodegard

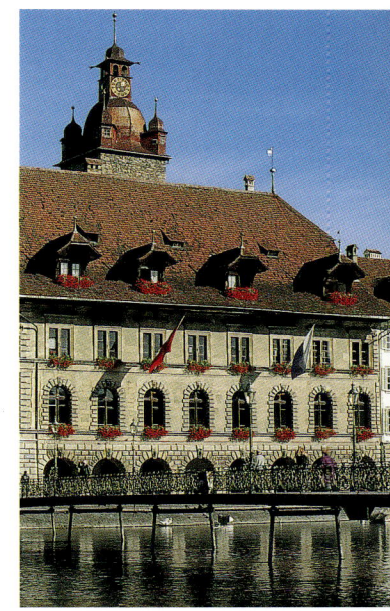

80-81 *Lucerne was once renowned for its wooden houses, which had storks nesting on their roofs, and for the harbour from which mercenary soldiers set sail on the first stage of journeys to fight for pope and emperor.*

81 top and bottom *Lucerne owes its origins to St. Leodegard, founder in the 8th century of a Benedictine monastery which played a key role in the conversion to Christianity of these lands; hemmed in by lakes and mountains, they were, in those days, difficult to reach and generally inhospitable. The city has long been an outpost of the*

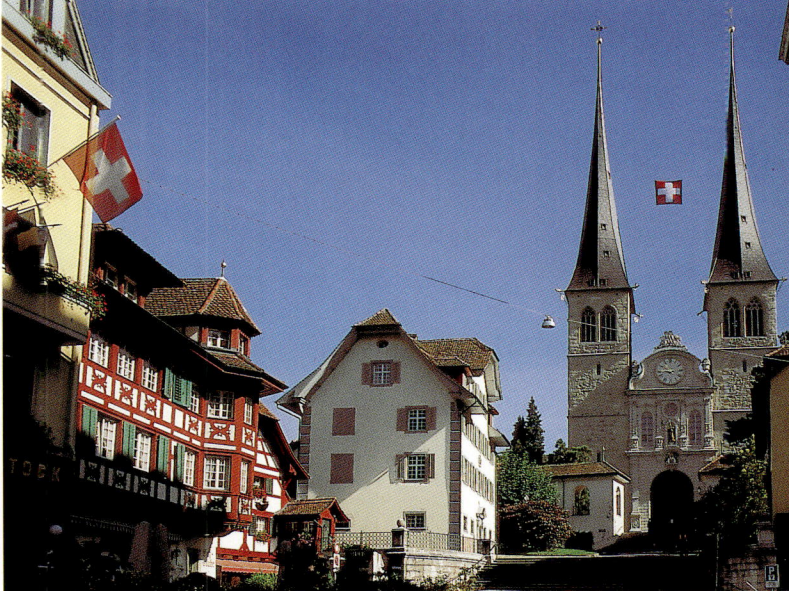

Roman Catholic church in an area of deeply ingrained Protestantism, a situation evident in several churches which testify to the culture of the Counter-Reformation.

81 centre *The cathedral, dedicated to the city's patron saint, still has its two original towers; the main body of the church was re-built in German Renaissance style in the 1600s by a Jesuit architect, Jakob Kurrer.*

82-83 *Rapperswil is a delightful little town situated on a small peninsula jutting out from the western side of Lake Zurich. Adding to its scenic appeal is a 14th-century castle, once a residence of the Hapsburgs and, since 1870, home of the Polenmuseum. The museum owes its existence to a large community of Polish emigrants who settled in Rapperswil in the 1860s and decided this would be a fitting testimony to their centuries-long fight for freedom.*

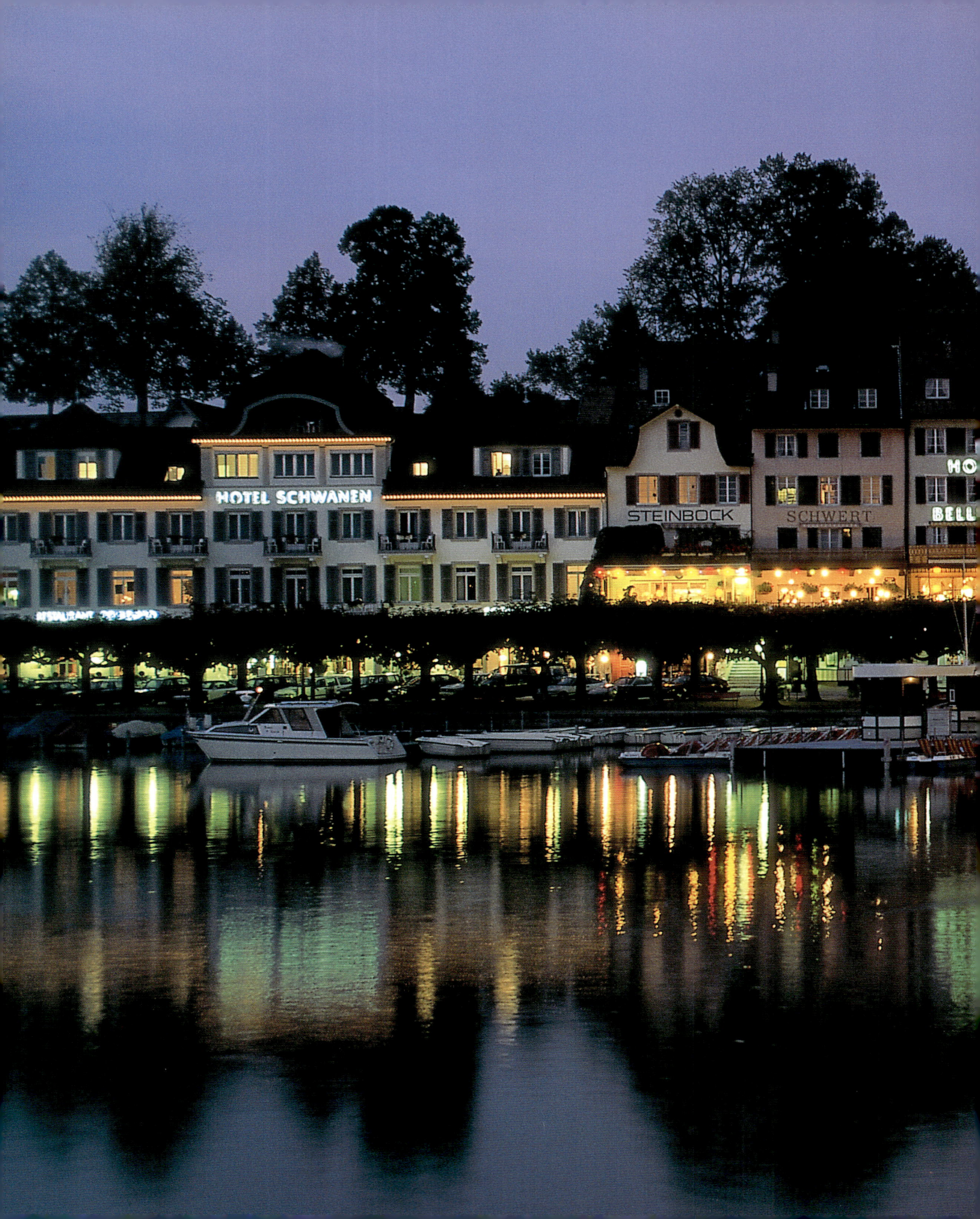

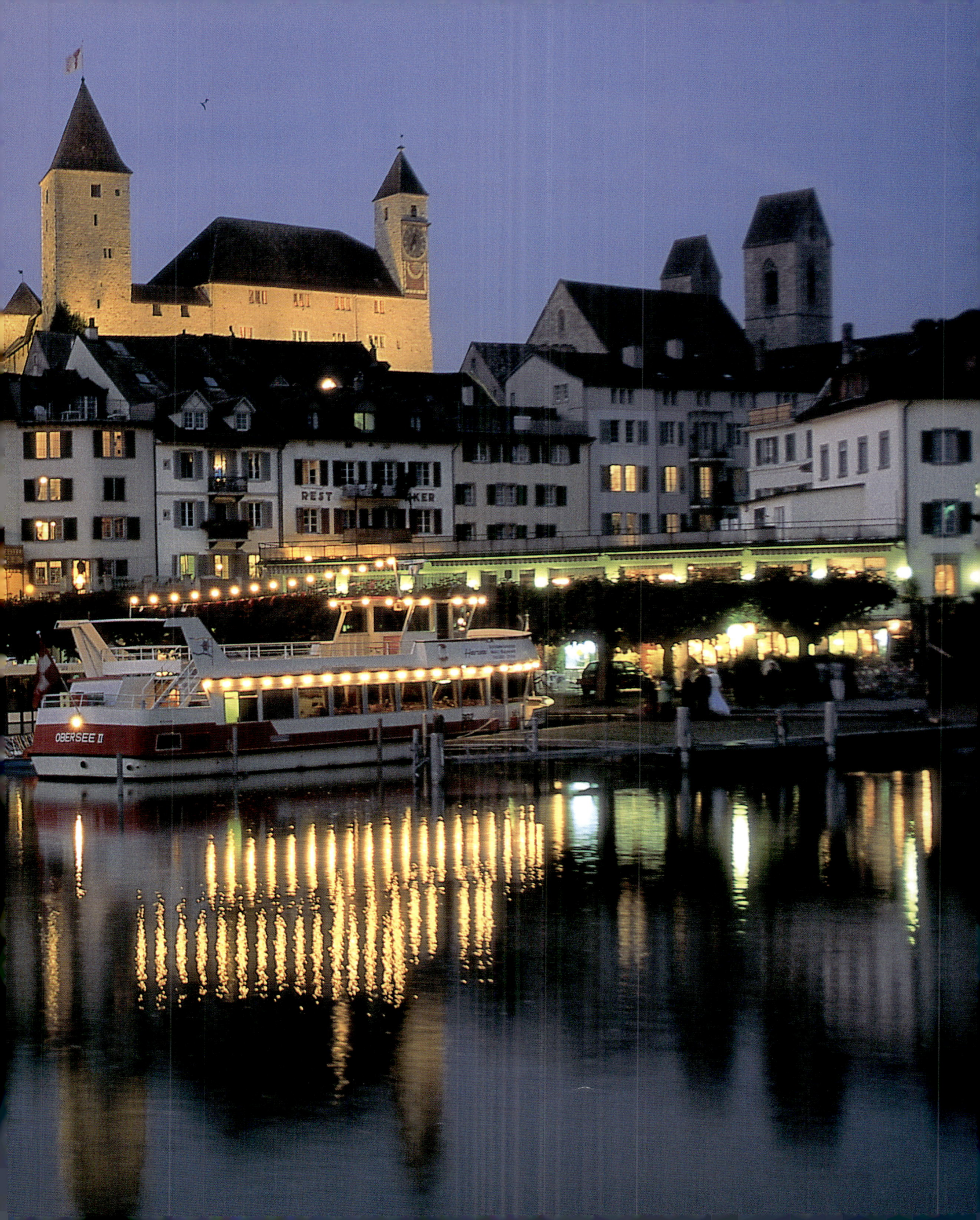

The Strength of Traditions

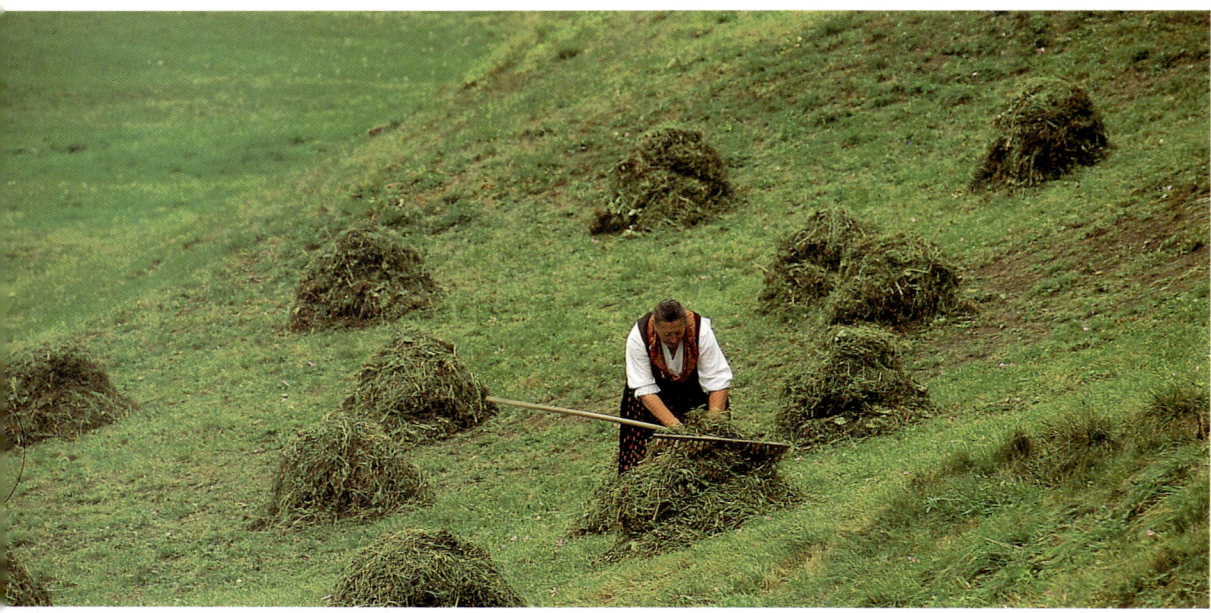

84-85 *The inhabitants of rural Switzerland are self-respecting, dignified people, proud of their long-standing traditions, people who have not succumbed to the seemingly tempting world of affluence, tourism and industry.*

The faces and crafts of Switzerland's mountains and valleys are a reminder of the history of this land, where freedom has always been embedded in the everyday lives of ordinary folk, of herdsmen and farmers.

Here firm belief in the values of the past seems unaffected by the passage of time and generations: age-old trades and crafts continue to thrive while the different ethnic groups, with their own languages and traditions, live harmoniously side-by-side.

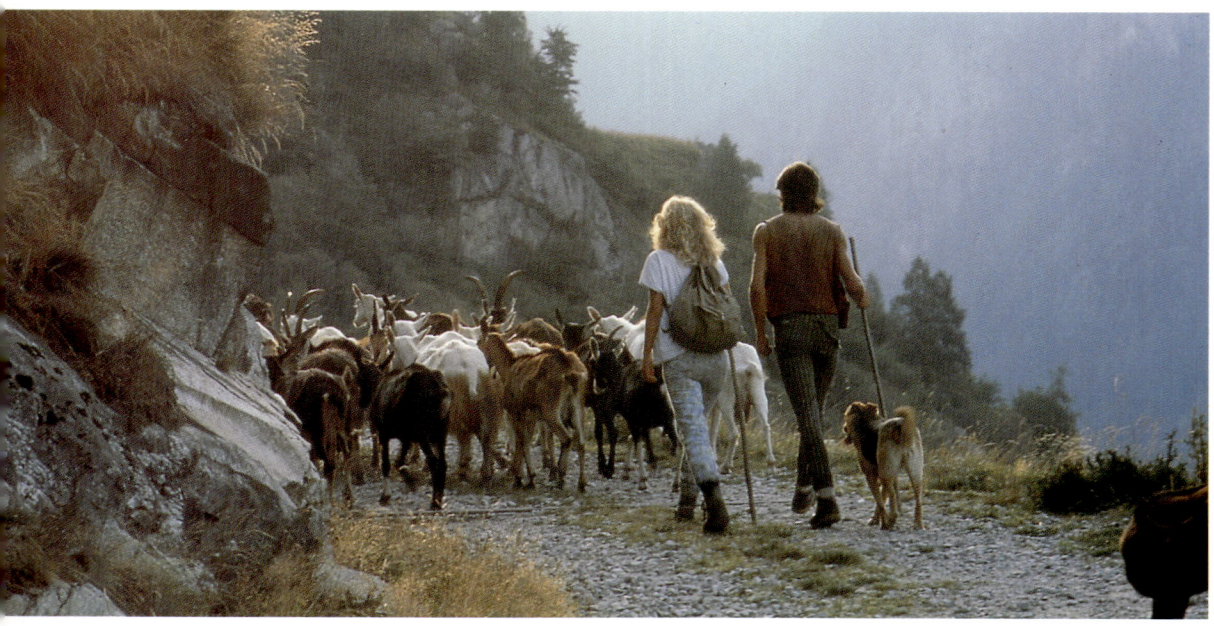

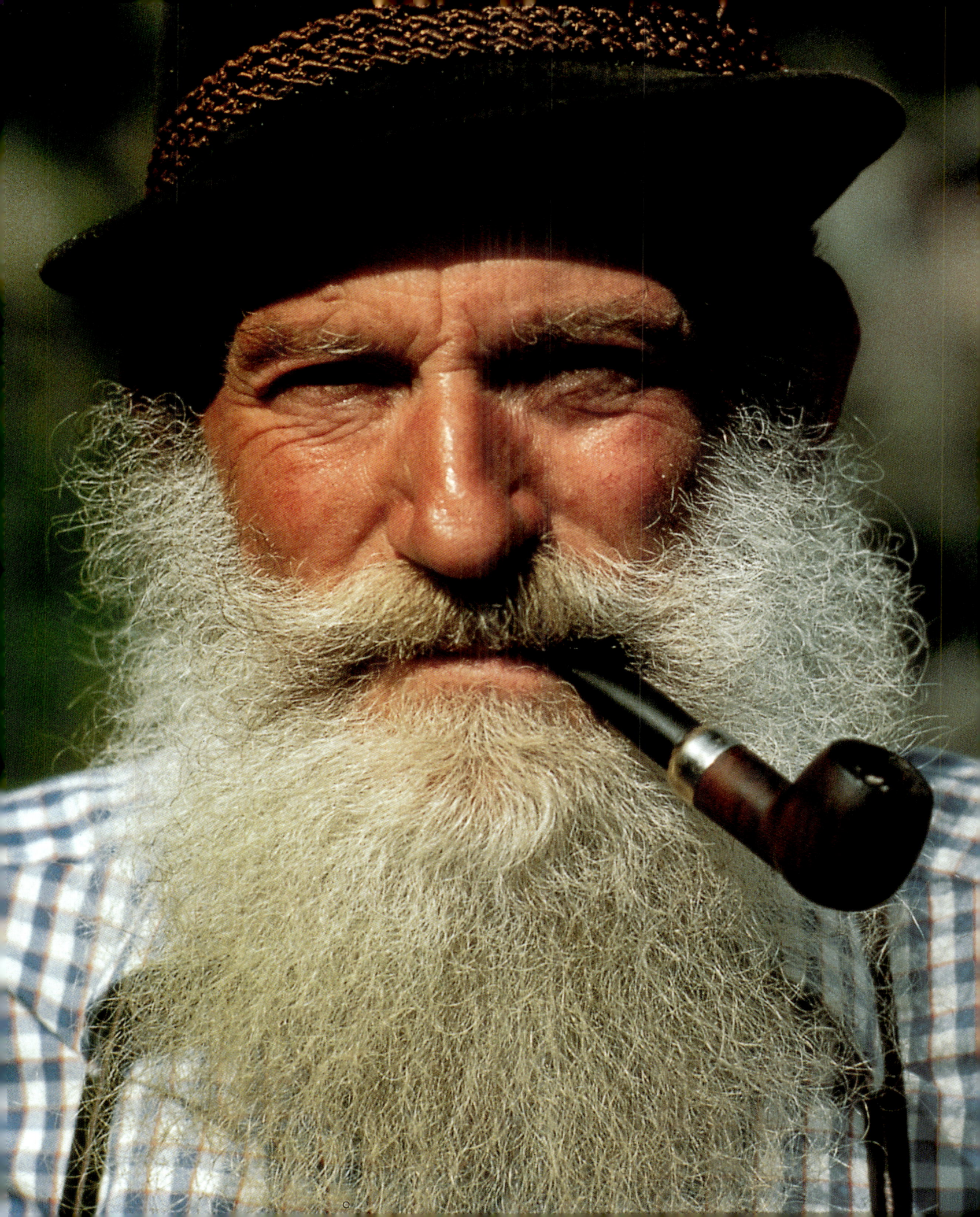

At the foot of the Bernese Oberland

86 *With its wide expanses of pastureland, dotted here and there with villages where old wooden houses cluster around tiny churches with pointed spires, the Simme valley offers an altogether typical Swiss mountain landscape. Its magnificent chalets - for instance, the celebrated Knuttihaus in Darstetten (shown bottom left), built 200 years ago - are a foretaste of the comfortable surroundings and wonderful amenities that Switzerland has been offering holiday-makers for over a century.*

87 *The beauty of Swiss scenery stems from the harmonious interplay of architecture and nature. Different types of dwellings prevail in different parts of the country: masonry and wood are used for houses in central Switzerland, plastered walls in Engadine. Their common feature is the use of decorations, applied by creative and talented craftsmen: geometric patterns, floral motifs (and real flowers too), garlands, animals and fruit, as well as propitiatory symbols of health, good fortune and plenty. Timber is the material most used for both public and private structures: the Wangen bridge on the Aare River is a fine example.*

88-89 *Pictured here, not far from Davos, is a typical landscape with idyllic chalets nestling among silvery firs and meadows from which emanates a fragrant smell of hay.*

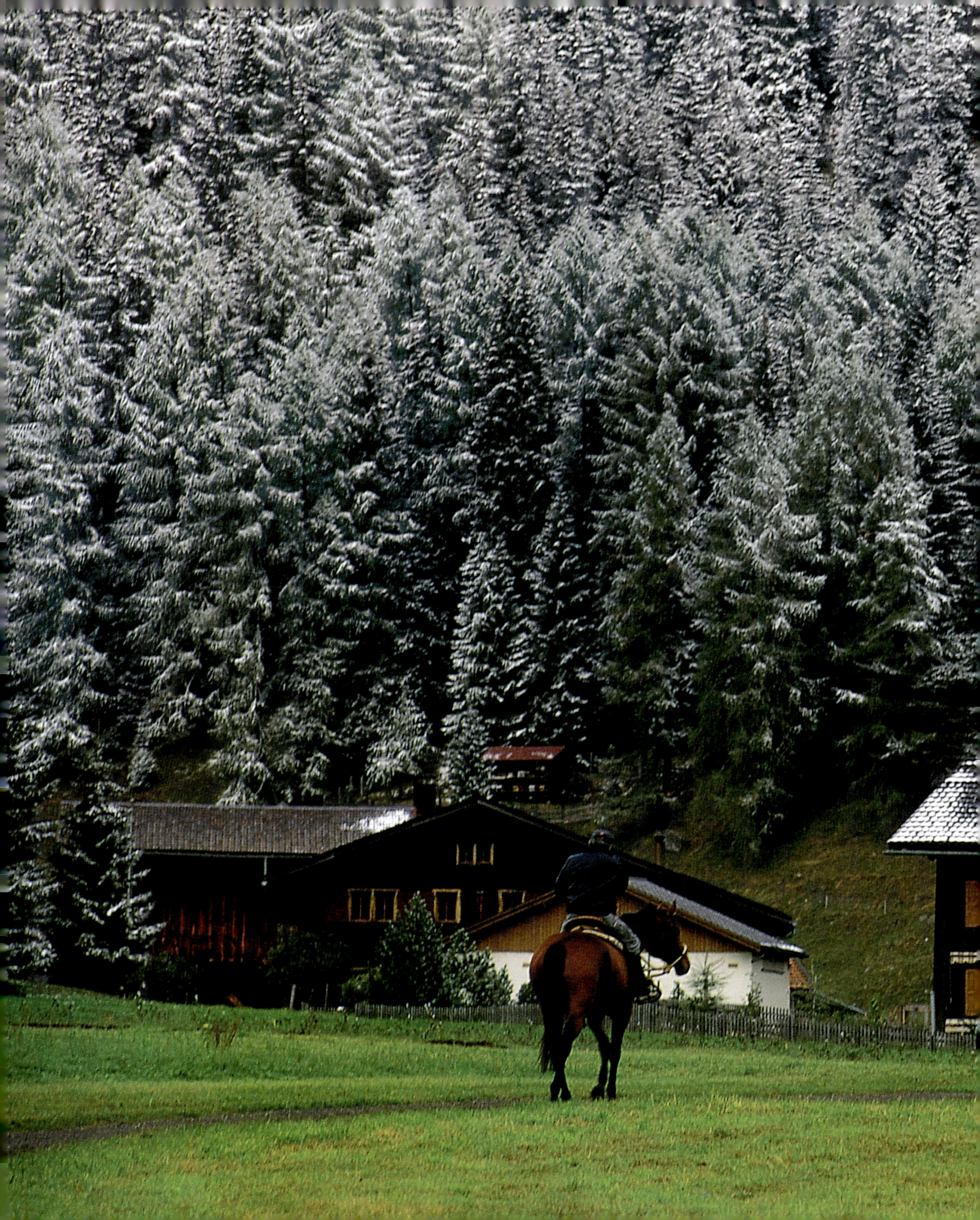

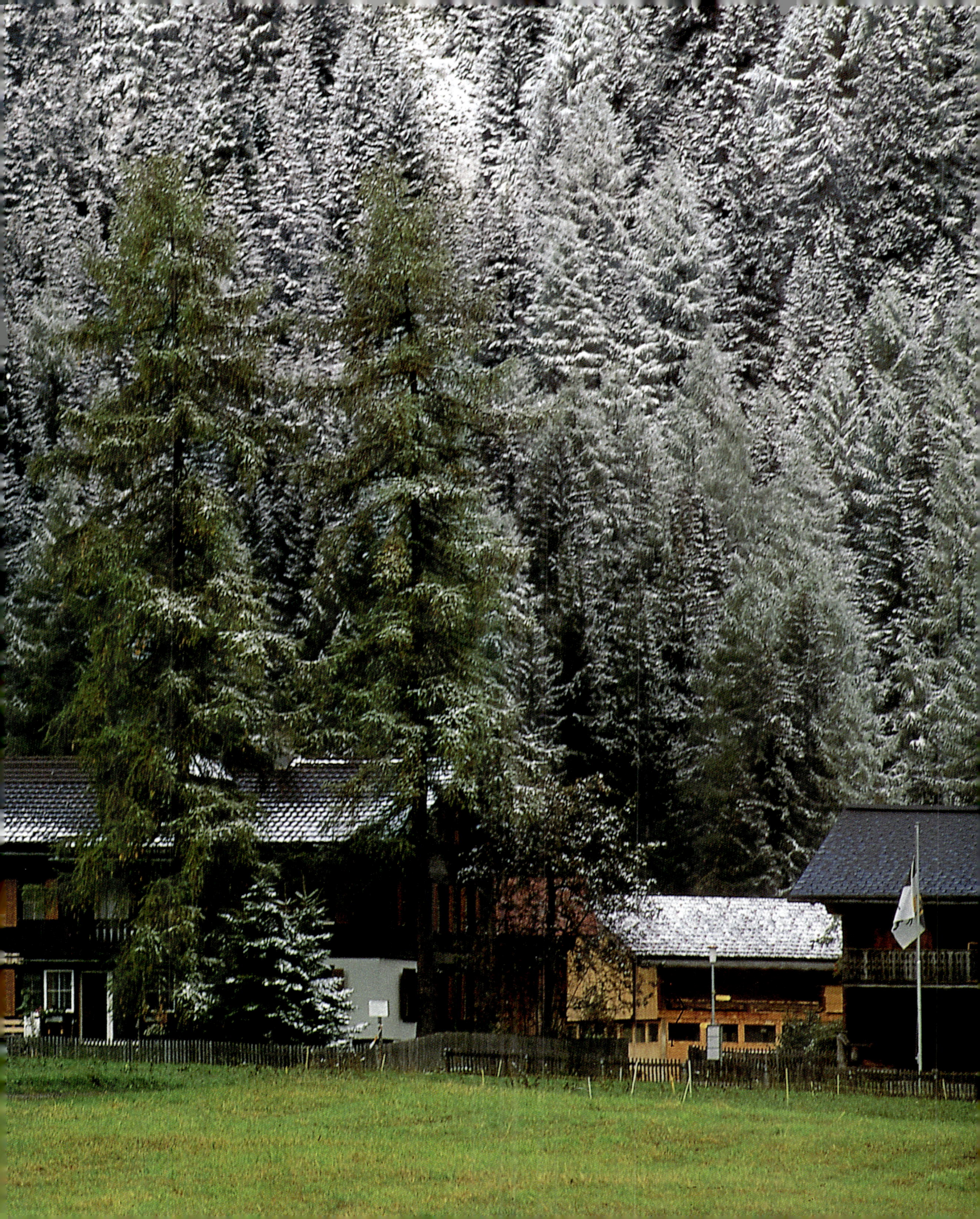

In the valleys where time has stood still

90-91 *Switzerland's cheeses are among the world's finest dairy produce, with an assortment including Emmental and Gruyère with their unmistakable holes (Gruyère's are smaller), soft Vacherin, Appenzeil, Sbrinz and Rebrochon. The rich, creamy milk of Swiss cows does much to ensure their high quality and delicious flavour. Only chocolate can compete with cheese for first place among Switzerland's most emblematic - and almost legendary - products. And in the case of mountain cheeses, it is the fact that they are made on the spot, using time-honoured methods, that guarantees their superb quality.*

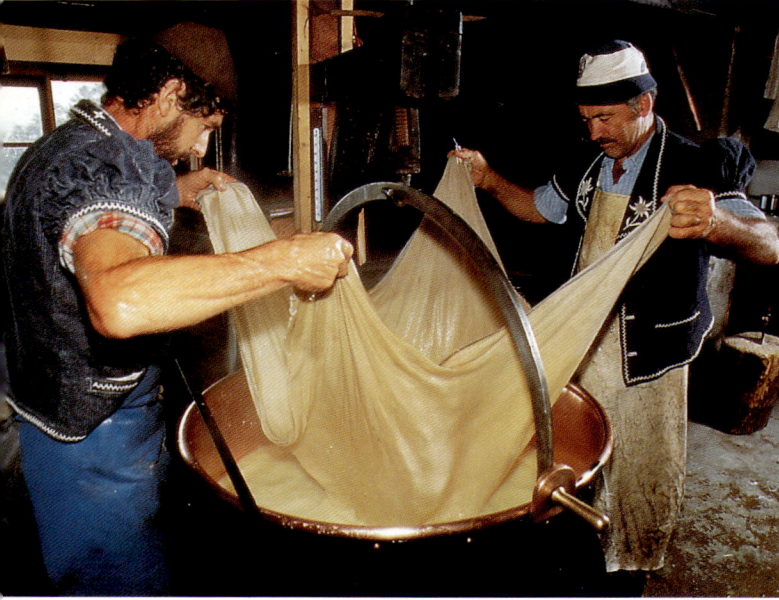

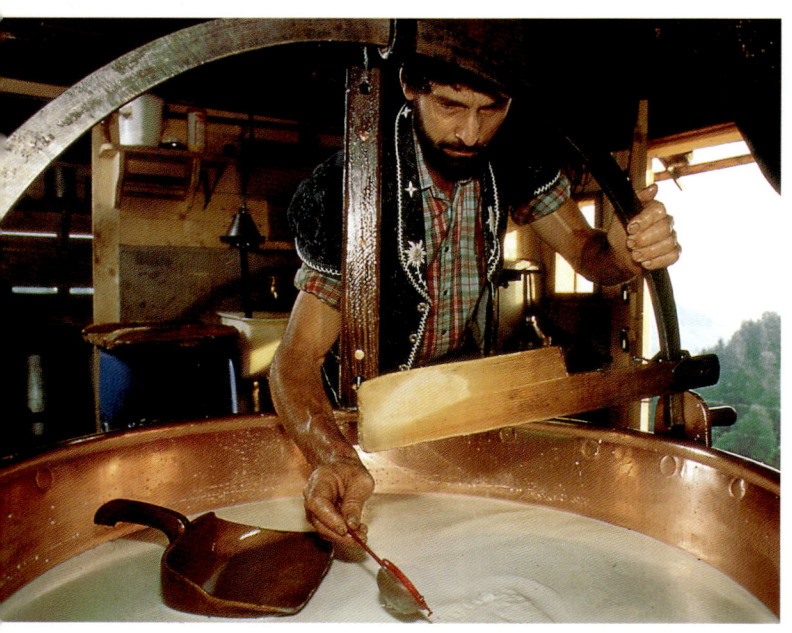

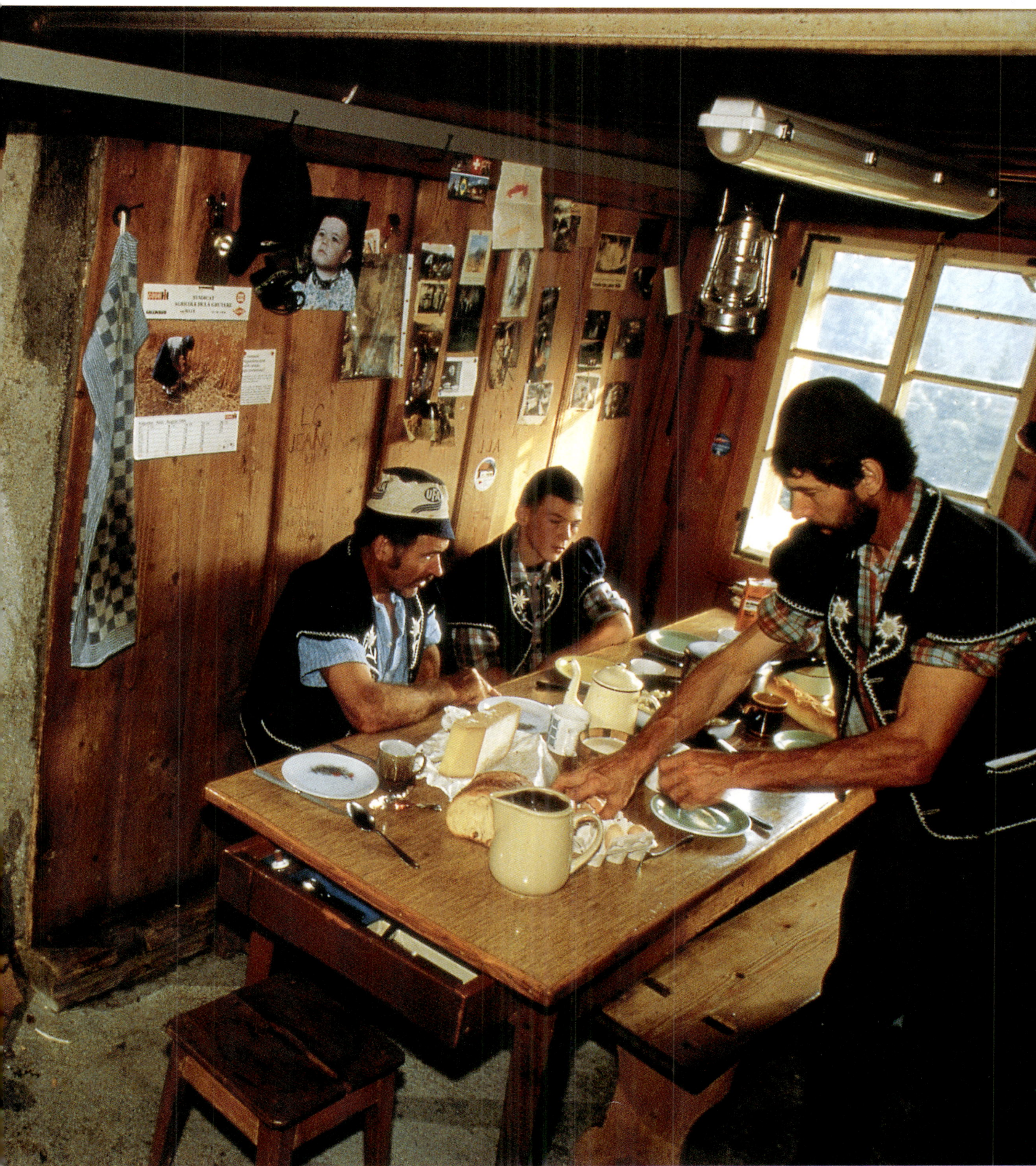

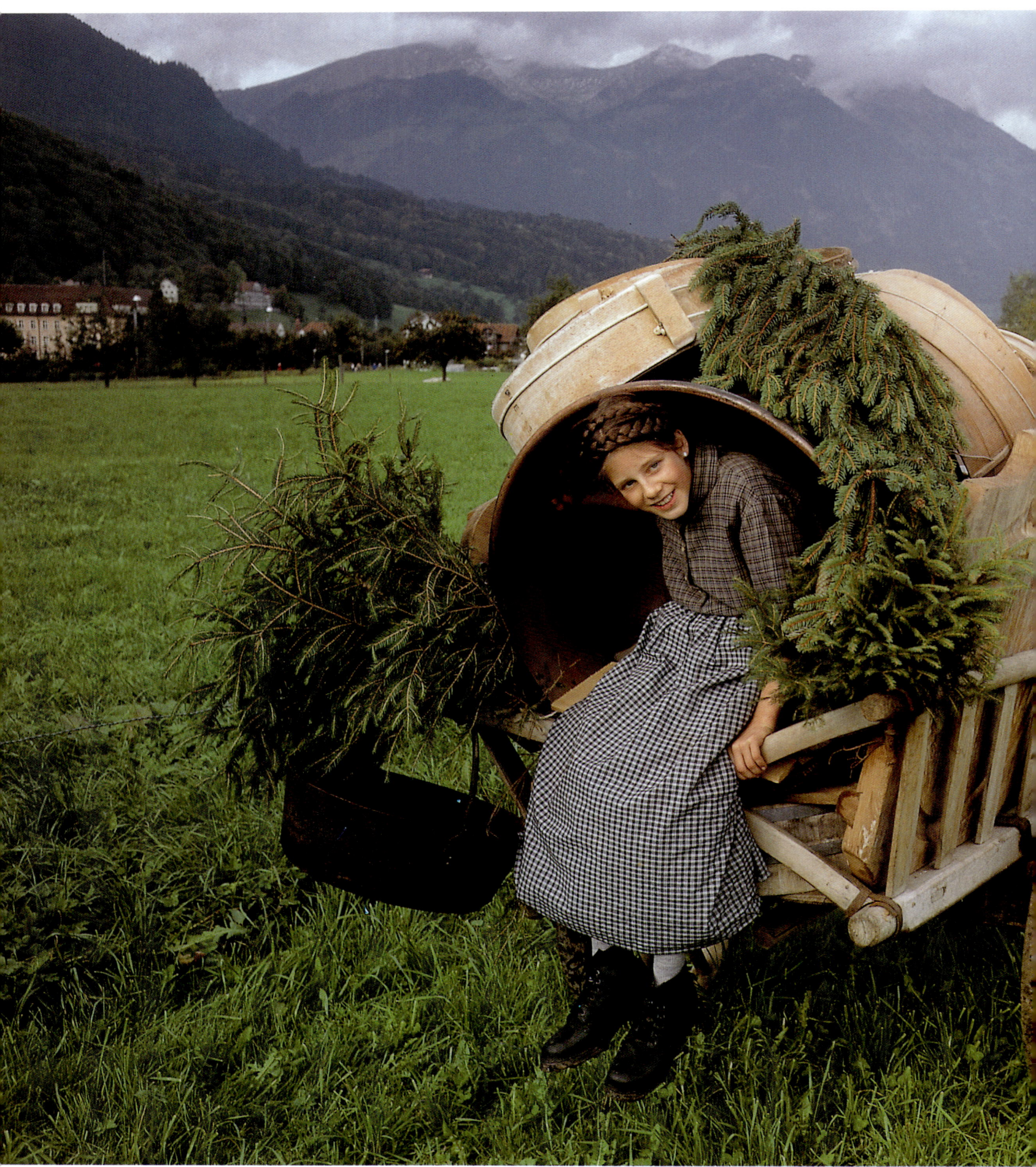

92-93 The first snowfalls on the highest pastures, at the end of summer, mean it is time to take the herds down to the valley. Herdsmen return to their villages after several months' absence and the occasion is celebrated in grand style. Elegant head-dresses are worn for the festivities, the cattle are "dressed up" too and villagers parade through the streets to the clanging of loud bells. And no such scene would be complete without the band, dancing and a lavish feast.

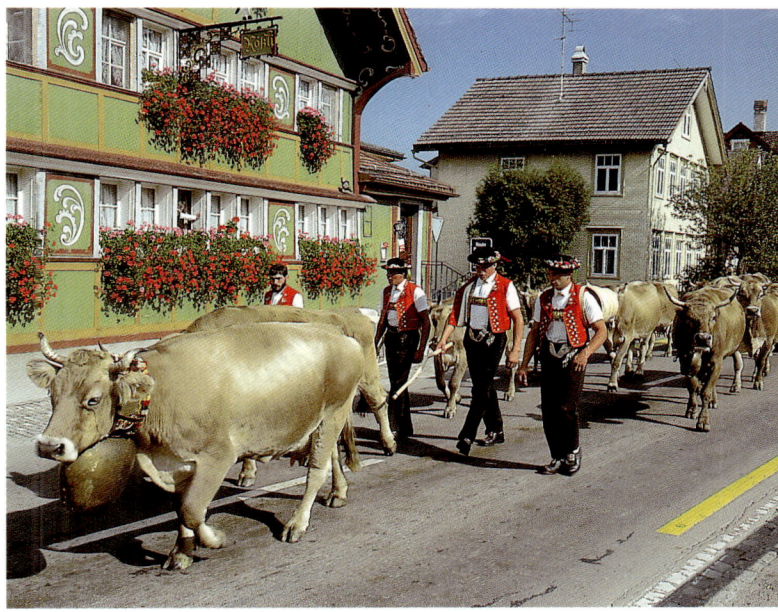

94-95 Splugen, and the village of San Bernardino, are closely connected with the history of the "via Mala", a mountain road which the Romans succeeded in building in spite of impervious gorges and other natural obstacles. As early as the 5th century the road was used by German merchants travelling to Lombardy. The San Bernardino pass was also opened, linking the Rhine valley with Val Mesolcina, now in the Ticino canton. In recent years Splugen has developed into a thriving tourist resort, popular with both the Swiss and Italians (also on account of its closeness to the cities of Northern Italy).

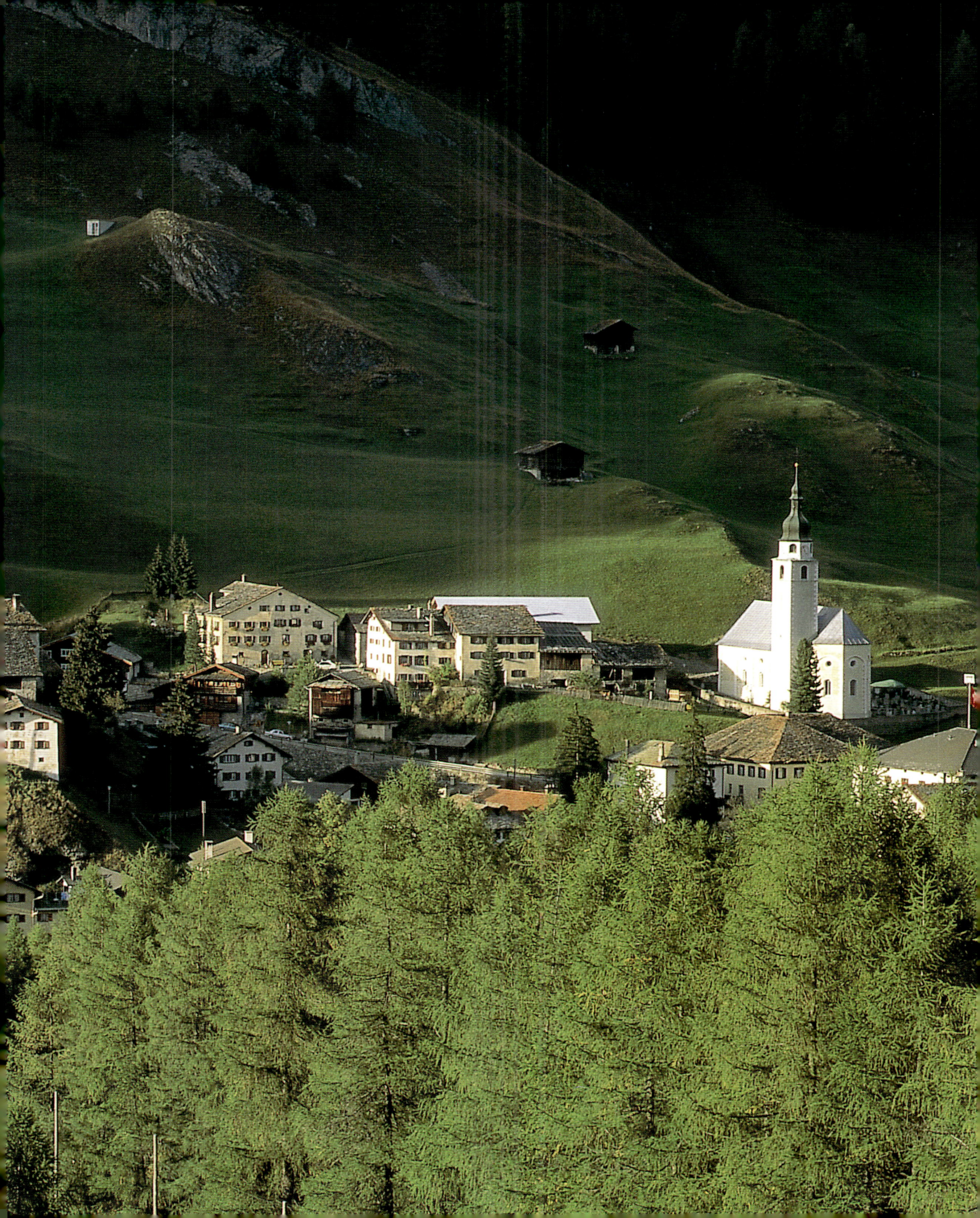

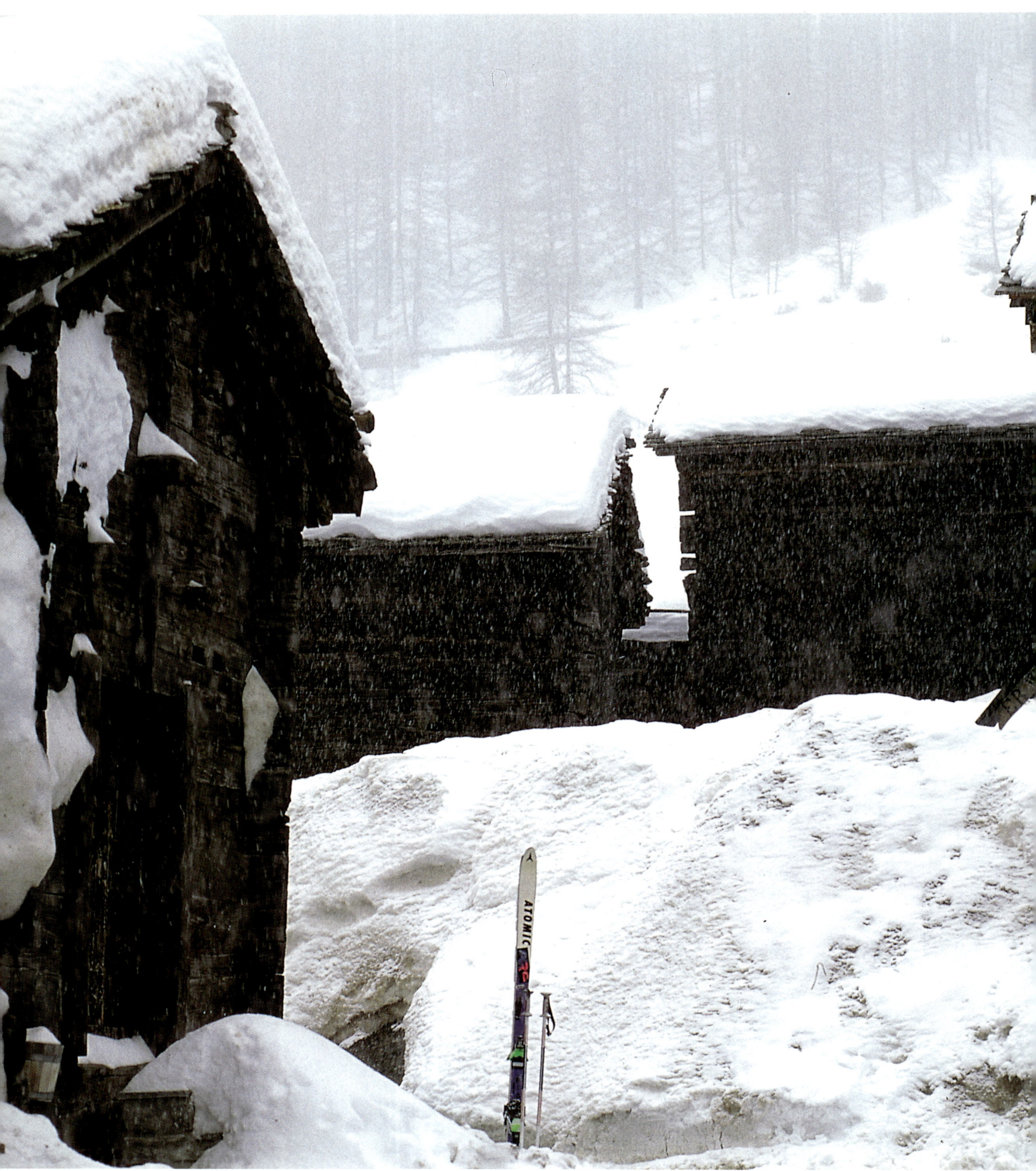

Discovering Walser country

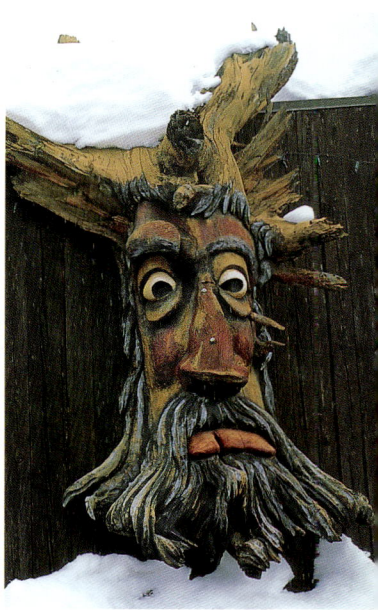

96-97 *As long ago as the 7th century, the forefathers of the Walsers were forced by economic and social difficulties to leave the Valais (German: Wallis) region and emigrate to other parts of Switzerland as well as Italy and Austria. The most numerous group settled in the Graubunden region, where between 30,000 and 40,000 Walsers still live today. Through the centuries they have preserved much of their culture: the Alemannic language, rural traditions, strong bonds with*

nature, profound Roman Catholicism, craft skills and a distinctive approach to building which is both original and functional. To keep rats out of their homes and create a healthier living environment, they learnt to build houses on piles made from tree-trunks, with pieces of wood projecting horizontally. Several Walser houses can be seen in Saas-Fee (shown in this photograph): this small, tranquil town where cars have long been banned has all the charm of other, more celebrated tourist resorts. Carved from the wood of the tree-trunks and here painted red, black and blue are grotesque masks which, according to ancient pagan beliefs, drive away the forces of evil and protect against misfortune and illness.

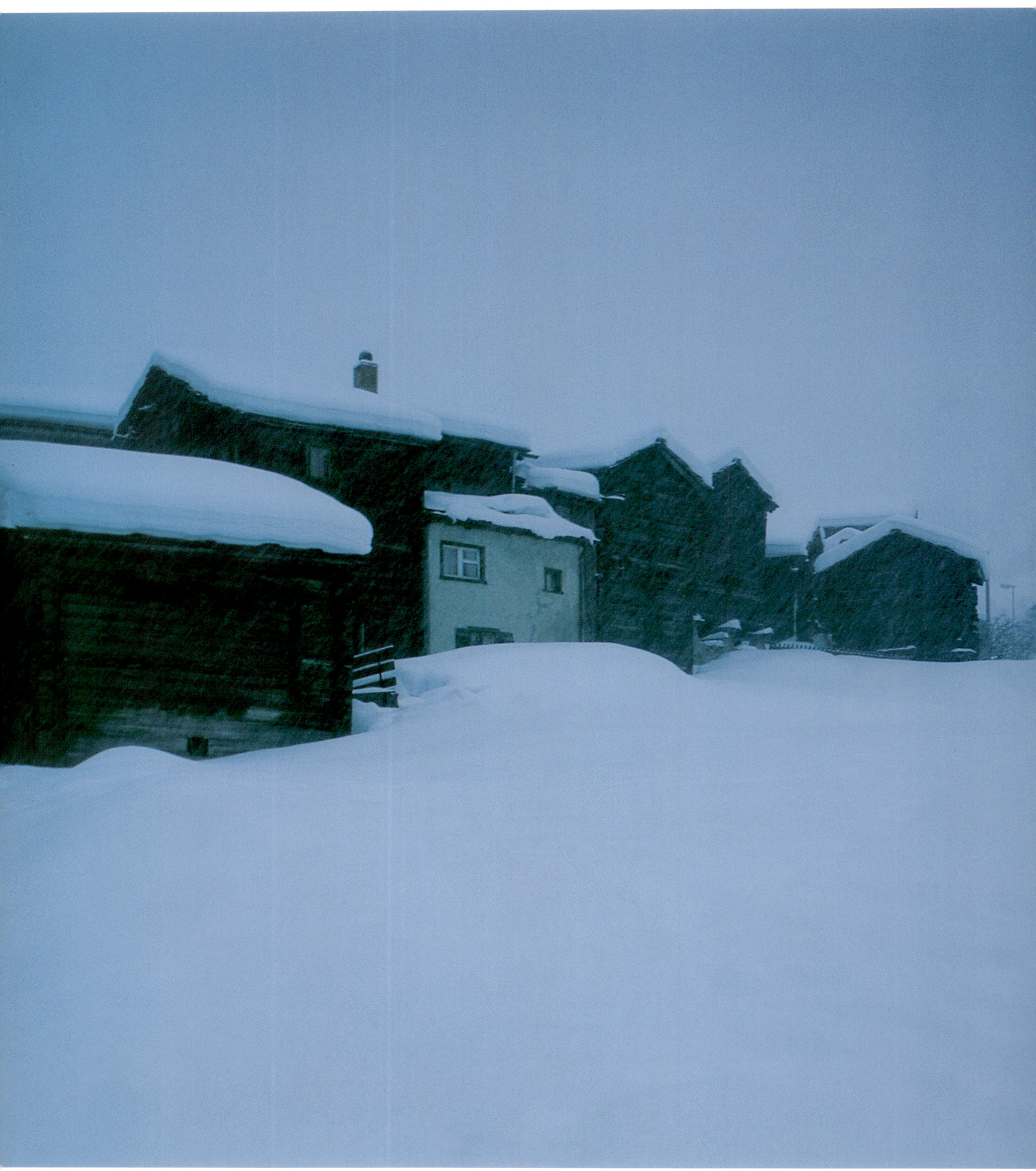

98-99 *The small Swiss town of Zermatt lies at the far end of a deep valley, encompassed by the massifs of Monte Rosa, the Breithorn and the awe-inspiring Matterhorn; it is a well-known tourist resort, packed with hotels catering for the seriously rich as well as for vacationers with smaller purses. Away from the main thoroughfare, however, the narrow side streets, flanked by wooden Walser chalets with slate roofs and dotted with stone fountains, are still an oasis of peace and quiet.*

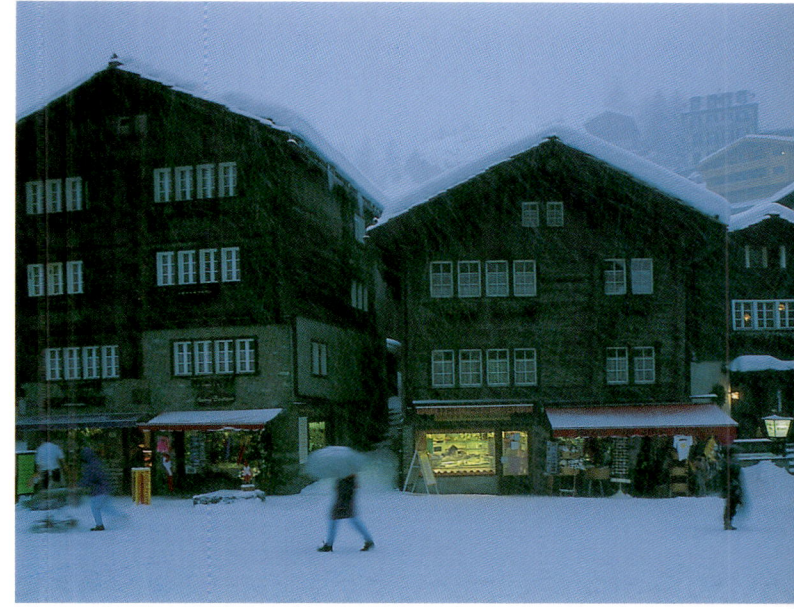

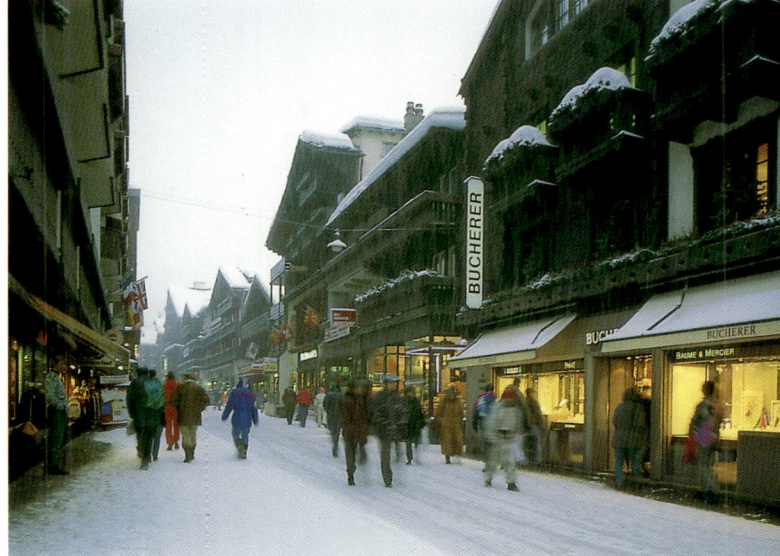

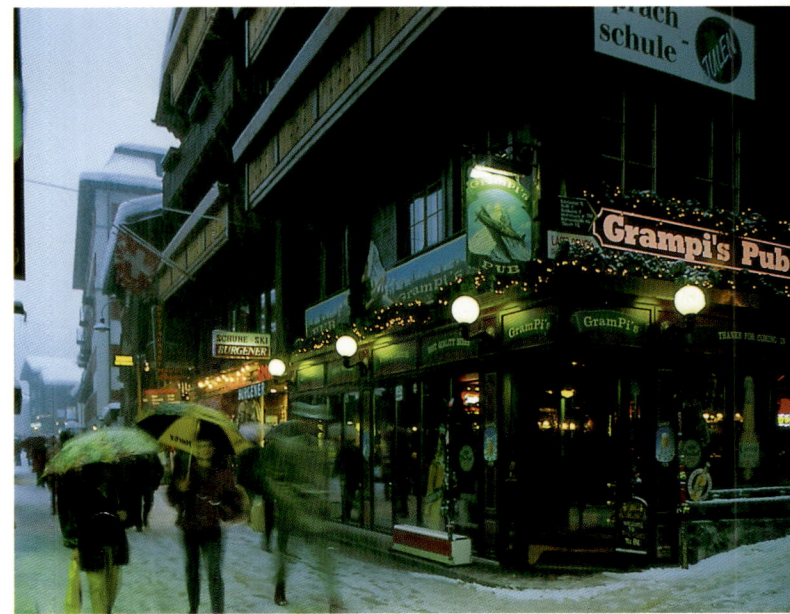

A tourist's paradise

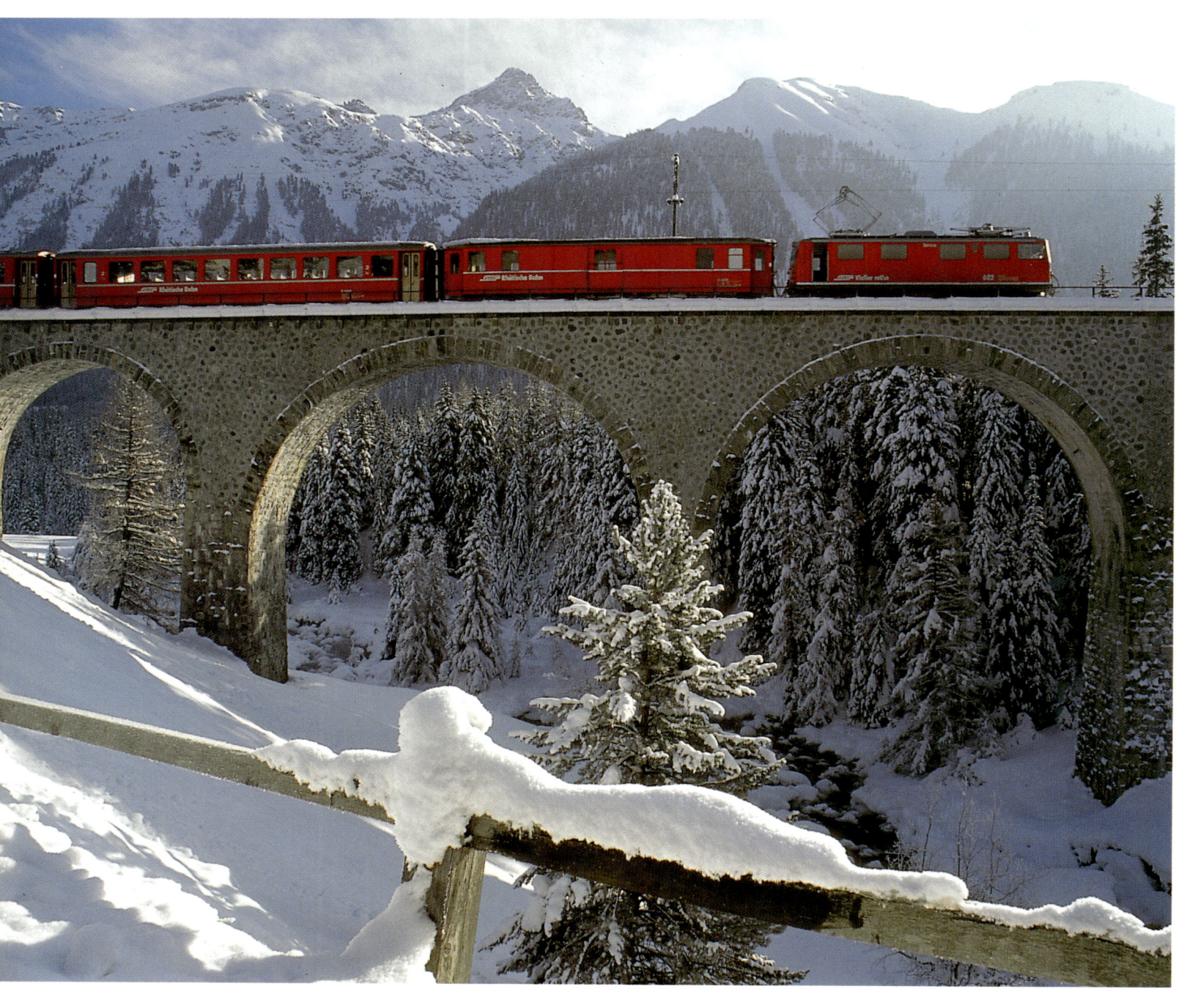

100-101 *All aboard! We're off!
Travelling on the Bernina Express past
soaring Alpine peaks and across broad
valleys scattered with churches, castles
and waterfalls is - still today - an
exhilarating experience.
The line connects Chur with Tirano, in*
*Italy, and the journey lasts about 4
hours. On the stretch between Bergun
and Preda the train copes with a
gradient of about 1,378 feet and
travels through 5 twisting tunnels
(2 natural, 3 man-made) and 9
viaducts.*

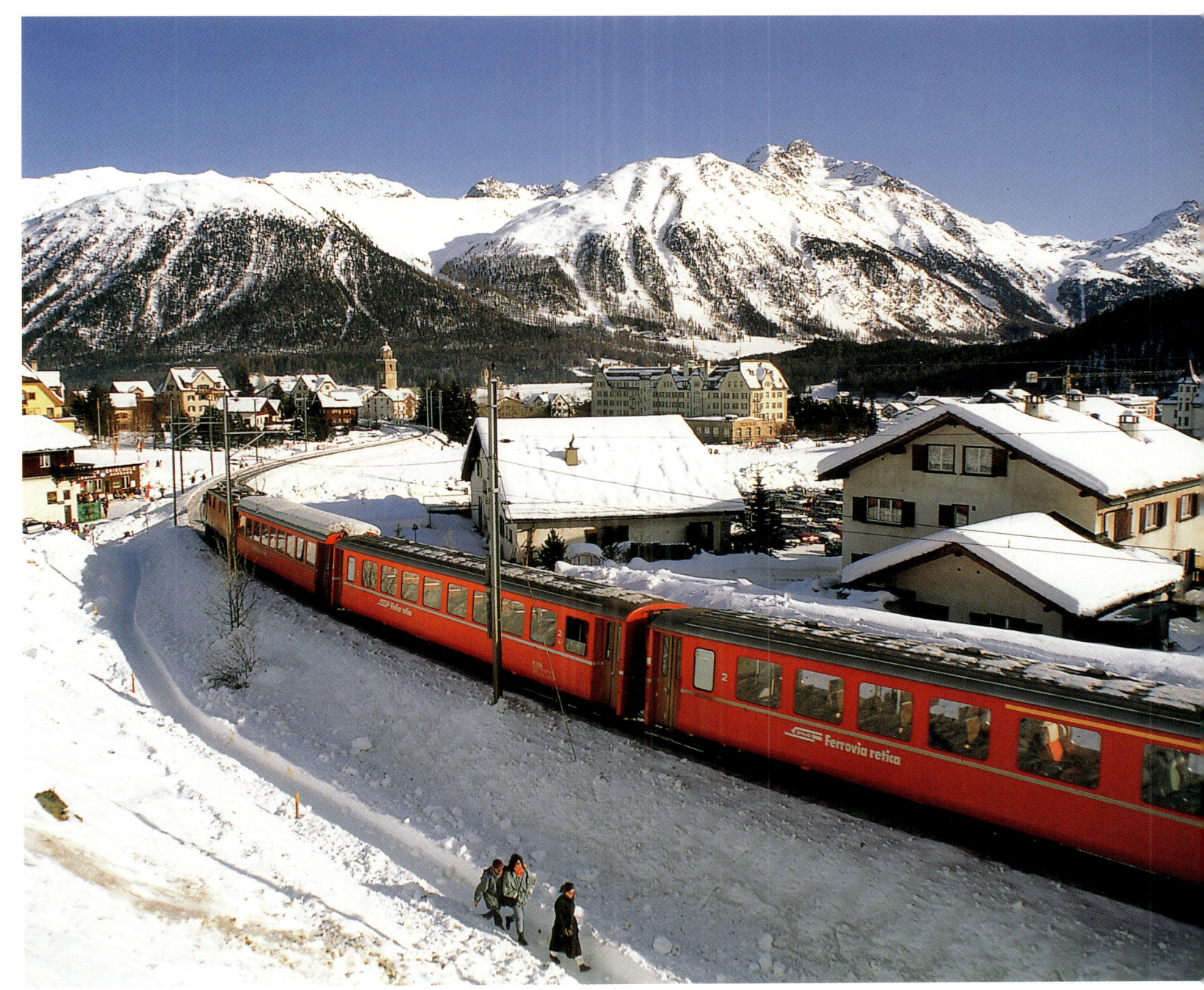

102-103 *Elegant, upmarket St.Moritz in Engadine is an élitist holiday destination. But as well as its luxury hotels and trendy designer stores, this famous resort offers every kind of sporting activity: downhill pistes, cross-country skiing trails (including a magnificent one across the huge frozen lake), bobsleigh runs and skating for winter sports enthusiasts, tennis courts and golf courses for summer visitors.*

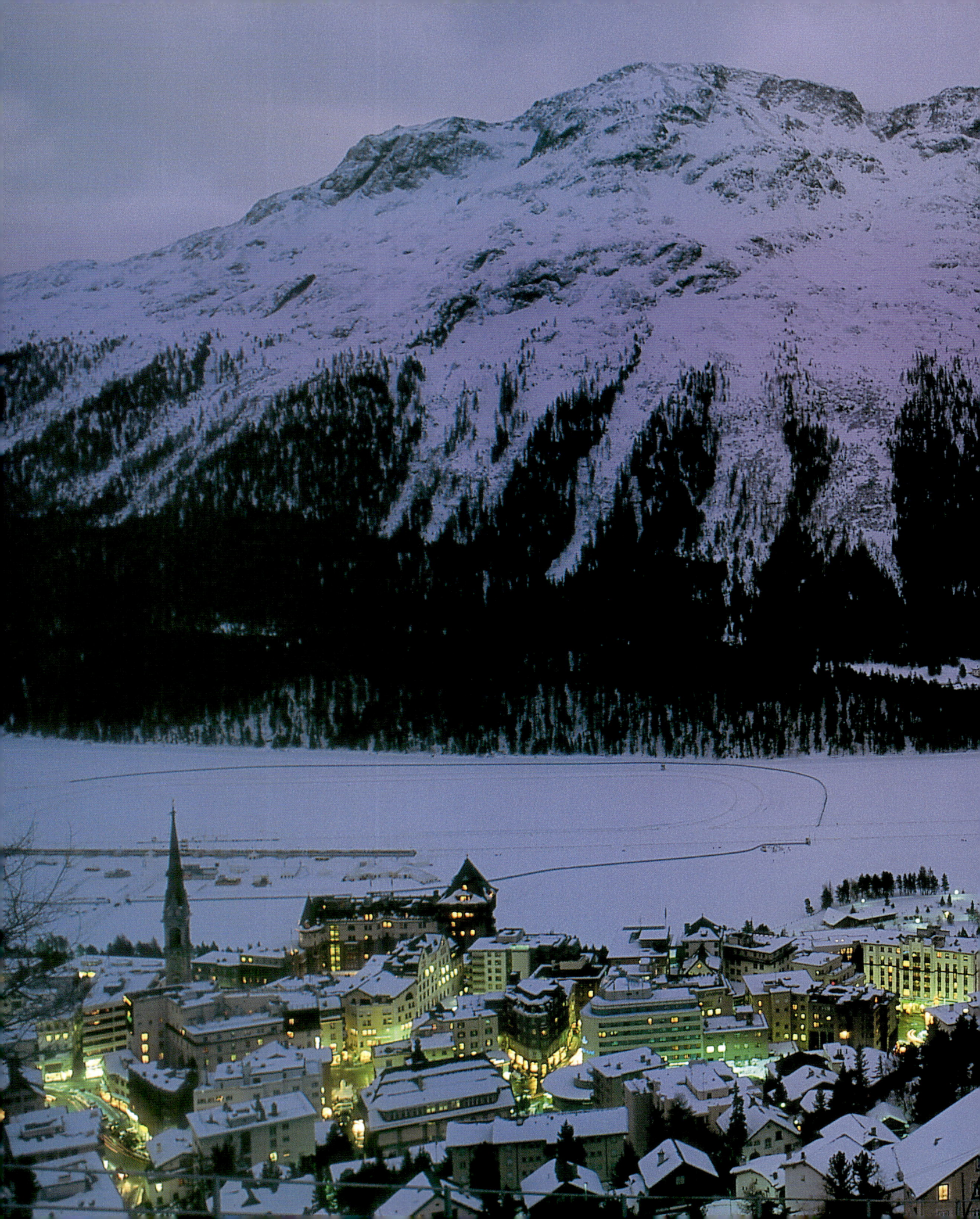

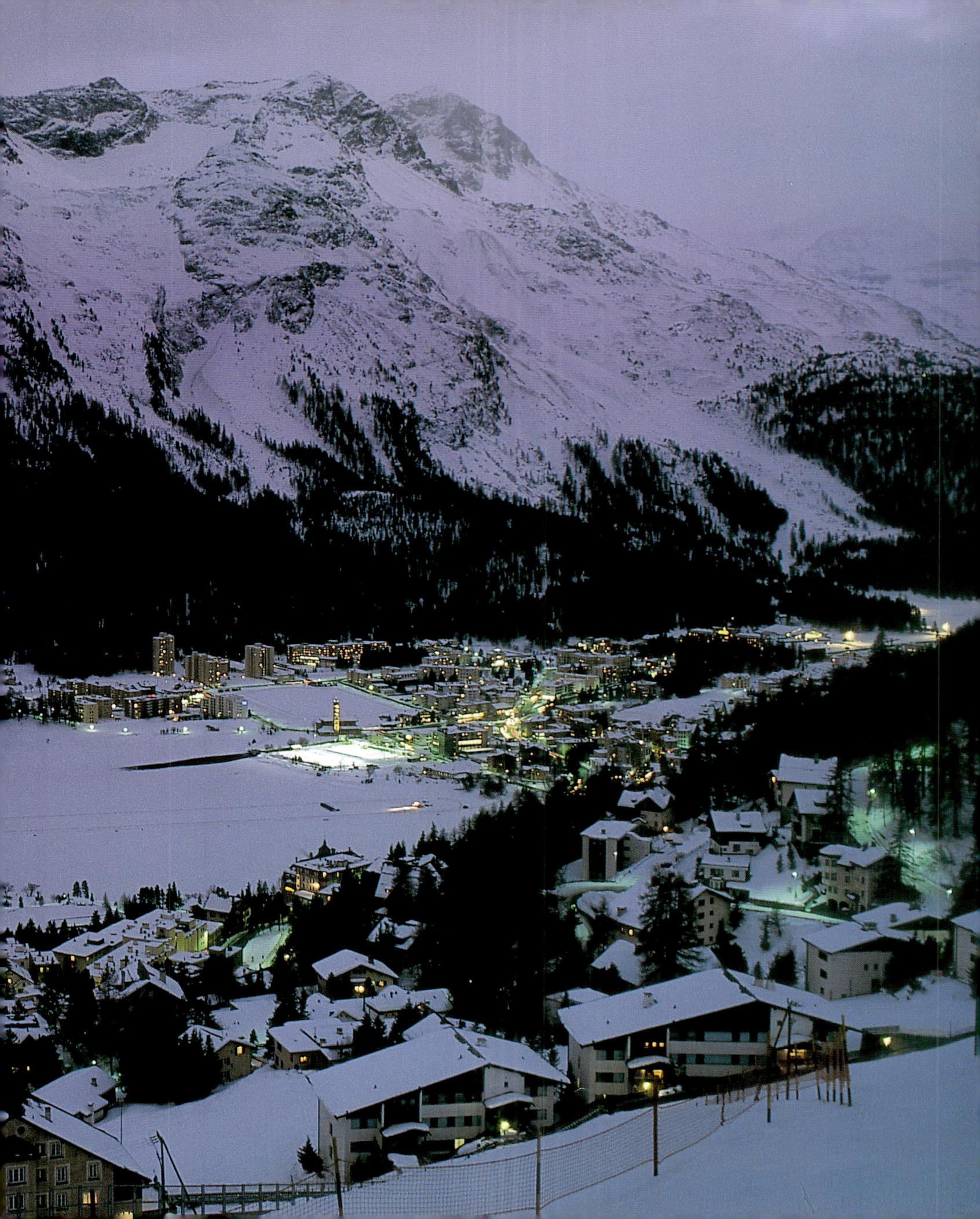

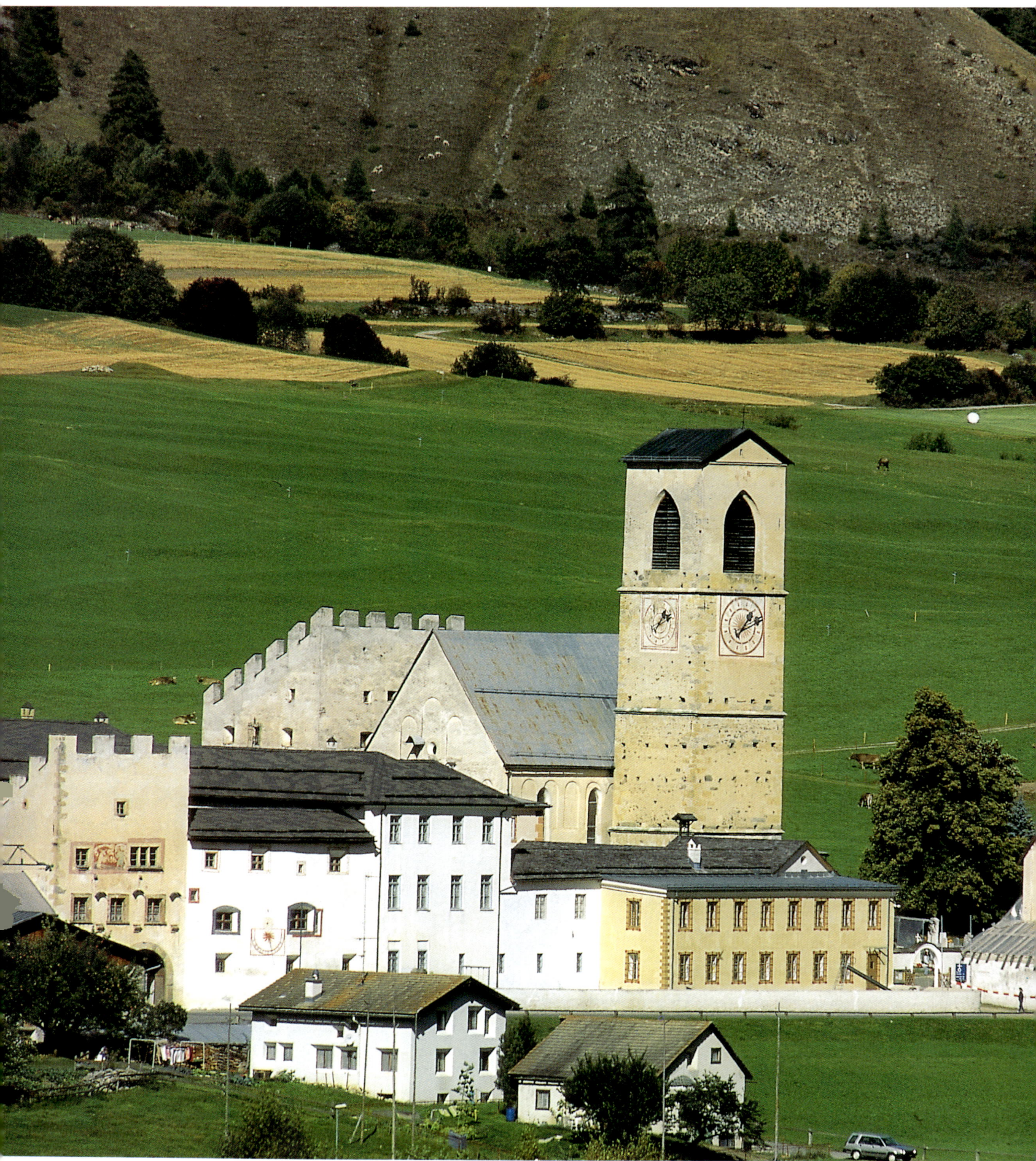

104-105 *According to legend, in the 8th century Emperor Charlemagne passed through Mustair, a village close to the border with Italy, and founded a monastery there which, in 1163, became a convent for nuns. It consists of a small group of buildings arranged around two courtyards and protected by turreted walls. The church, of Carolingian origin, was altered several times in the Gothic and Baroque periods. Its campanile is a sturdy square tower, built in the 15th century. The spacious interior has a nave and two aisles, with slender columns which open out into the ribbing of the vaults. Lining the walls are frescoes depicting the Life of Christ, Prophets, Apostles and the Last Judgement.*

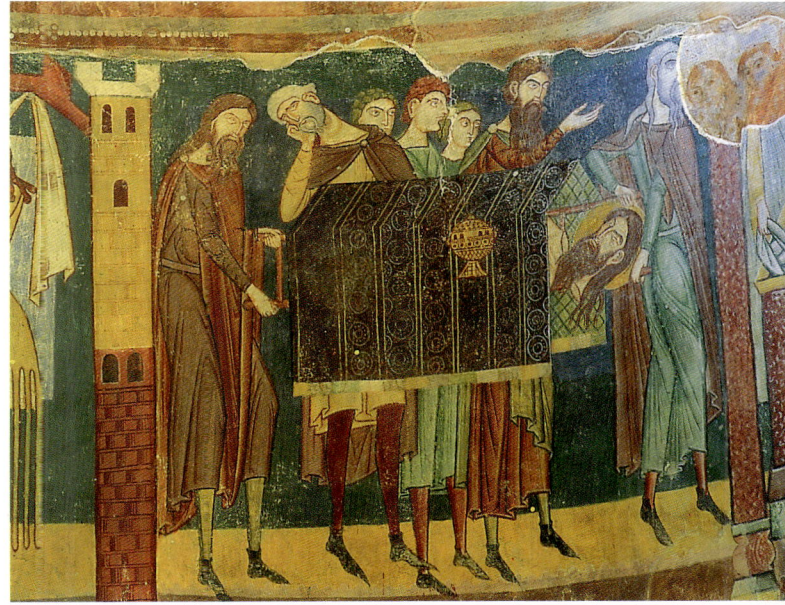

106-107 *On a rocky island near the shores of the lake Geneva stands Chillon Castle, its separate square tower keeping watch over the lake; it is connected to the mainland by a 19th-century covered bridge, once a drawbridge. From the lookout points along the parapet there is a splendid panorama.*

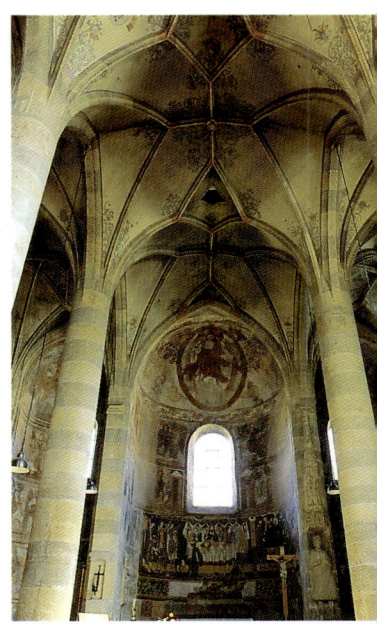

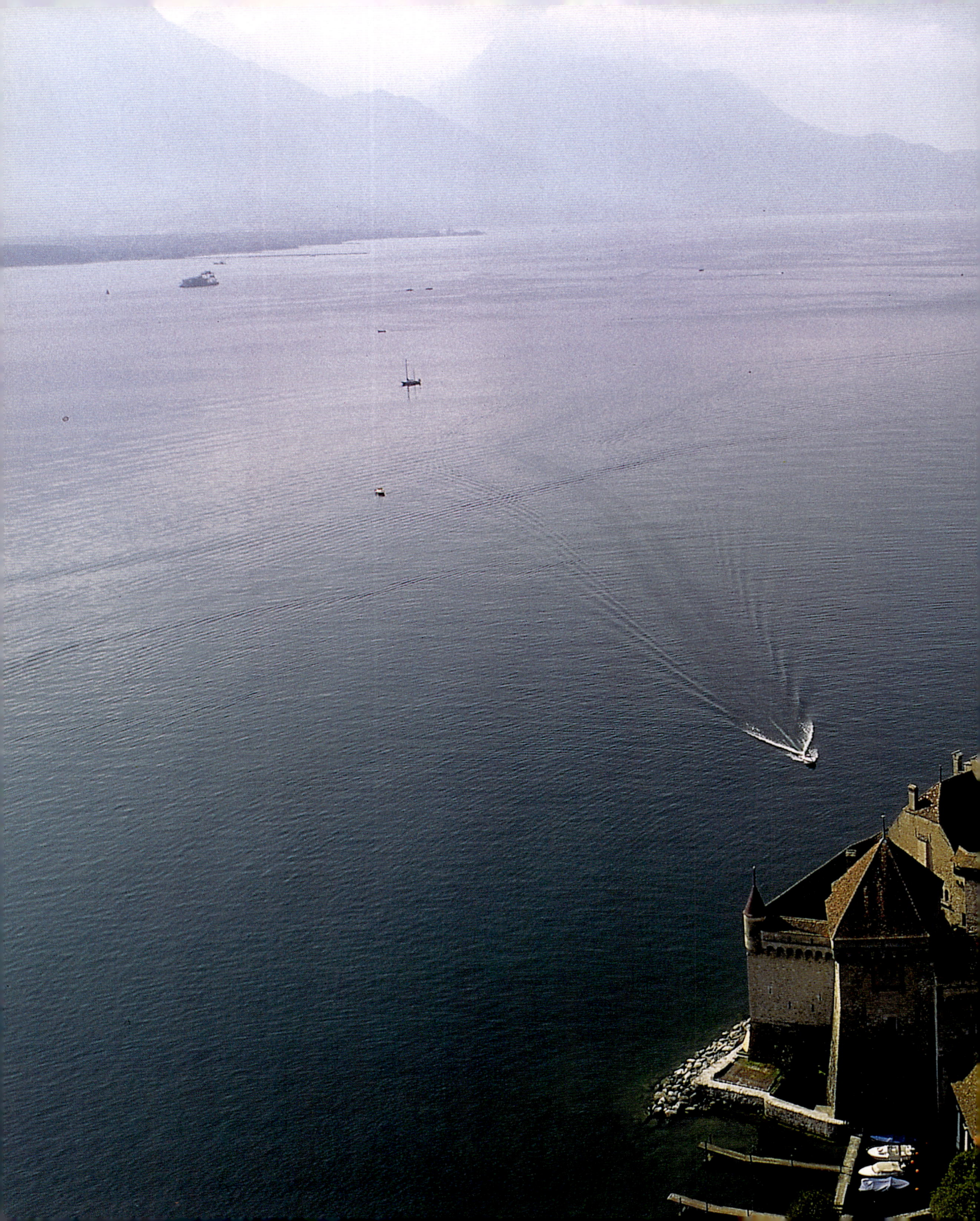

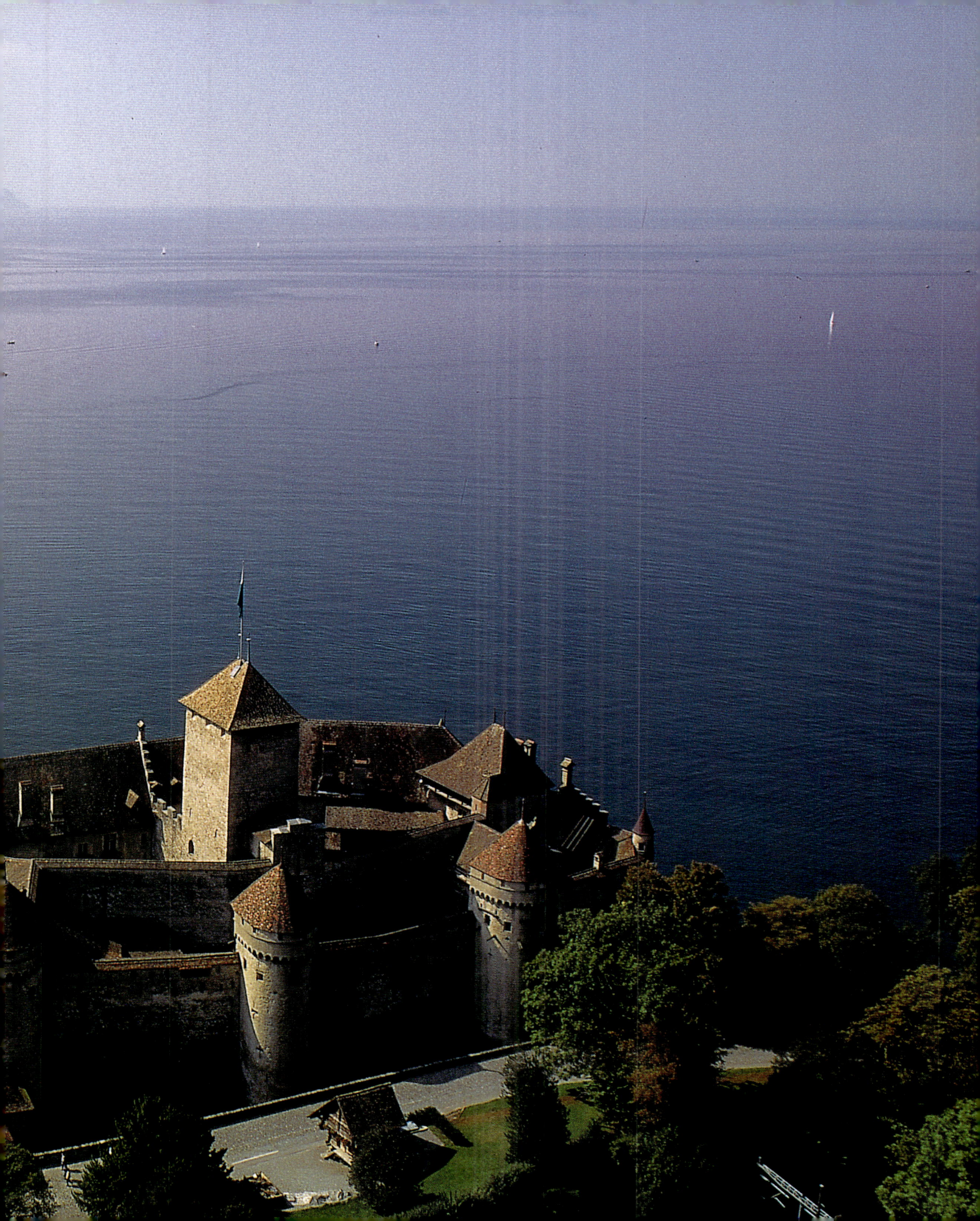

At the heart of Switzerland, past and present

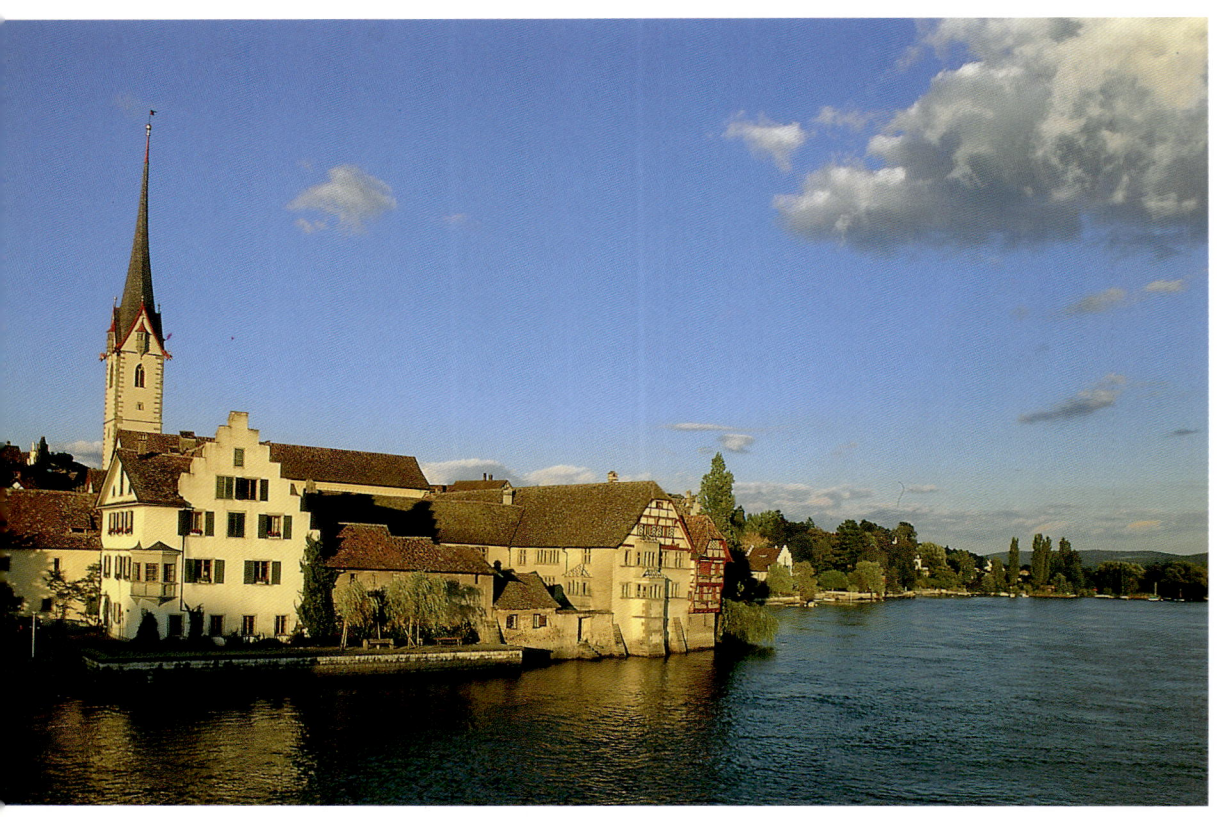

108 top *The picturesque medieval town of Stein am Rhein boasts charming old houses with frescoed walls and attractive bay windows; it is situated on the right bank of the Rhine, where the river leaves the Untersee basin of Lake Constance.*

108 bottom *The countryside around Lake Geneva has always been used as arable land: thanks to the mild climate, vines and - as the photo shows - tobacco are both crops that flourish here.*

109 *Thun the 12th-century castle stands high above the town and its lake. With its imposing corner towers its architectural style recalls that of a Norman keep.*

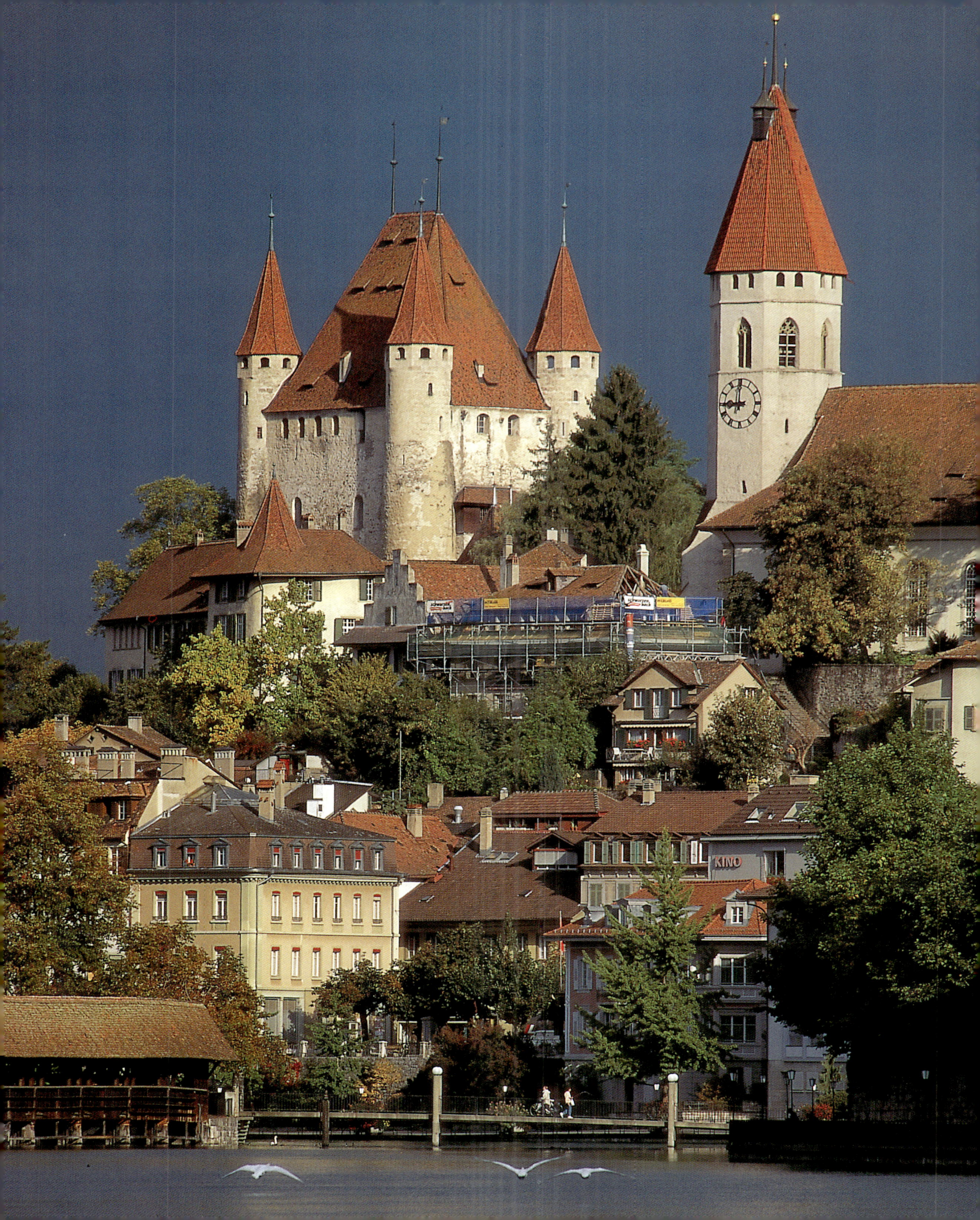

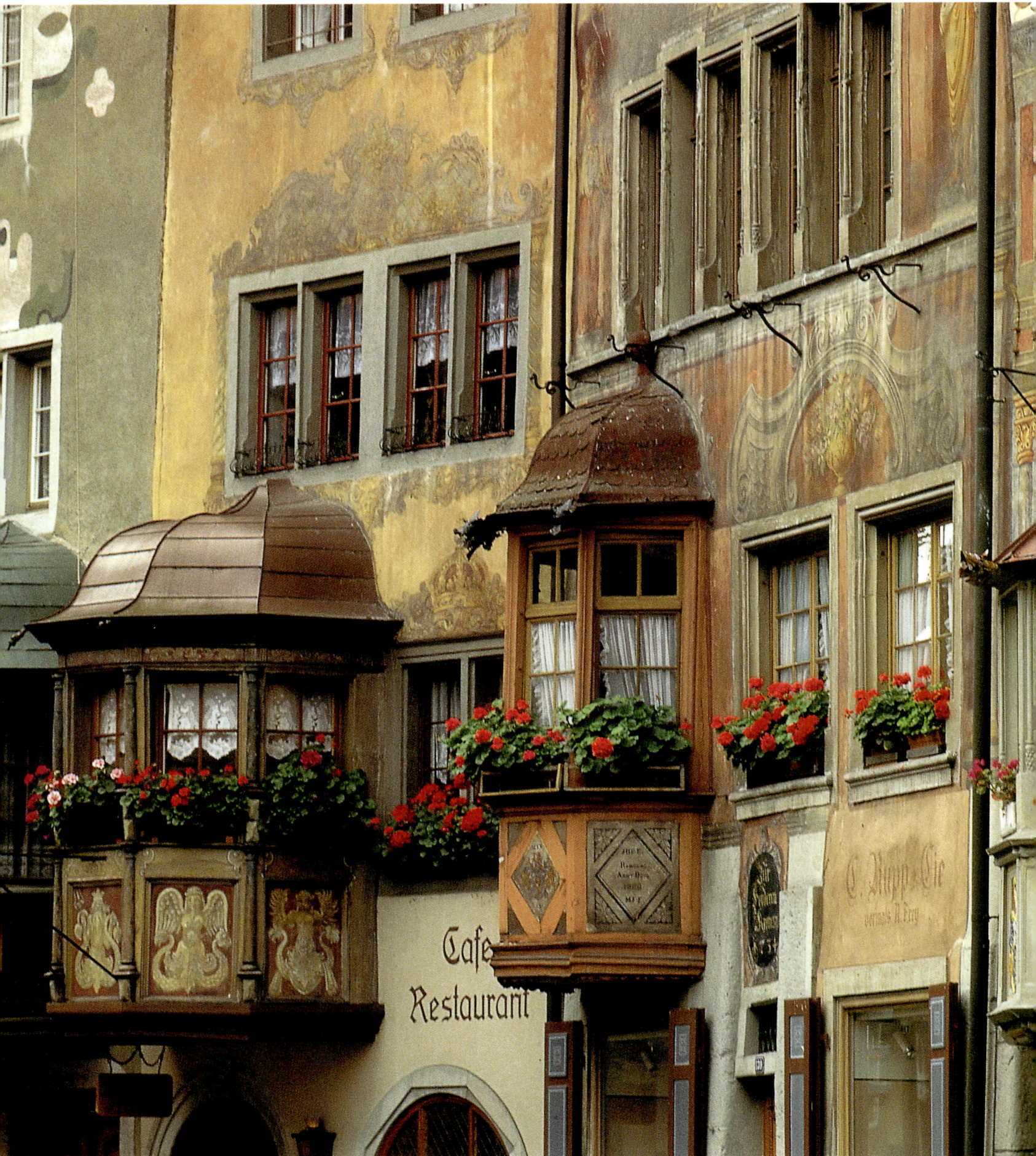

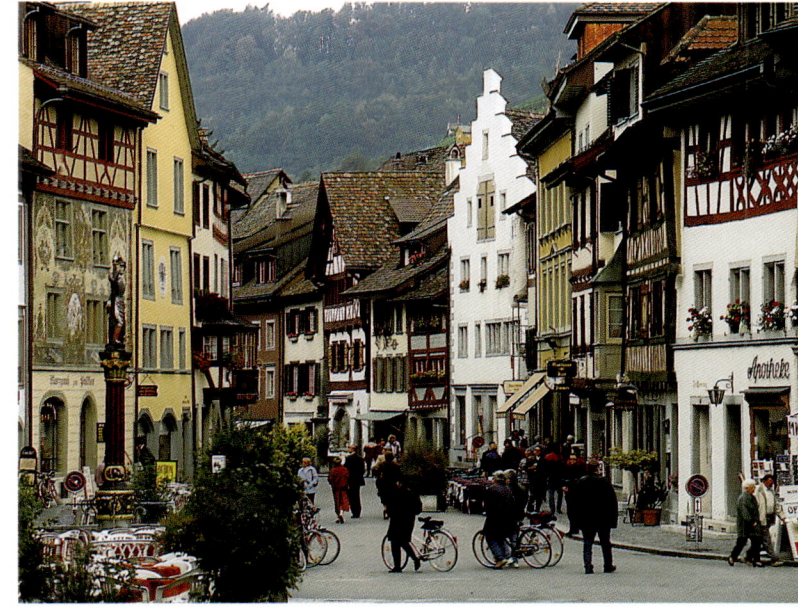

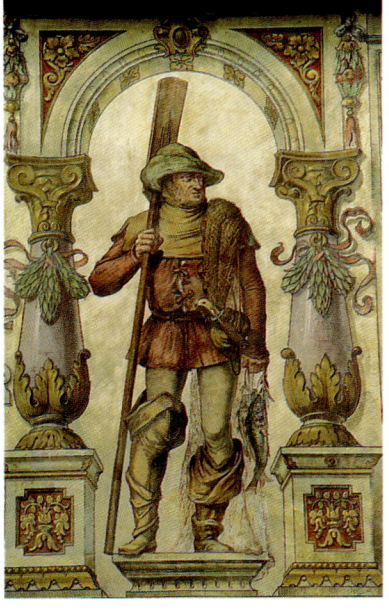

110-111 *Flowers, gay colours, overhanging windows, wood decorations applied to shining white walls and façades painted in the local style: the buildings of Stein am Rhein do much to create the pleasant atmosphere that pervades the town. The loveliest house of all is undoubtedly the Haus zum weissen Adler, frescoed in 1520-25 by Thomas Schmid with allegorical scenes and tales from the Decameron.*

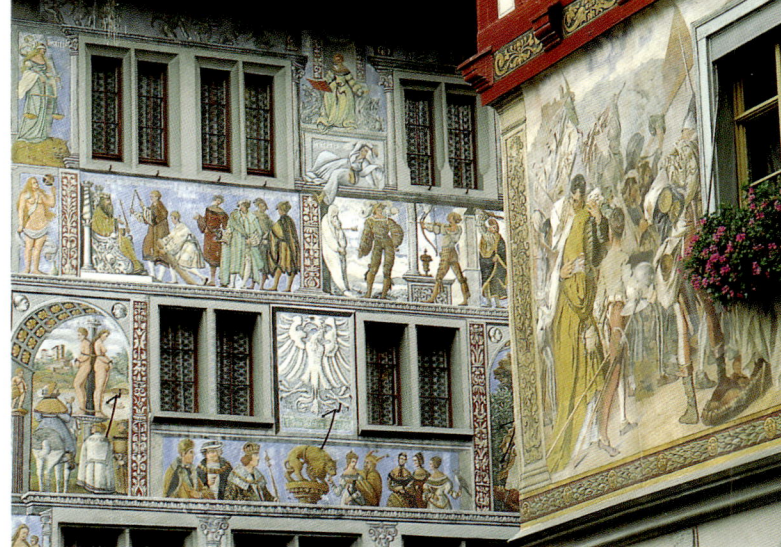

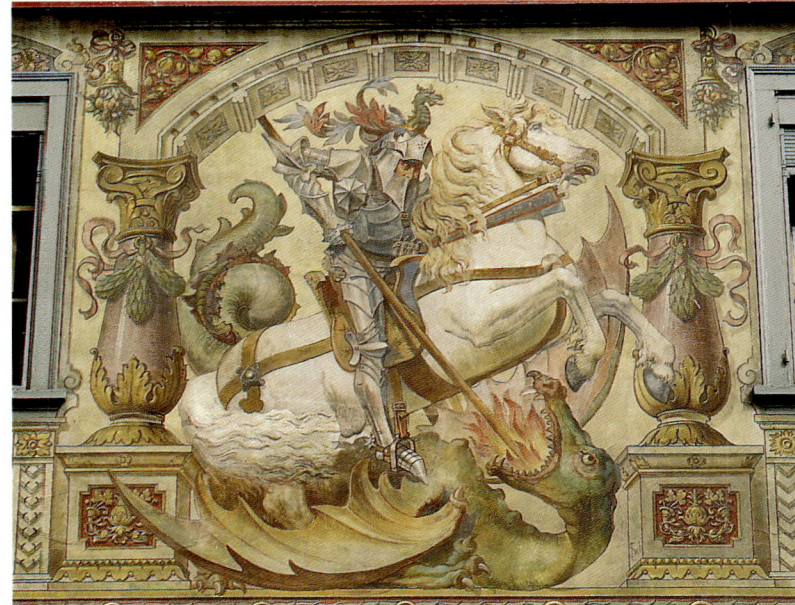

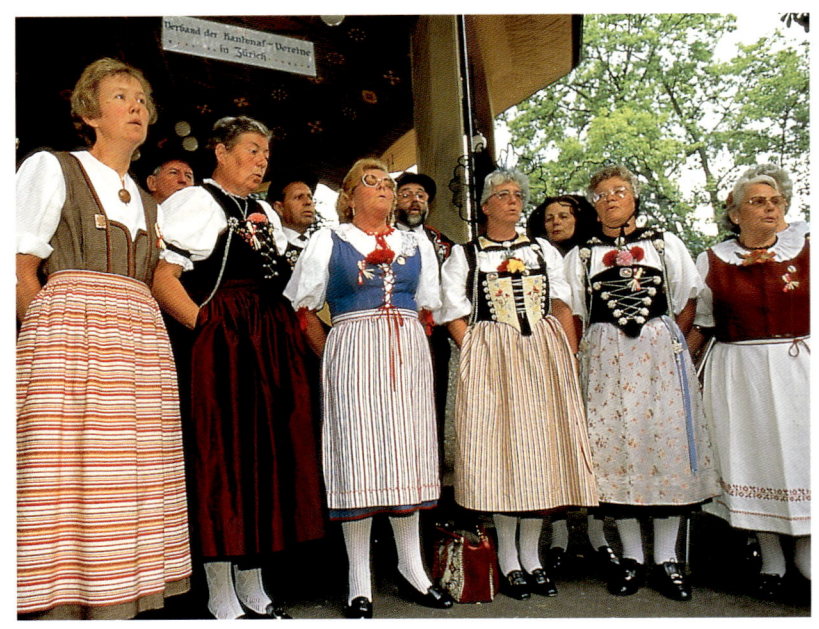

112-113 *Zurich, situated in the heart of the Germanic cantons, is one of Switzerland's most culturally vibrant cities. The local ethnic heritage is very much alive here as can be seen, for instance, from the characteristic costumes, folk dances and typically Alpine choral singing during festivities held on August 1st, and again during the Sechselauten festival in spring, when people dress up in costume to commemorate episodes from Zurich's history.*

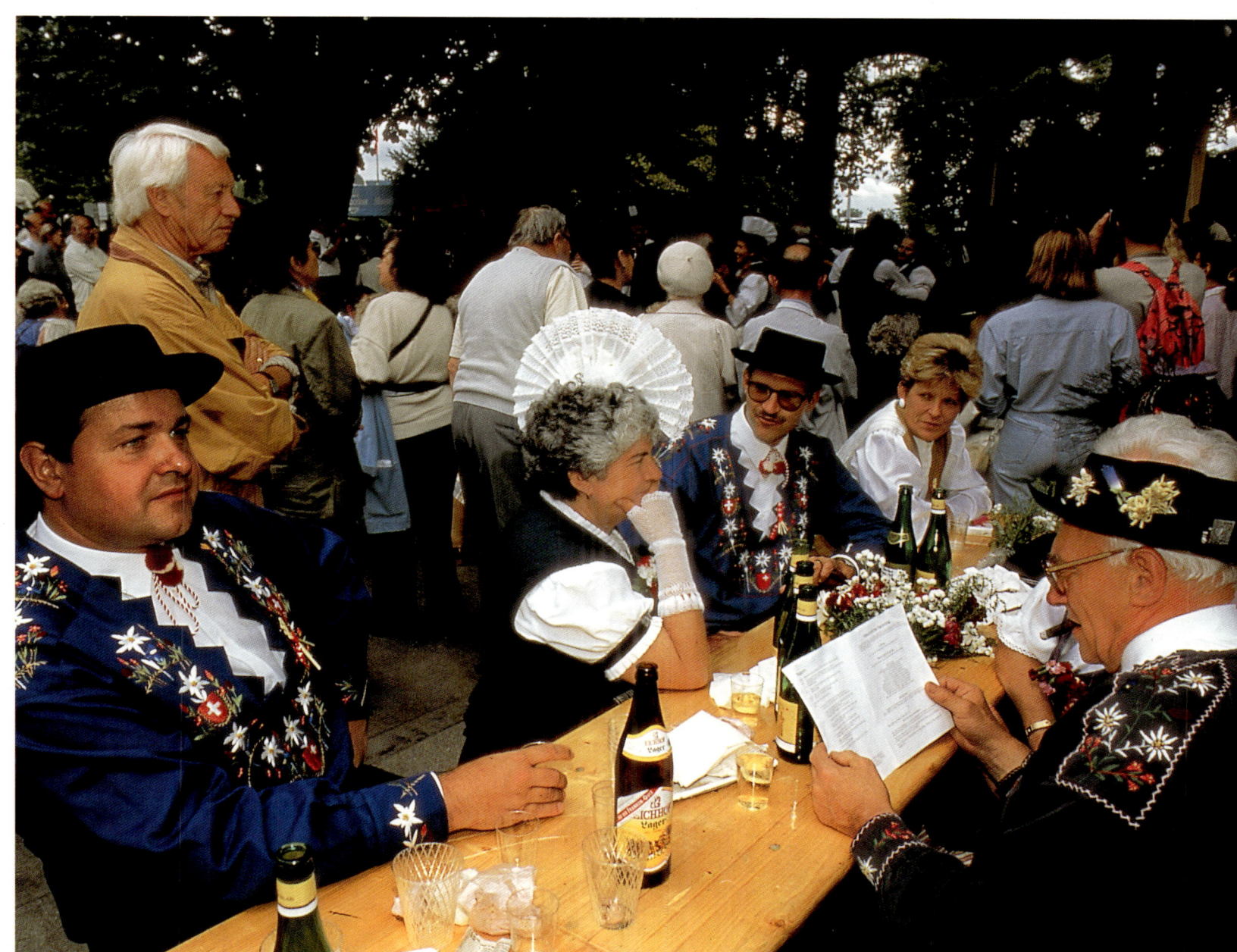

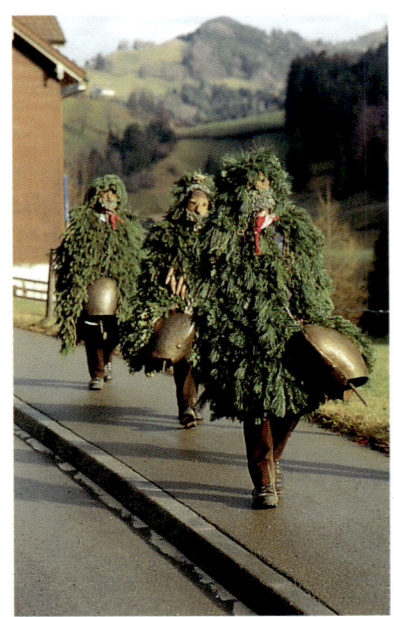

114-115 *Just a few miles from Austria, Urnasch owes its fame to the New Year procession held - in accordance with the Gregorian calendar - on January 13. A procession of people wearing leafy branches of trees and grotesque masks (Silvesterklause) inspired by rural life, winds its way through the streets of the town, to the accompaniment of an infernal noise made with the huge cow bells hanging around their necks.*

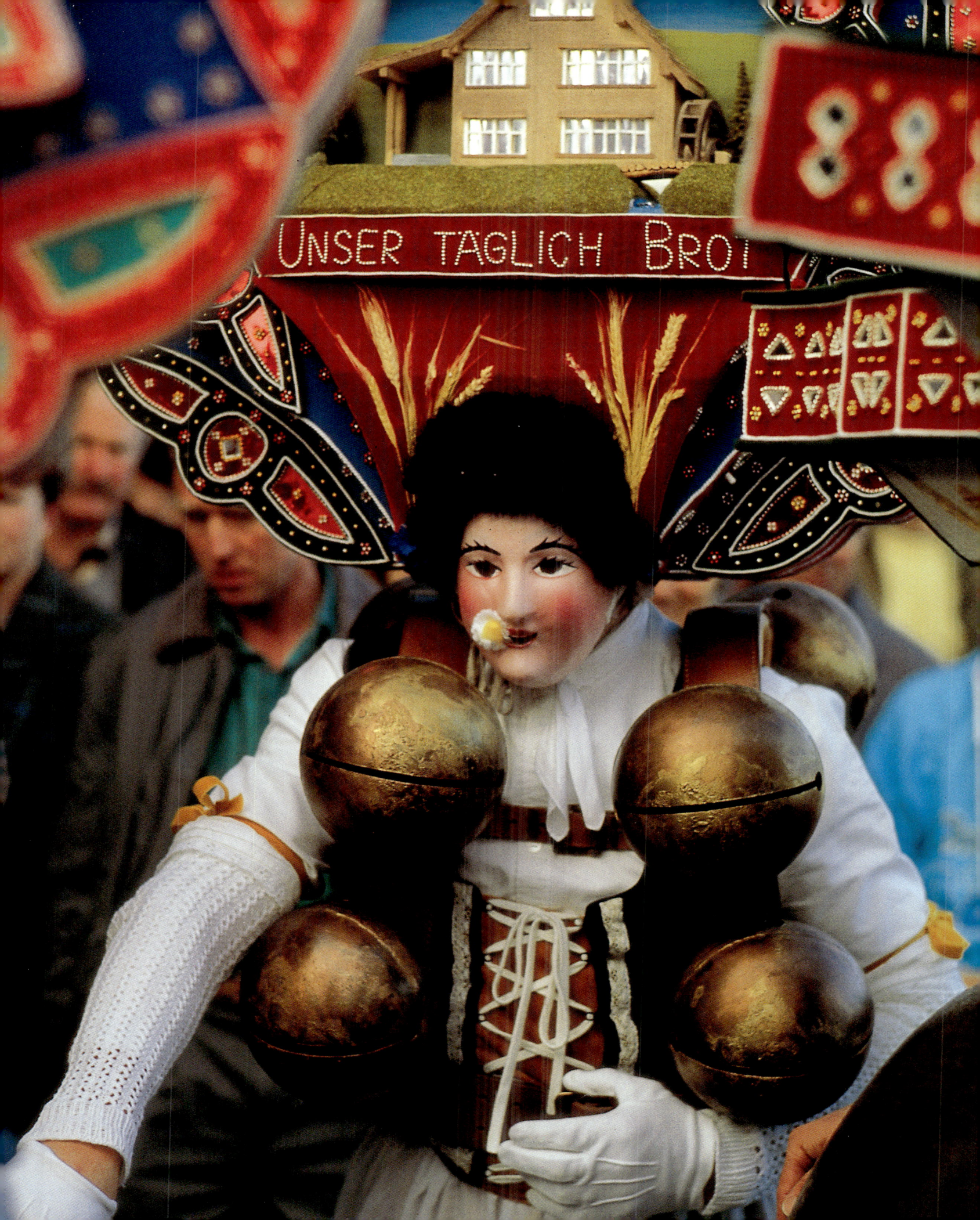

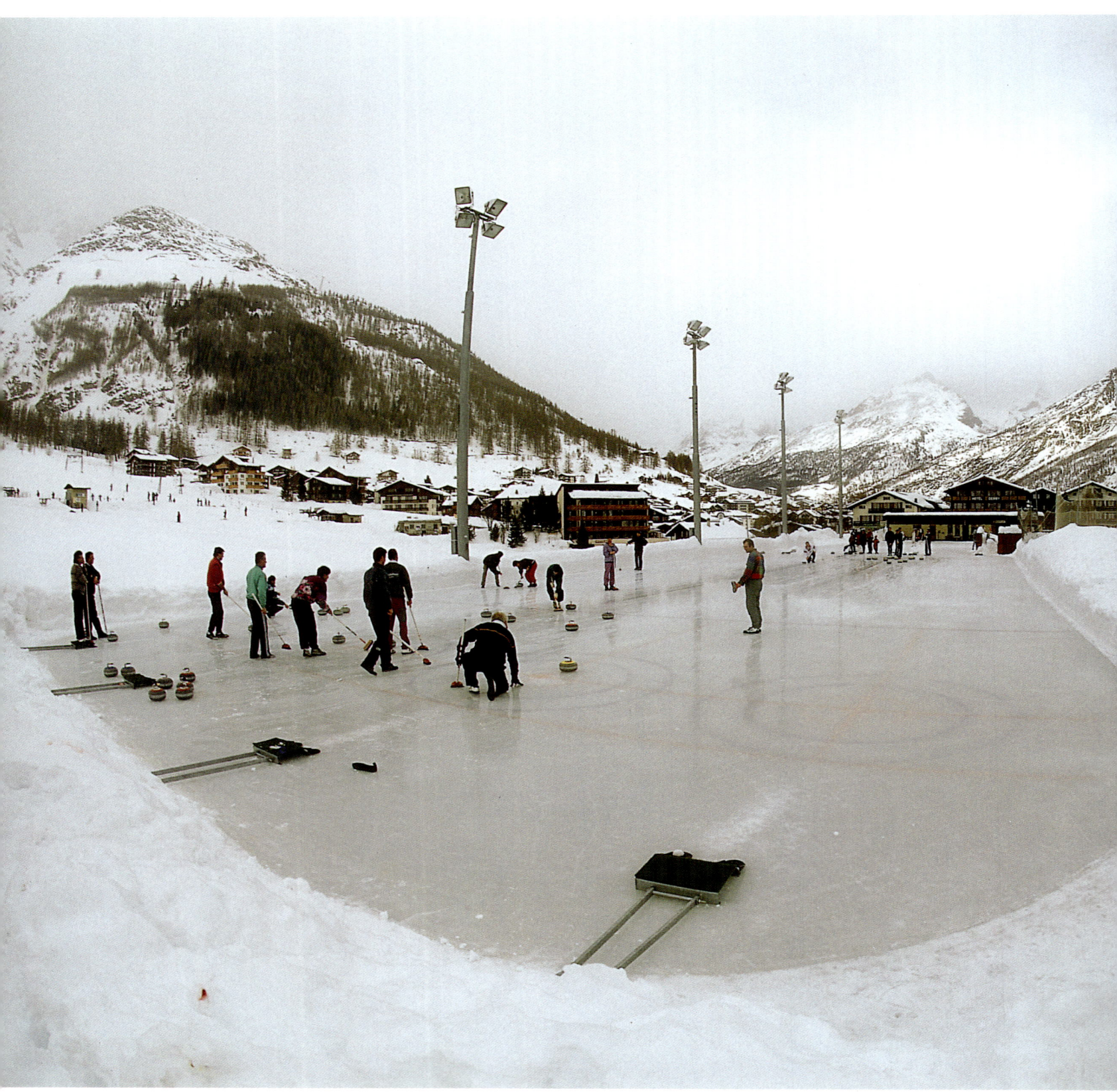

116-117 *Switzerland is considered a paradise for winter sports lovers, not only on account of its stunning Alpine setting but also because of the exceptionally high-level facilities it offers them. As well as numerous, ultra-efficient lift systems for downhill skiing, all the foremost tourist resorts have groomed cross-country trails, sometimes also lit at night, and natural or artificial ice rinks for skating, curling and hockey. There are also many riding schools, since Switzerland has a long experience of this sport, with particular emphasis on the specialities of show jumping and dressage.*

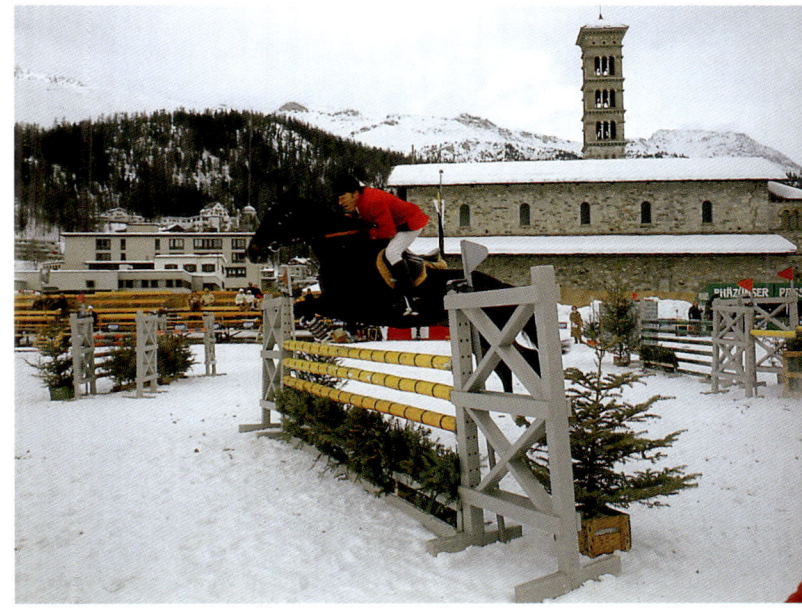

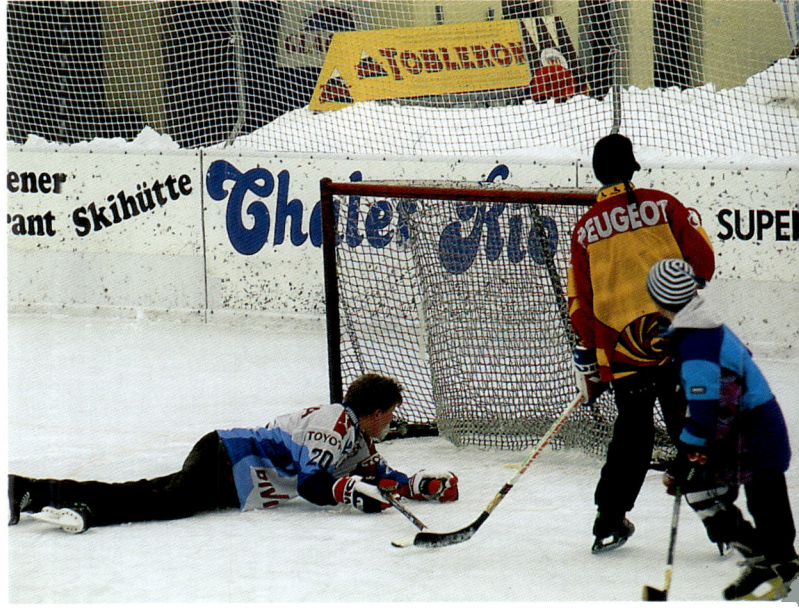

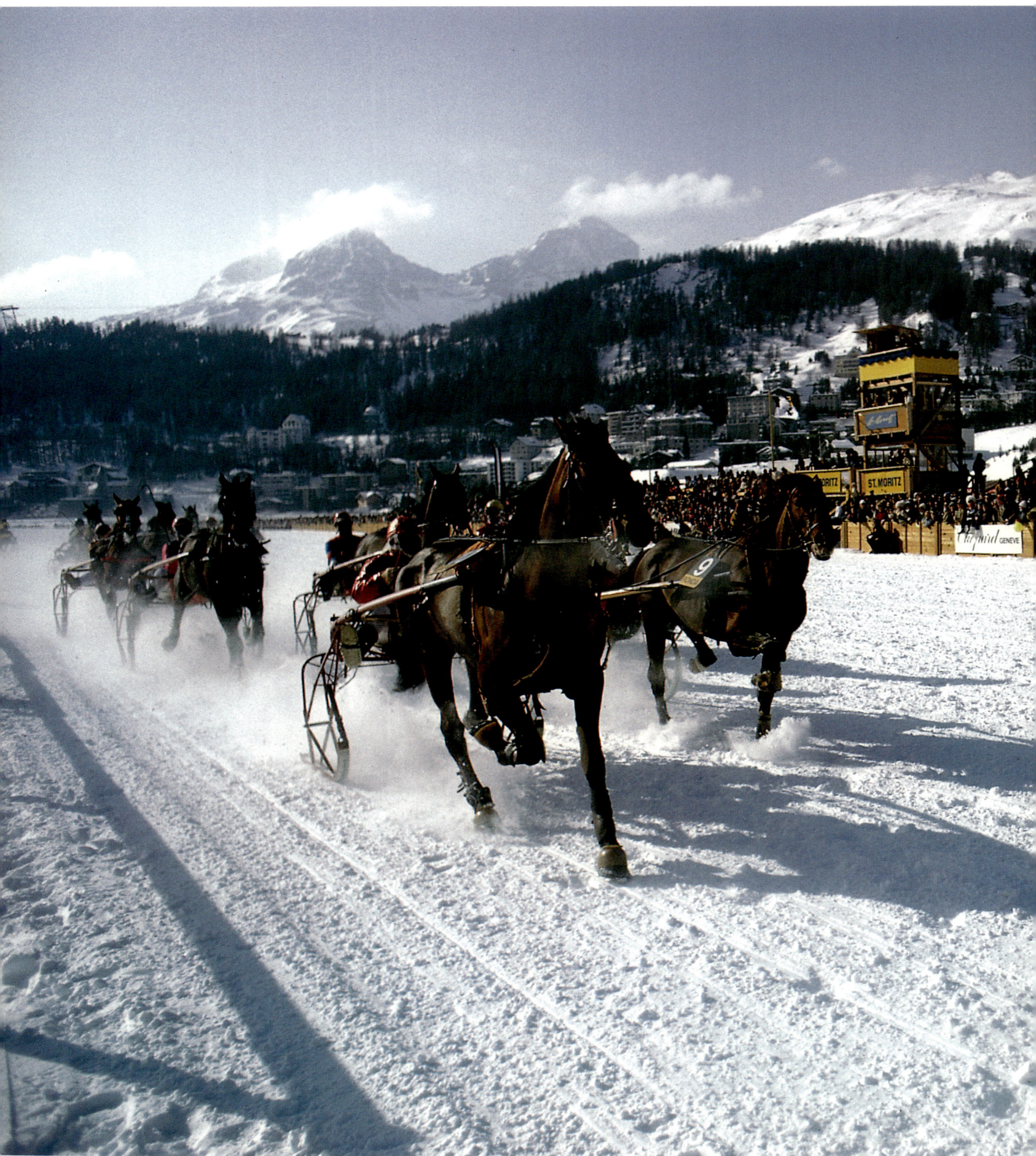

St. Moritz, a wintry "Ascot"

118-119 *Horses, first imported by the English at the end of the 1800s, have contributed to make St.Moritz famous the world over: thousands of enthusiasts come to watch the races held here. The renowned Sclitteda takes place in the middle of winter: engaged couples from the town, wearing traditional costume, parade on horse-drawn sleighs*

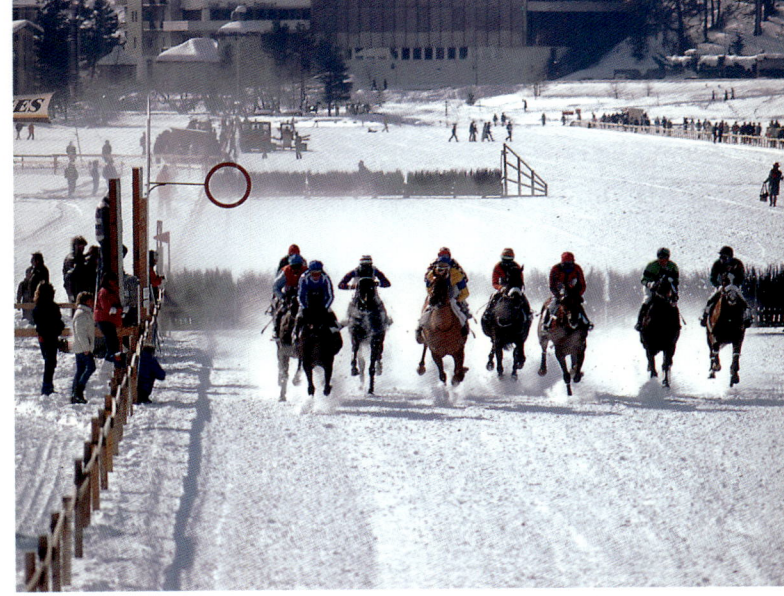

decorated with colourful ribbons and tinkling bells. January 14th is the date of the famous horse race run over the snow-covered polo field; a week later, the Cartier Polo World Cup on snow is a not-to-be-missed event for VIPs from every corner of the globe.

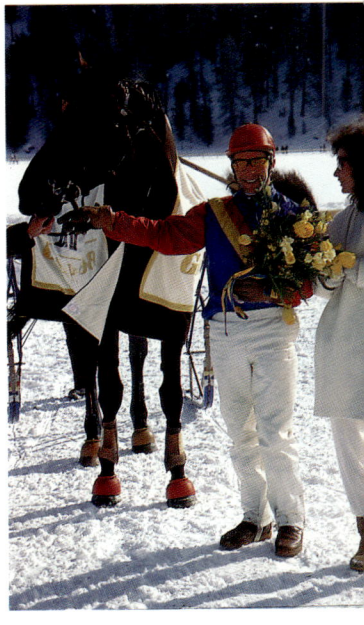

Sport,
on top of the world

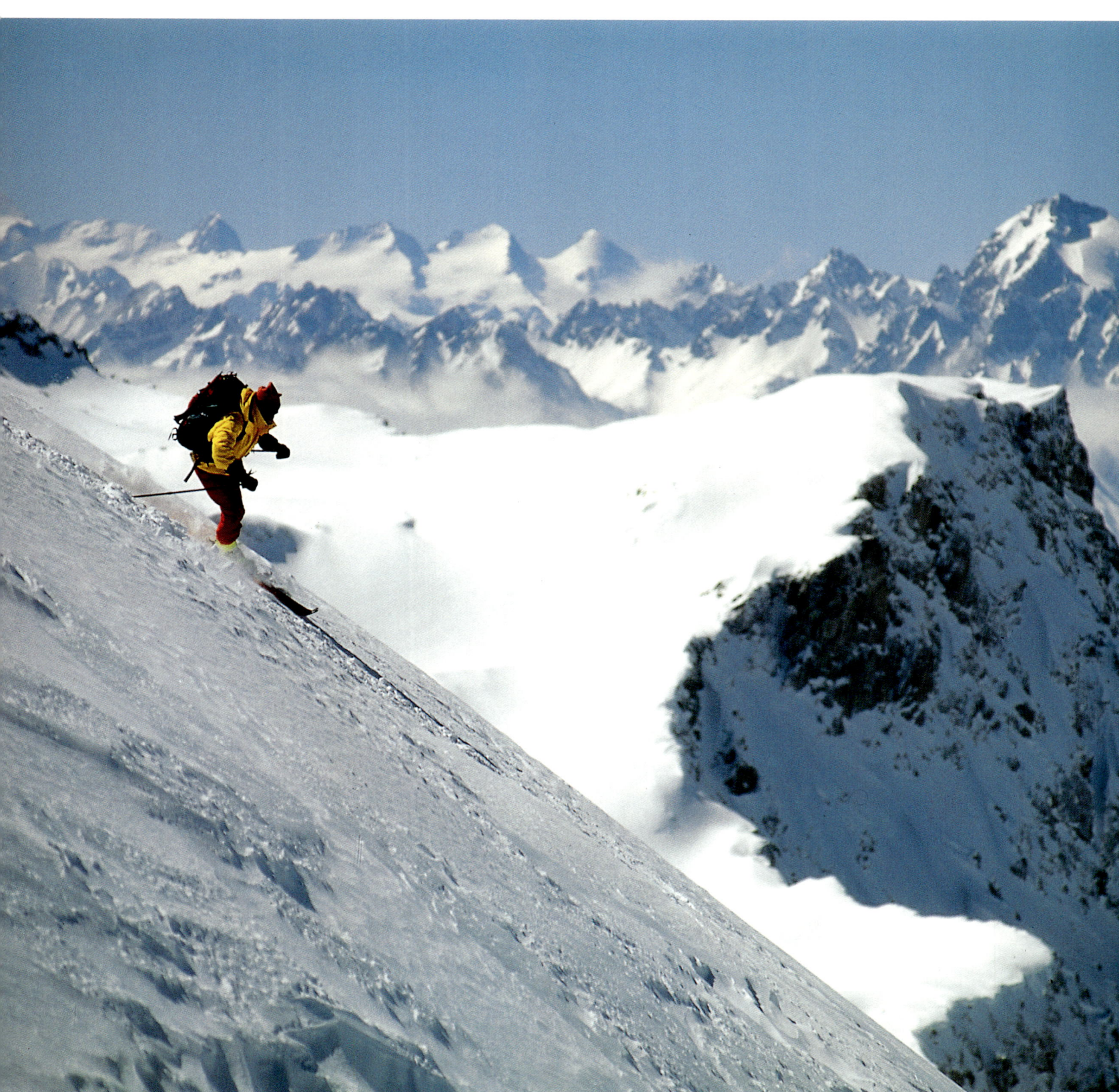

120-121 *Far from groomed pistes, from thronging crowds queuing at ski lifts and from all the ultra-fashionable trappings of the winter sports scene, the rugged individualists who practise ski mountaineering have endless opportunities to savour the real magic of these mountains. Surrounding the skier are vast spaces and absolute silence. Only initiates can know the indescribable thrill of skiing down a slope or fresh snow, dazzled by the glare of the sun, and then stopping for a moment to look back at the tracks they have left in the pristine whiteness.*

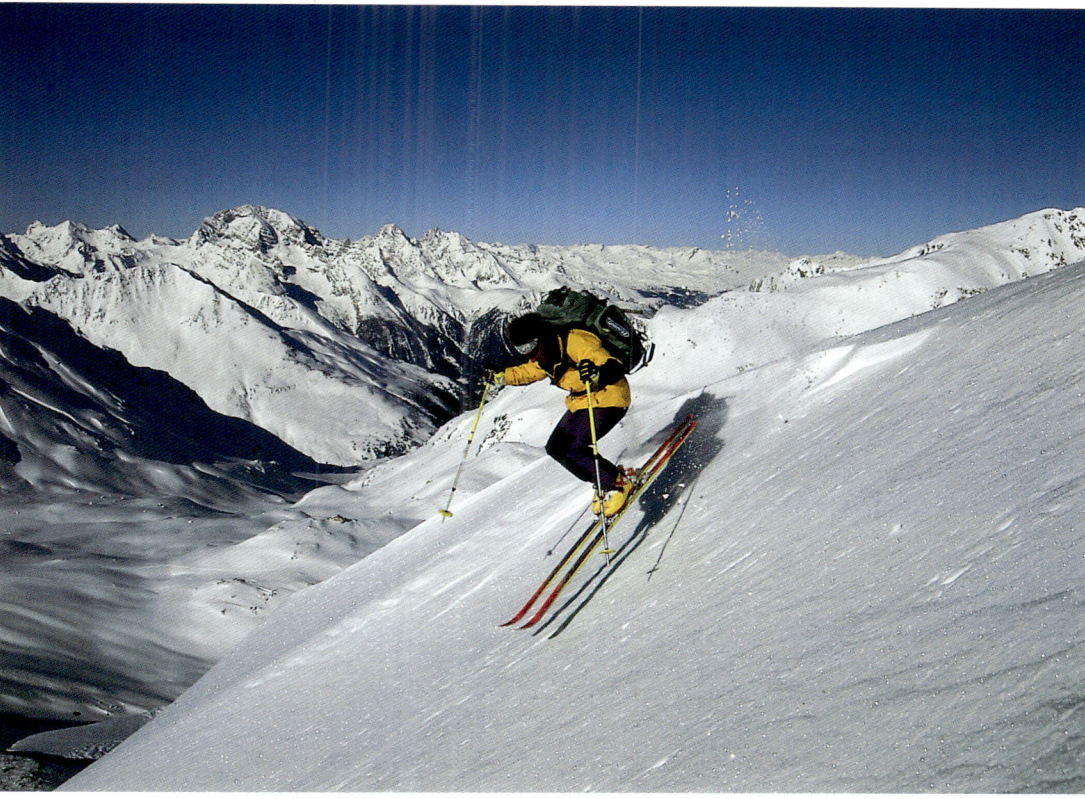

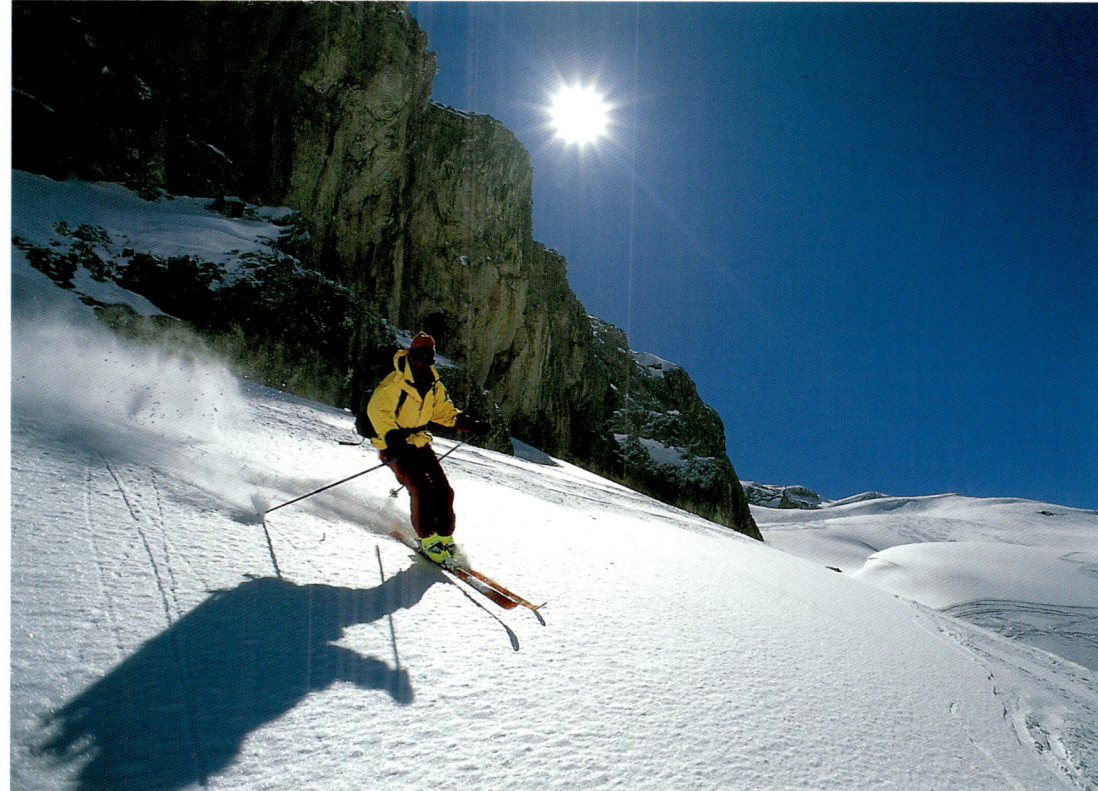

122-123 *Upon ascending Cima di Rossa, in Engadine, Monte Disgrazia and the head of the Forno Valley are left far behind. Ski mountaineering is perhaps the ideal way to enjoy the spectacular scenery of the Alps of Central Switzerland.*

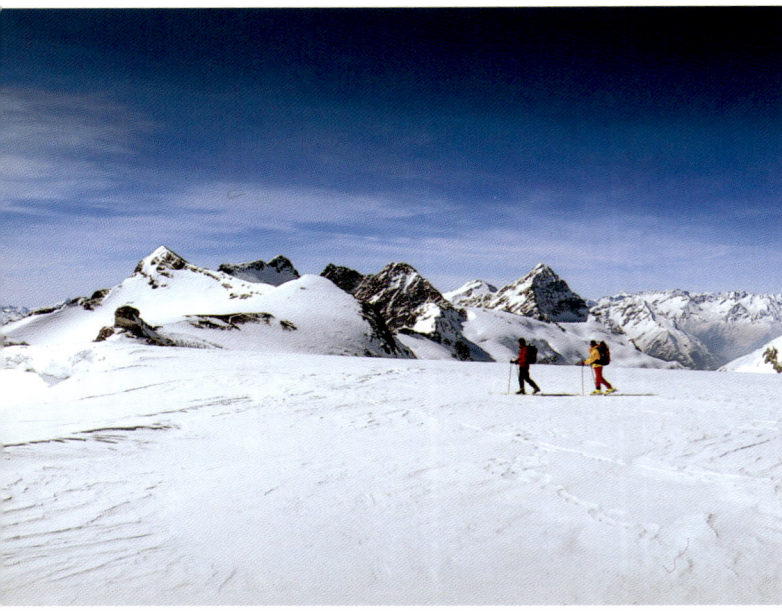

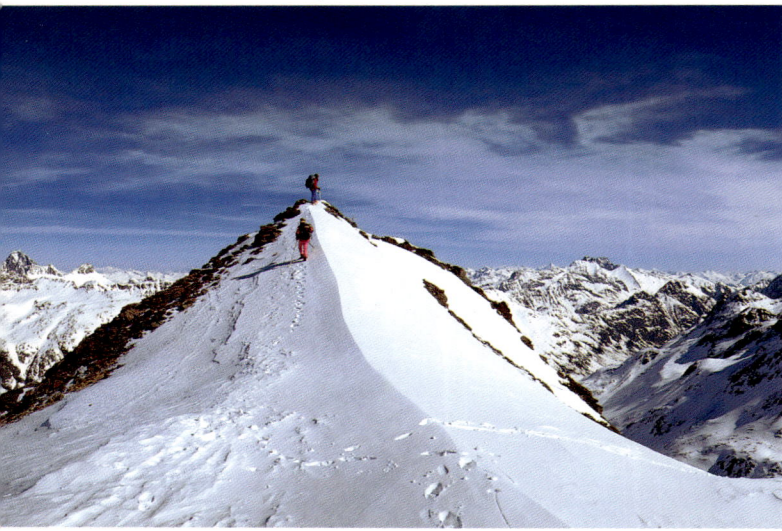

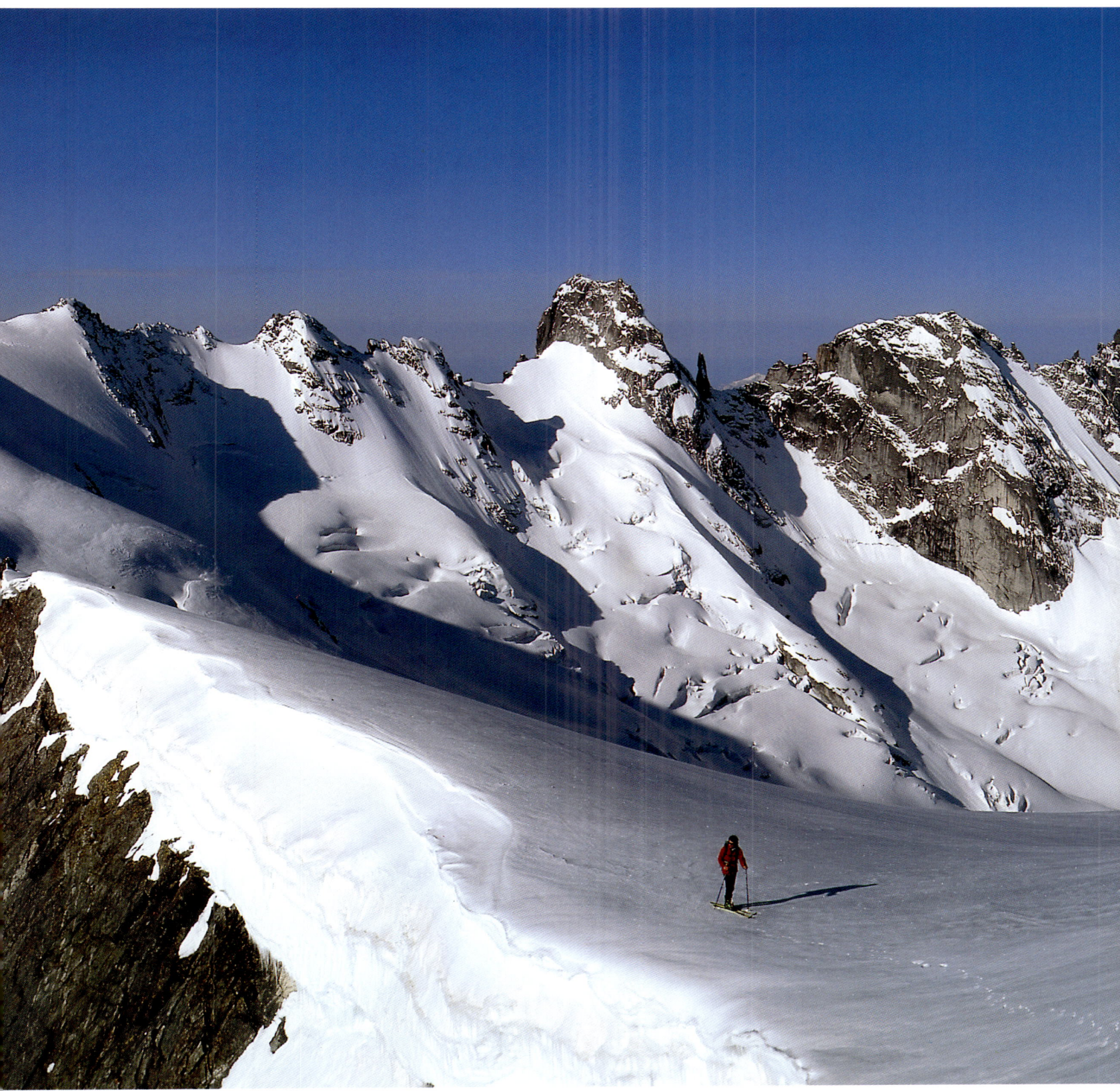

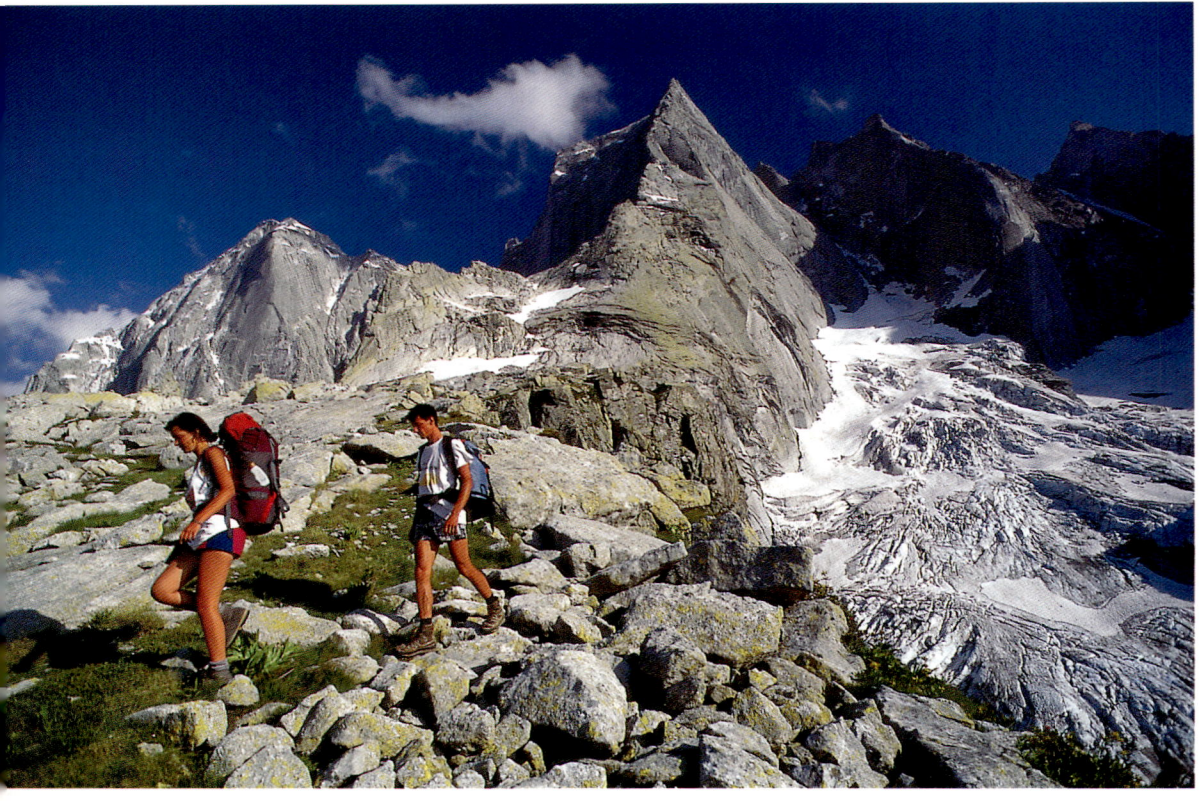

124-125 *Three different ways of getting up a mountain: traditional hiking (in Val Bondasca), climbing (on the Grosse Scheidegg-Grindelwald) for adventurous loners and peddling uphill on a mountain bike (the Lenzsptize - Saas-Fee run), the latest craze among summer sports, now increasingly popular where biking is a feasible proposition.*

126-127 *In the heart of the Valais region, Saas-Fee nestles in the embrace of fourteen mountains which soar to heights of over 13,123 feet. You can almost hear the ice crack beneath the measured steps of a climber making his way to the summit of the Lenzspitze, while the wind creates a swirling veil of snow at his feet. The reasons for his climb matter little: he may be testing his personal skills and endurance; he may have responded to a challenge from others; this may be a quest that will bring him closer to the mysteries of life. Whatever the case, the lure of mountain peaks never changes.*

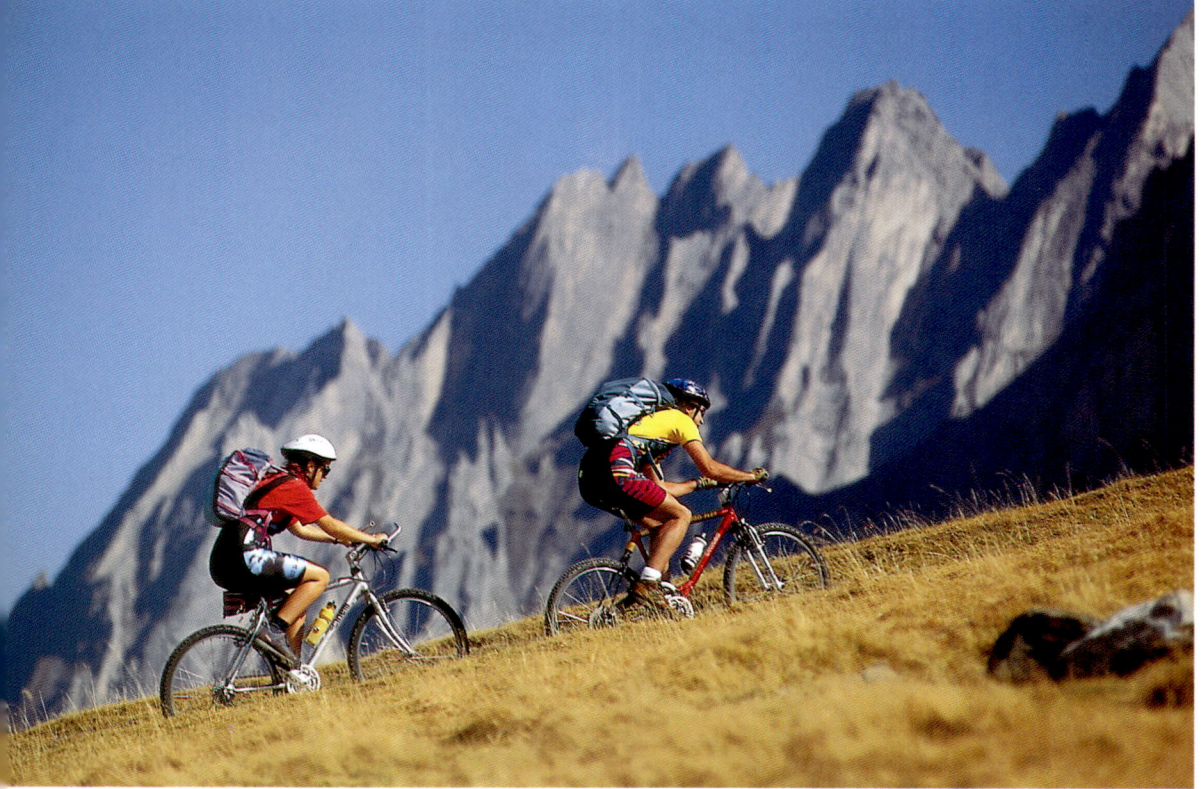

128 *Viewed from the lake, Chillon Castle could be a prince's palace; from the shore it looks like medieval stronghold. Pierre II of Savoy had this fortress built in the 13th century, on a rocky outcrop close to bank of Lake Geneva, not far from Montreux. Inside are spacious rooms with 15th-century fireplaces and carved wood ceilings, as well as a large collection of weapons and armour worn by knights in the Middle Ages. Its basements were often used as prisons: Françoise Bonivard, anti-Savoyard and strenuous defender of the freedom of Geneva, was held here in chains from 1530 to 1536; his misadventures were related by Lord Byron in "The Prisoner of Chillon", and also by Victor Hugo, who turned him into a hero of the people.*

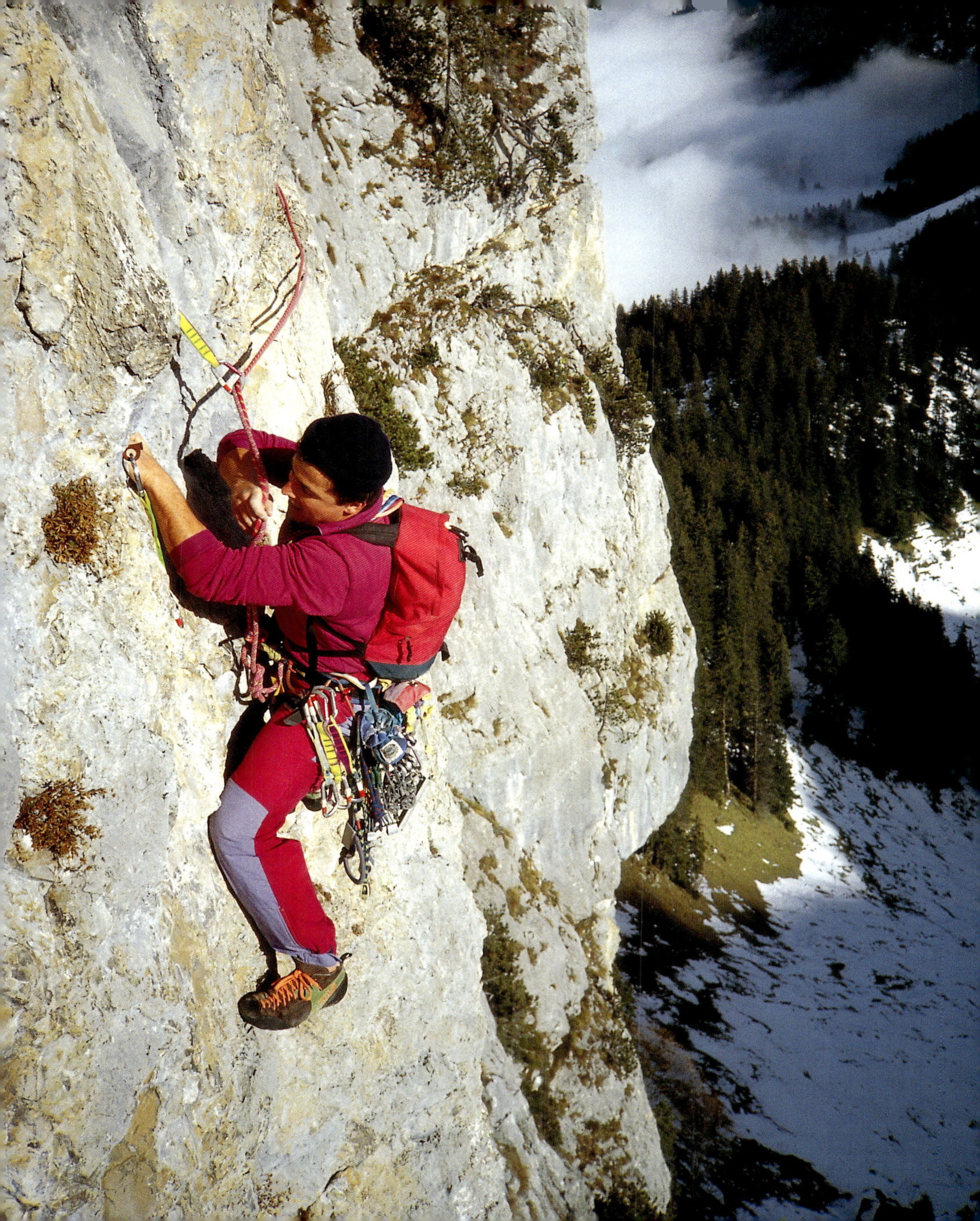

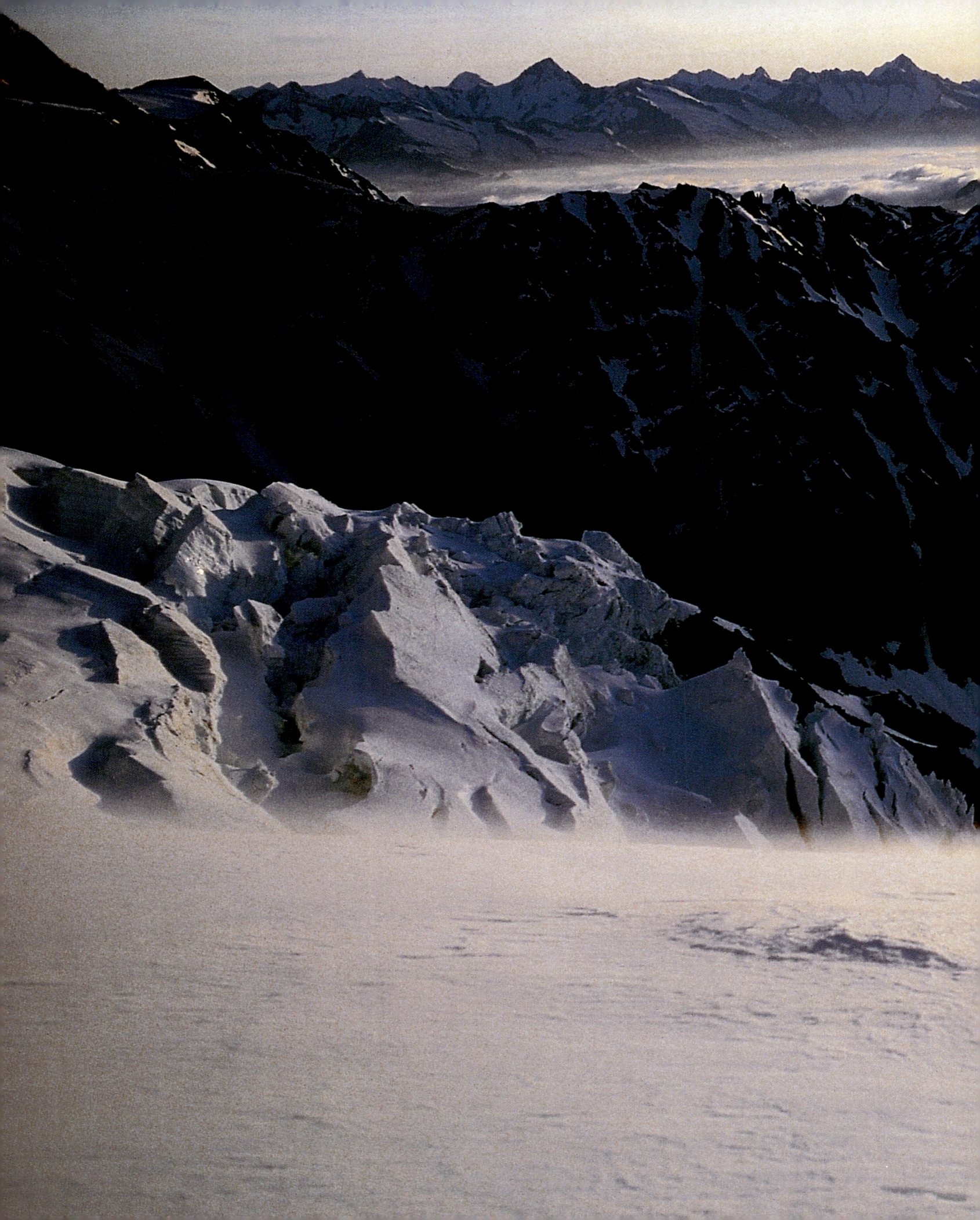

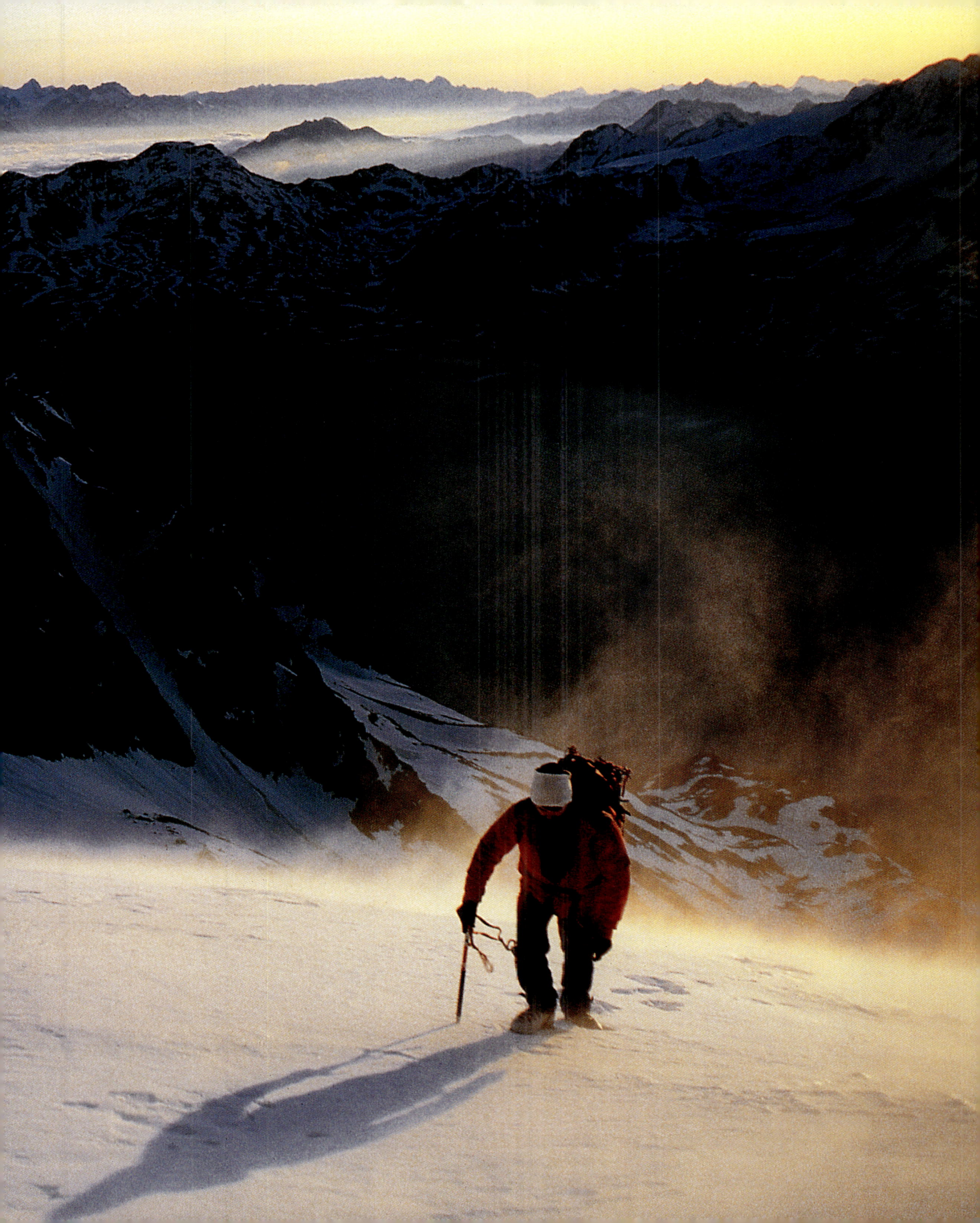

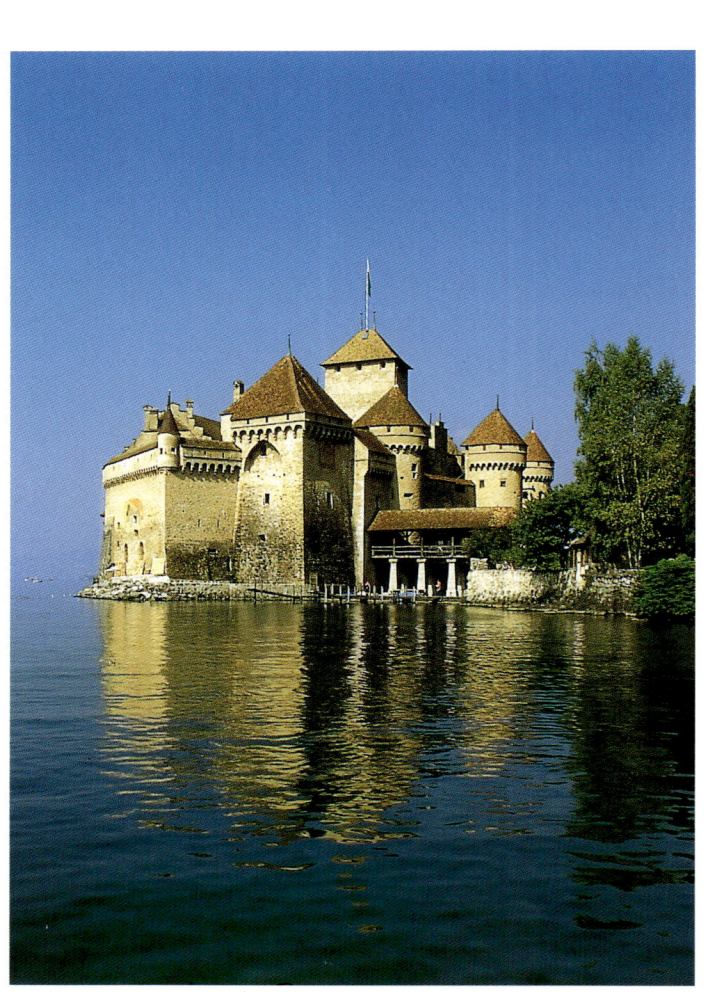

Illustrations credits

Marcello Bertinetti / Archivio White Star:
pages 42-43, 117 in alto, 118, 119.

Giulio Veggi / Archivio White Star:
pages 4-5, 6-7, 8, 9, 12-13. 16-17, 18,
19, 22-23, 26, 27, 32, 33, 34, 35, 44,
45, 48, 49, 51 left, 52-53, 54, 55, 56,
57, 58-59, 60, 61, 62, 63, 64, 65, 66,
67, 68, 69, 70, 71, 72, 73, 74, 75, 78,
79, 80, 81, 82-83, 84 top, 86, 87
bottom, 88-89, 94-95, 96, 97, 98, 99,
102-103, 104, 105, 106-107, 108, 109,
110, 111, 116-117, 117 bottom, 128.

Alberto Azzoni / Overseas:
page 87 top.

Stefano Cellai / SIE:
pages 76 top, 77.

P. Delarbre / Explorer / Overseas:
page 93.

Fausto Giaccone / SIE:
page 76 bottom.

Thomas Mayer / Ag. Franca Speranza:
page 85.

Walter Mayr / Grazia Neri:
page 84 bottom.

Marco Milani / K3:
pages 2-3, 20-21, 24-25, 28-29, 30-31,
36-37, 38-39, 40-41, 46-47, 50-51,
120, 121, 122, 123, 124, 125, 126-127.

Max Messerli / Ag. Franca Speranza:
page 14.

Tomas Muscionico / Grazia Neri:
page 100.

Grazia Neri:
pages 90, 91.

Photo Bank:
page 1.

Mauro Raffini / Ag. Franca Speranza:
pages 114, 115.

D. Robotti / Overseas:
page 15.

S. Tauquer / Ag. Franca Speranza:
page 112, 113.

Tetrel / Explorer / Overseas:
pages 92-93.

Villa Rosa / Overseas:
page 101.